ST ANDREWS

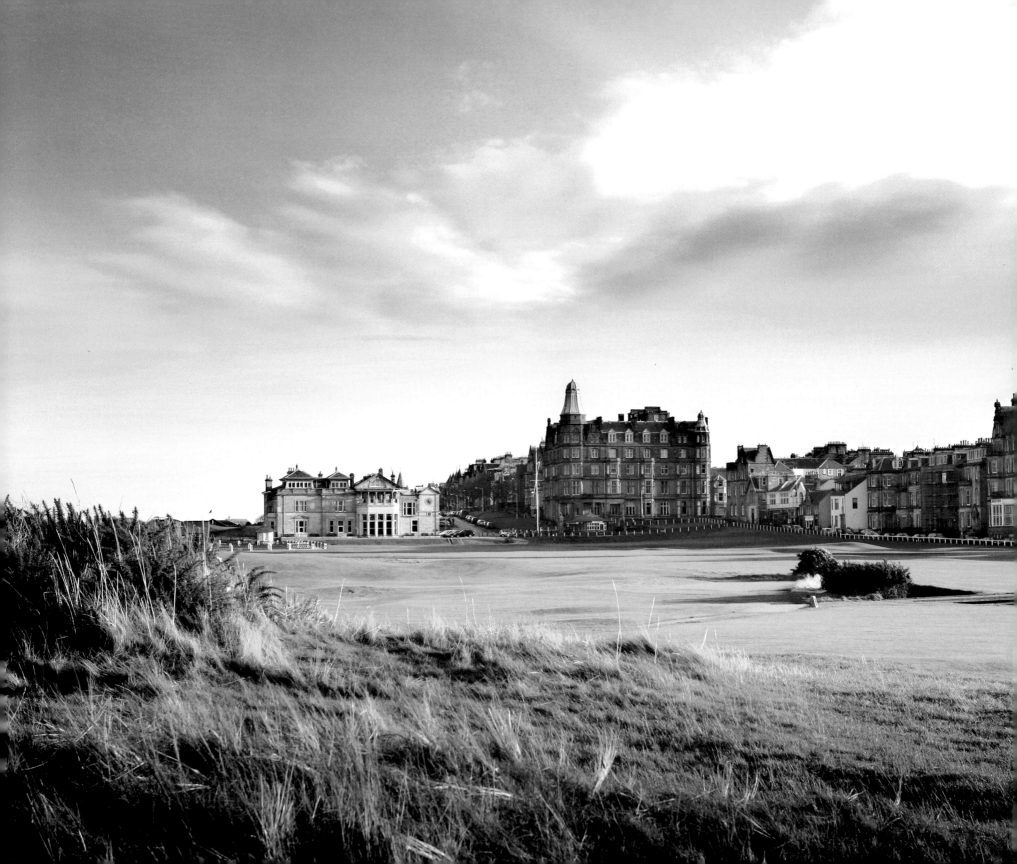

ST ANDREWS

THE HOME OF GOLF

Photography by Kevin Murray

Henry Lord and Oliver Gregory

Foreword by Seve Ballesteros

CORINTHIAN BOOKS

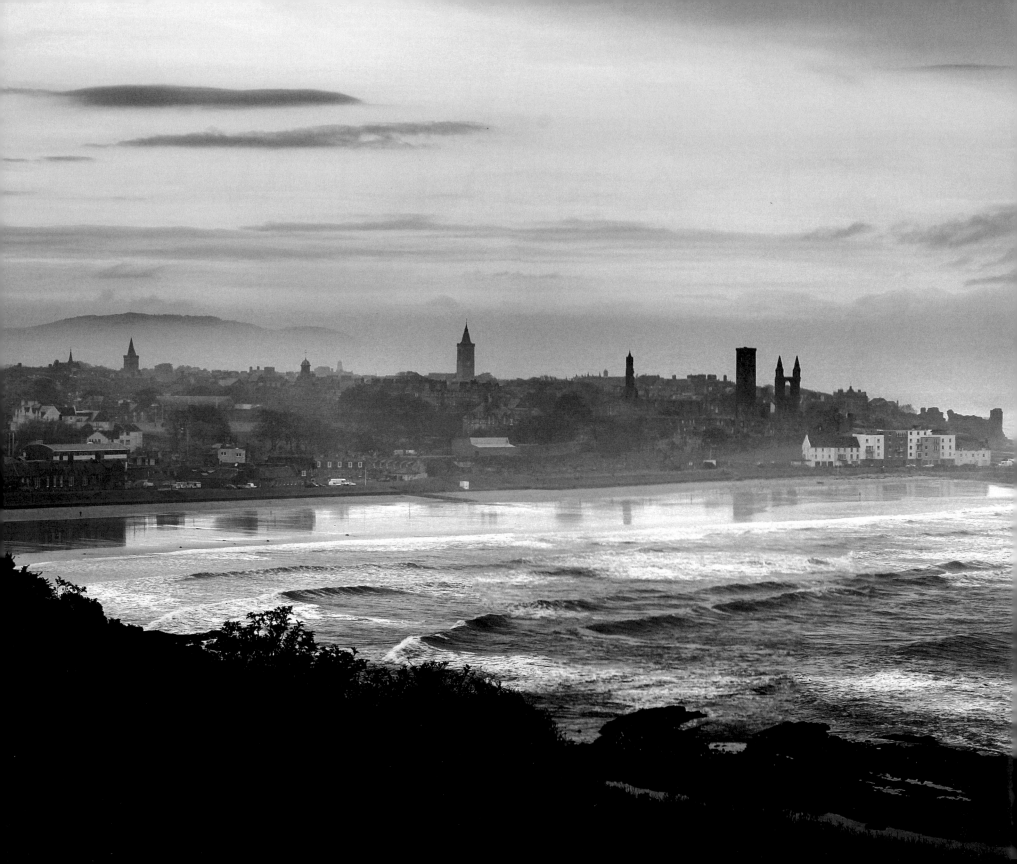

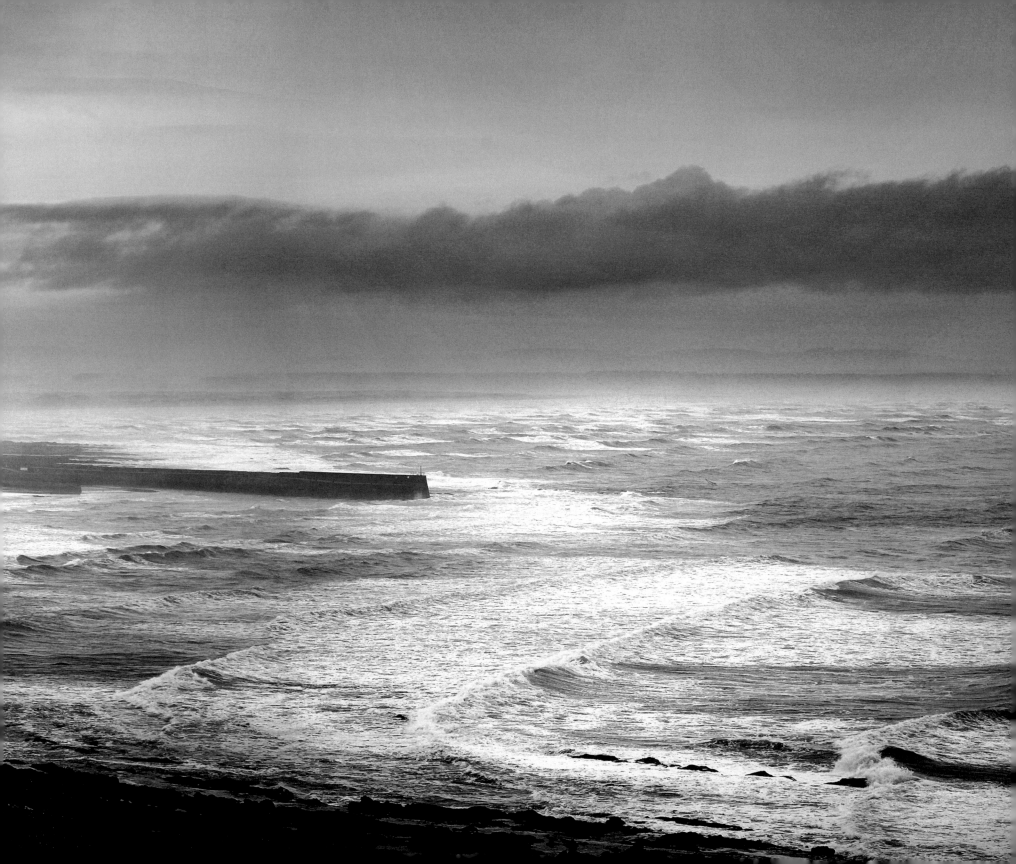

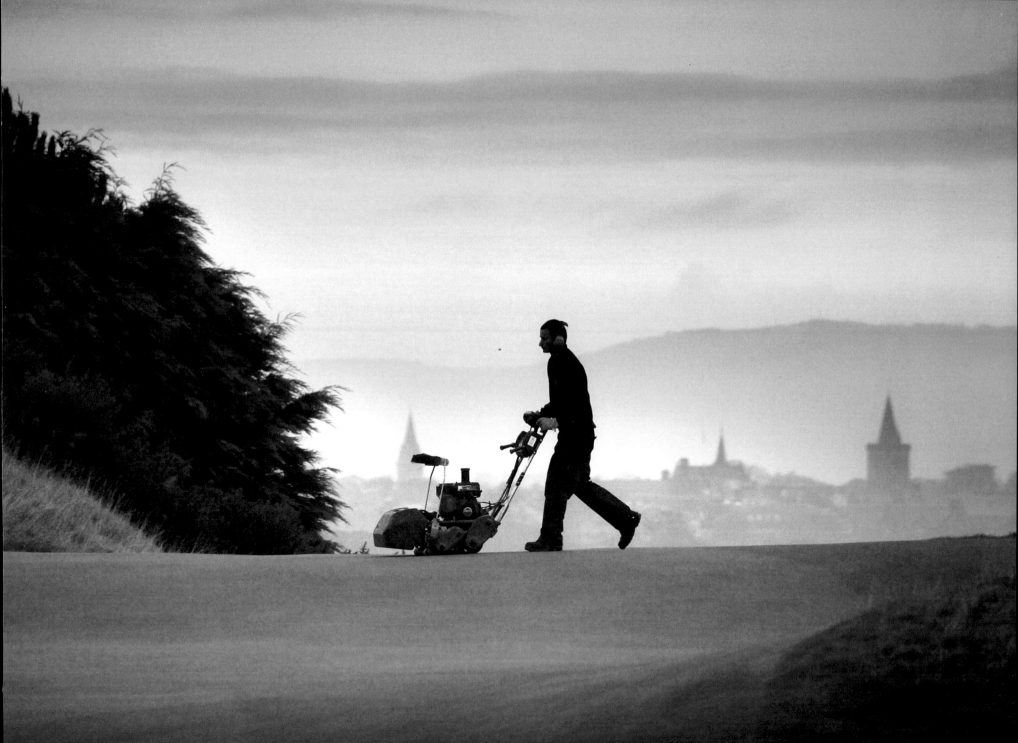

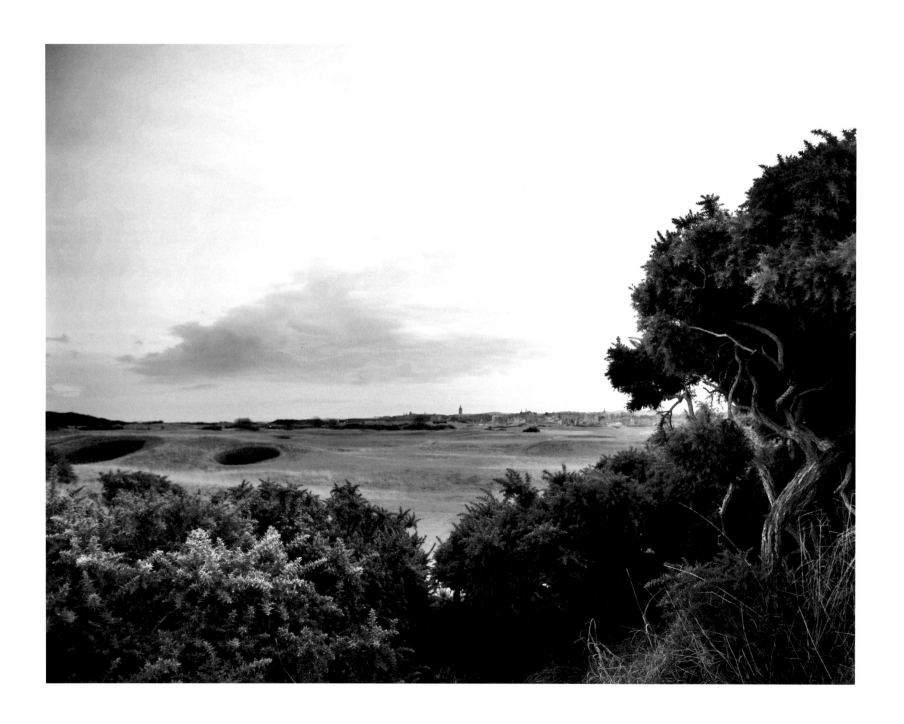

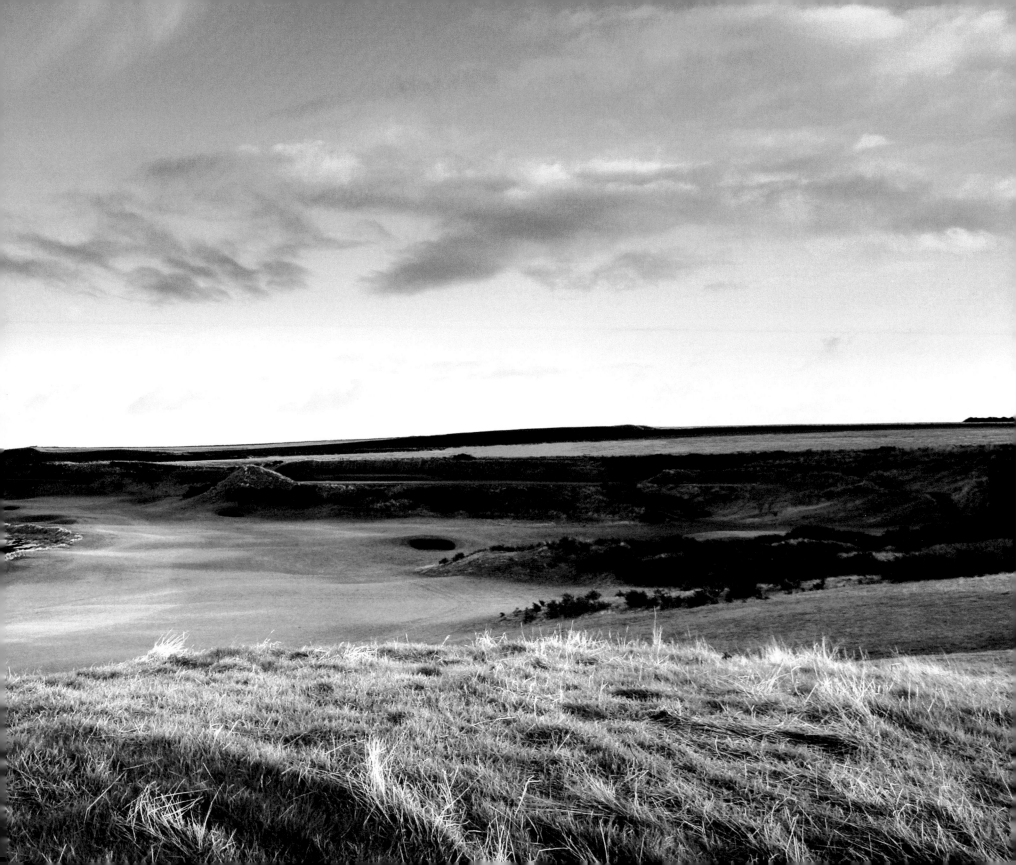

Published in the UK in 2010 by Corinthian Books, an imprint of
Icon Books Ltd, Omnibus Business Centre,
39–41 North Road, London N7 9DP
email: info@iconbooks.co.uk
www.iconbooks.co.uk

Sold in the UK, Europe, South Africa and Asia
by Faber & Faber Ltd, Bloomsbury House,
74–77 Great Russell Street,
London WC1B 3DA or their agents

Distributed in the UK, Europe, South Africa and Asia
by TBS Ltd, TBS Distribution Centre, Colchester Road,
Frating Green, Colchester CO7 7DW

Published in Australia in 2010
by Allen & Unwin Pty Ltd,
PO Box 8500, 83 Alexander Street,
Crows Nest, NSW 2065

Distributed in the USA by
Consortium Book Sales & Distribution
The Keg House
34 Thirteenth Avenue NE, Suite 101
Minneapolis, Minnesota 55413-1007

Distributed in Canada by Penguin Books Canada,
90 Eglinton Avenue East, Suite 700,
Toronto, Ontario M4P 2Y3

ISBN: 978-190685-014-2

Text copyright © 2010 Henry Lord and Oliver Gregory
Majority photography copyright © Kevin Murray
The authors and photographer have asserted their moral rights.

Typeset and designed by Simmons Pugh

Printed and bound by Gutenberg Press, Malta

Previous pages:

The Old Course's opening and closing holes.
St Andrews Bay.
Morning mist around St Salvator's College tower.
Greenkeeping on the Castle Course.
Gnarled gorse on the Old Course.
Heather on the Links.
The 12th hole at Kingsbarns.

CONTENTS

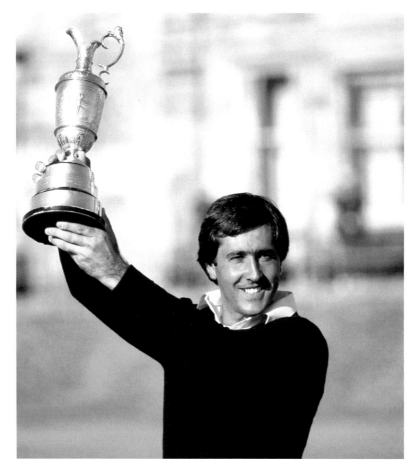

Severiano Ballesteros, Open champion 1979, 1984, 1988; Masters champion 1980, 1983.

FOREWORD

This is a book about an extraordinary place and a living tradition. It offers an unprecedented tour around St Andrews, where the game of golf in its earliest form was cradled and nurtured. For me, looking through its pages brings back many happy memories of my time spent there, both on and off the course, so I am pleased to be a part of this special publication.

My first Open experience at St Andrews came in 1979 when I was 22 years old. Much like Bobby Jones discovered on his way to winning The Open on the Old Course more than 50 years earlier, I quickly realised that St Andrews rewards clever placement of every shot rather than raw distance, and that could only be mastered by diligent study of the course's subtleties. When The Open returned to St Andrews in 1984, my practice and determination paid off. After making par at the difficult 17th hole on the final day, I felt that I needed to birdie the last to have a chance of winning. When I hit my approach shot over the Valley of Sin to within fifteen feet of the pin and sank the putt, the roar of the crowd lifted me like never before and I was certain that I was champion. It was one of the most exciting moments of my career.

Not only have I had the past good fortune to win The Open at St Andrews, I have always been made to feel most welcome there. In 2000 I was awarded an honorary degree from St Andrews University and more recently made an honorary member of the Royal and Ancient Golf Club. To be embraced in such a personal, heartfelt way has only served to strengthen my connection with the town and its golfers.

There are numerous reasons why St Andrews is special and this book presents many of them in rich detail. Perhaps one of the most important is the accessible public nature of the Links: the courses belong to the town, and the game played upon them belongs to everyone – girl or boy, woman or man – whatever their age, background or ability.

After retiring from professional golf in 2007, the toughest match of my life came a year later when I was diagnosed with a brain tumour. With the help of my doctors and the courage I know from a lifetime of competing on the golf course, I never gave up fighting. I have since gone on to set up the Seve Ballesteros Foundation, working in partnership with Cancer Research UK in the United Kingdom. The Foundation's ambition is to raise research funds to help prevent, diagnose and treat brain tumours, an area that is widely recognised as being underfunded. It had always been my ambition to win The Open at St Andrews. I am delighted that this wonderful book about the place will go some way in helping achieve another ambitious goal – beating brain cancer.

Seve Ballesteros

* 80p from the sale of this book will be donated to the Seve Ballesteros Foundation working in partnership with Cancer Research UK to beat brain cancer. Cancer Research UK is registered charity number 1089464.

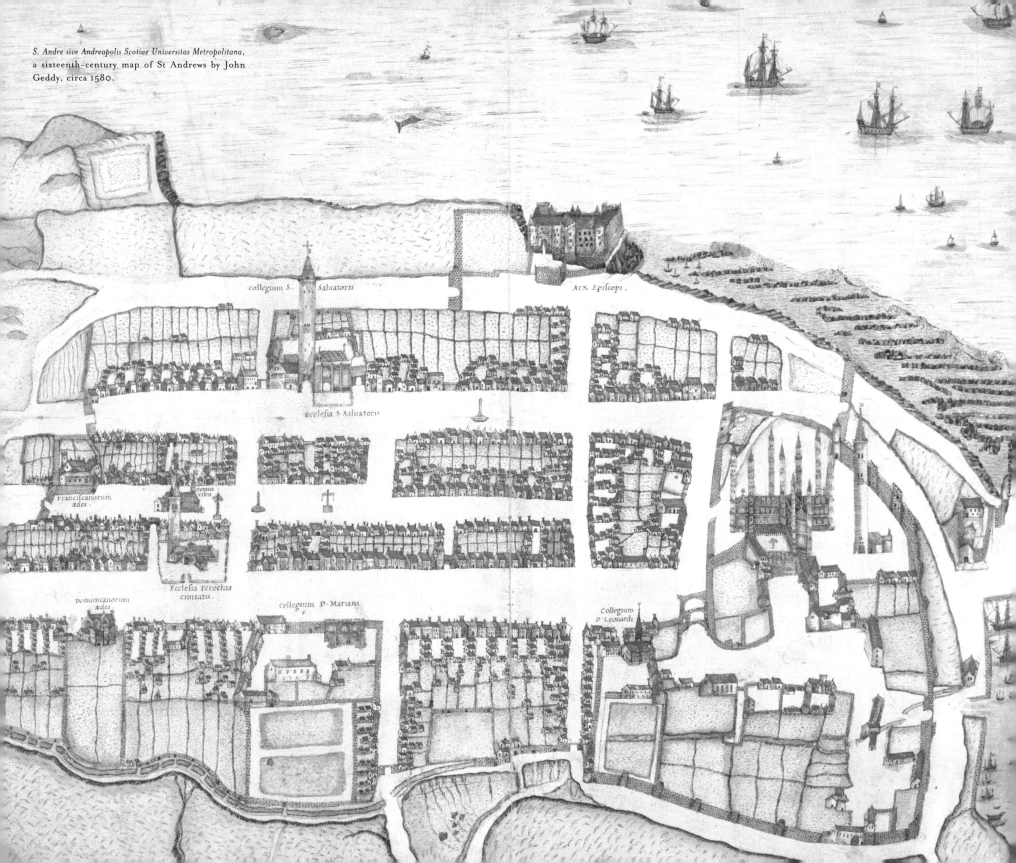

S. Andre sive Andreapolis Scotiae Universitas Metropolitana,
a sixteenth-century map of St Andrews by John
Geddy, circa 1580.

collegium S. Saluatoris

Arx Episcopi.

Ecclesia S Saluatoris

Franciscanorum
ædes.

Domus
vrbis

Ecclesia Parochiæ
ciuitatis.

Dominicanorum
ædes.

collegium D. Mariani

Collegium
D Leonardi

ST ANDREWS:
CITY BY THE NORTHERN SEA

… It is delightful to see a whole town given up to golf; to see the butcher and the baker and the candle-

stick maker shouldering his clubs as soon as his day's work is done and making a dash for the links.

Bernard Darwin on St Andrews

As day breaks over St Andrews, the city's ancient grey walls loom up from the darkness. A mist, known locally as haar, rolls in off the North Sea and is pierced by medieval spires before drifting down cobbled wynds (lanes) and twining around cloistered quadrangles of scholarship. Located in the Kingdom of Fife, this was once Scotland's most revered and influential burgh, its ecclesiastical capital and the home of its oldest university. In the strengthening light, the fog lifts and a more harmonious Victorian aspect emerges — elegant crescents and ordered terraces of sandstone brick.

The rhythmic clicking of golf clubs being carried breaks the early morning stillness. Keen golfers shoulder their bags and stride through the streets to the abutting strip of linksland on which the game has been played for over half a millennium. 'The links of St Andrews holds premier place as indubitably as Lord's Ground in the kingdom of cricket,' wrote Horace Hutchinson in the 1890 volume *Golf* for the Badminton Library of Sports and Pastimes. 'All the great mass of golfing history and tradition — principally perhaps the latter — clusters lovingly within sight of the grey towers of the old University town; and, to most, the very name St Andrews calls to mind not a saint nor a city, nor a University, but a beautiful stretch of green links with a little burn, which traps golf balls, and bunkers artfully planted to try the golfer's soul.'

Hutchinson's words of more than a century ago still resonate

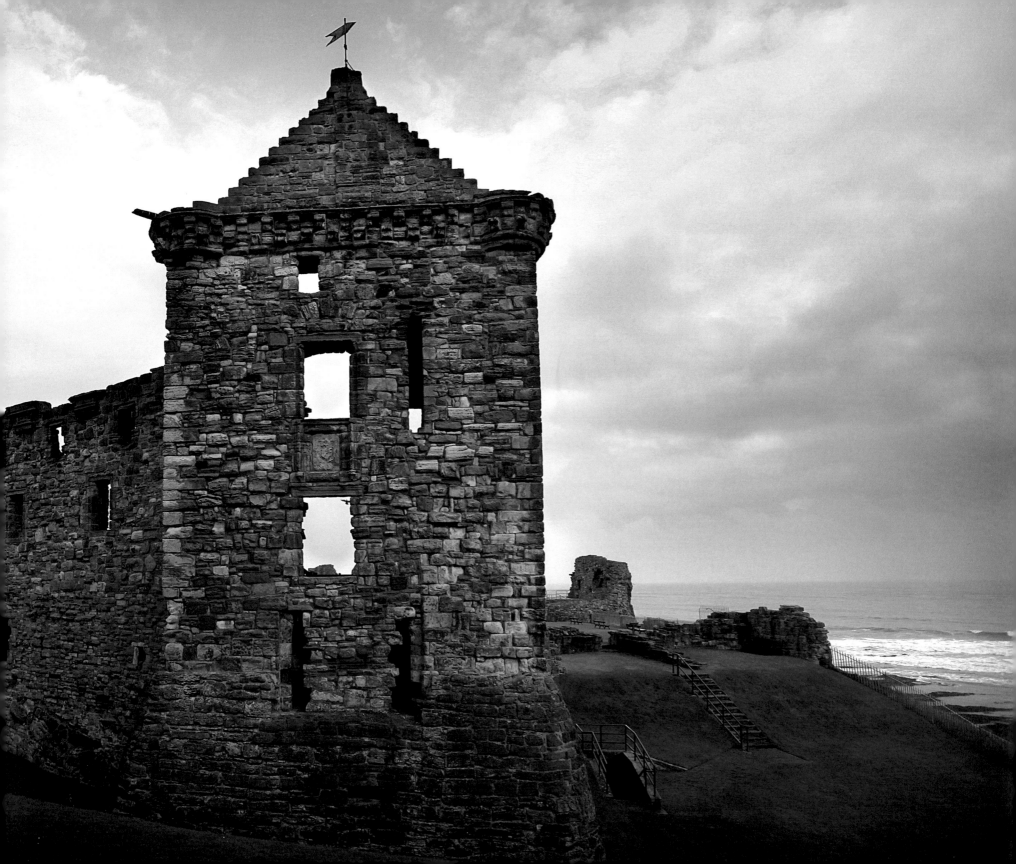

today. St Andrews is universally acknowledged as the 'Home of Golf', visited by tens of thousands of people every year who make the pilgrimage to play across the Old Course's hallowed turf or watch the world's greatest tournament professionals and amateurs do battle there. Yet religious pilgrims were heading to St Andrews before the golfing ones. Nowadays, even travellers whose thoughts are bent on golf cannot fail to notice the dramatic cathedral and castle ruins at the east end of town. The limits and purpose of this book preclude a full historical account of St Andrews, but a short walk around its streets will give a sense of its rich and turbulent past.

St Andrews grew up around its great Cathedral, which was founded circa 1160 to expand upon the earlier church of St Regulus (or St Rule). Perched high on a rocky bluff above the sea, the town's three principal streets — North, Market and South — run parallel to one another and converge on the Cathedral's mellow ruins. The preceding church at the site was named after a fourth-century monk who, legend has it, came to the area from Greece with relics of Saint Andrew the Apostle — Scotland's patron saint — and interred the remains. All that is left of the church is St Rule Tower. Standing 108 feet high, its almost Tuscan style of architecture can probably be attributed to the Augustinian monks who came to St Andrews from mainland Europe and founded a priory nearby.

Left: The ruins of St Andrews Castle.

Right: A statue of Saint Andrew holding the Saltire Cross in the Botanical Gardens.

POLISH SOLDIER
1939 AND RESCUE

HOPPITY
HOUSE

38

PILMOUR LINKS GOLF PLACE

DUM SPIRO SPERO

ST ANDREWS PRESERVATION TRUST

Old Tom Morris 1821-1908
Open Champion
1861, 1862, 1864 and 1867
Born in a house which stood on this site
16th June 1821

DUM SPIRO SPERO

Work continued on St Andrews Cathedral for over 150 years, interrupted by a storm in 1272 that blew down the building's west front, and by the first War of Independence against England (1296–1307). It was eventually consecrated in 1318 in the presence of King Robert the Bruce, who rode his horse up the main aisle to mark the occasion. As the largest cathedral in the Scottish Church at the time, it became a powerful and immensely wealthy seat for leading Catholic bishops and archbishops right up to the Protestant Reformation in 1560. At that point, the reformer John Knox and his followers 'cleansed' the building and tombs of their ornate idolatry. After the fanatical sacking, the Cathedral was left to fall into ruin and no preservation measures came into effect until the mid-nineteenth century.

The Cathedral is now surrounded by a graveyard, with some of the older flat-stone tombs dating back to the four-teenth century. There are more recent citizens as well, including the eighteenth-century Enlightenment philosopher and historian Adam Ferguson, who was educated at St Andrews University; many of the town's famous home-grown golfers; and Sir Hugh Lyon Playfair, who reposes in an ornate tomb set into the precinct wall. Sir Hugh was very much the saviour of St Andrews in the 1840s and '50s.

Opposite page, clockwise from top left: Town Hall memorial dedicated to Polish soldiers; gate on North Castle Street; house door; street signs; lamp post (detail); symbolic stone-work; St Andrews crest; Old Tom Morris plaque; St Andrews Preservation Trust insignia.

Having retired from the Horse Artillery in India, he became Chief Magistrate and then Provost (Mayor) of the Royal Burgh of St Andrews. As Provost he laid down '40 Rules and Regulations which must be obeyed' in an attempt to clean up the town. It worked and he went on to buy a train and build a railway track to link up with the main line. Sir Hugh was instrumental in the building of the Royal and Ancient Golf Club's clubhouse in 1854 and the Town Hall, among many other improvements. He was always to be seen in a long black coat and stovepipe hat about the Links.

Historically, the Cathedral's chief clergymen were housed in sumptuous accommodation at St Andrews Castle, the hunched remains of which can be found further along the cliff edge. Notable residents include James I of Scotland, who stayed there while receiving his education from Bishop Wardlaw, the founder of St Andrews University, circa 1410, and Bishop Kennedy, a trusted advisor to James II of Scotland; and it is also said that James III of Scotland was born there in around 1451. Over the centuries, the Castle has been destroyed and rebuilt several times as it was besieged at various points by Protestants, Catholics, Scots and the English. The stronghold was also a centre of persecution and had a well-equipped dungeon to contain unfortunate prison-ers. Many suffered a painful martyrdom in the name of reli-gion during those bloodthirsty years. As the office of the bishop was increasingly eroded following the Reformation, the Castle's function dissipated and like the Cathedral it was left to crumble into the sea.

Nestling below the Cathedral ruins, at the base of the

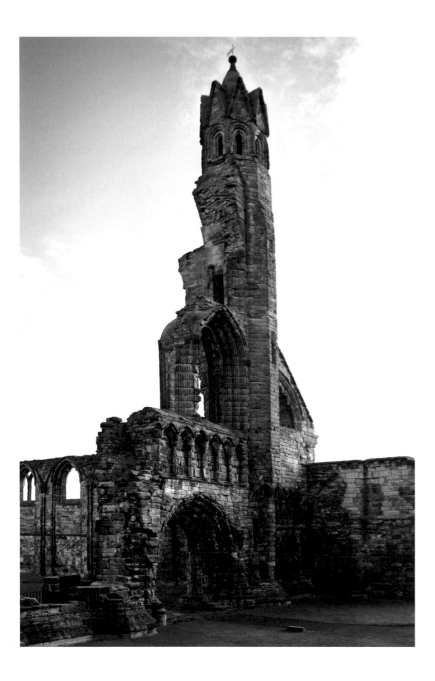

Left: The western ruins of St Andrews Cathedral.

Right: Cottages on College Street.

rocky headland on which they sit, are the town's harbour and pier, built from stones taken from the decaying buildings above. In the Middle Ages, St Andrews was a considerable port with a thriving fishing industry and mercantile trade. Fishing died out in the seventeenth century when the town's economy went into decline after the Church's wealth was stripped from it and various European wars damaged trade routes. However, many of the low fishermen's cottages are still in existence at the east end of North Street and inter-secting Castle Street, an area once known as 'Fishergate'. With the passing of the town fleet, a lot of fishermen went on to become caddies and early golf professionals on the links.

Golf was not a new game in Scotland at the time St Andreans decided to hang up their fishing nets. Although the first written record of golf in the Royal Burgh does not occur until 1552 — the year Archbishop John Hamilton drafted a charter in which the rights of the town's citizens to play golf on the Links were safeguarded — it is likely that the ground was used for golf as early as the University's foundation circa 1410–13 and probably much earlier.

Over the centuries, nature forged the barren, sandy and windswept coastal grassland into the Links we know today (the word 'links' derives from the Old English *hlinc* or 'lean ridge'). The layout that became the Old Course was never

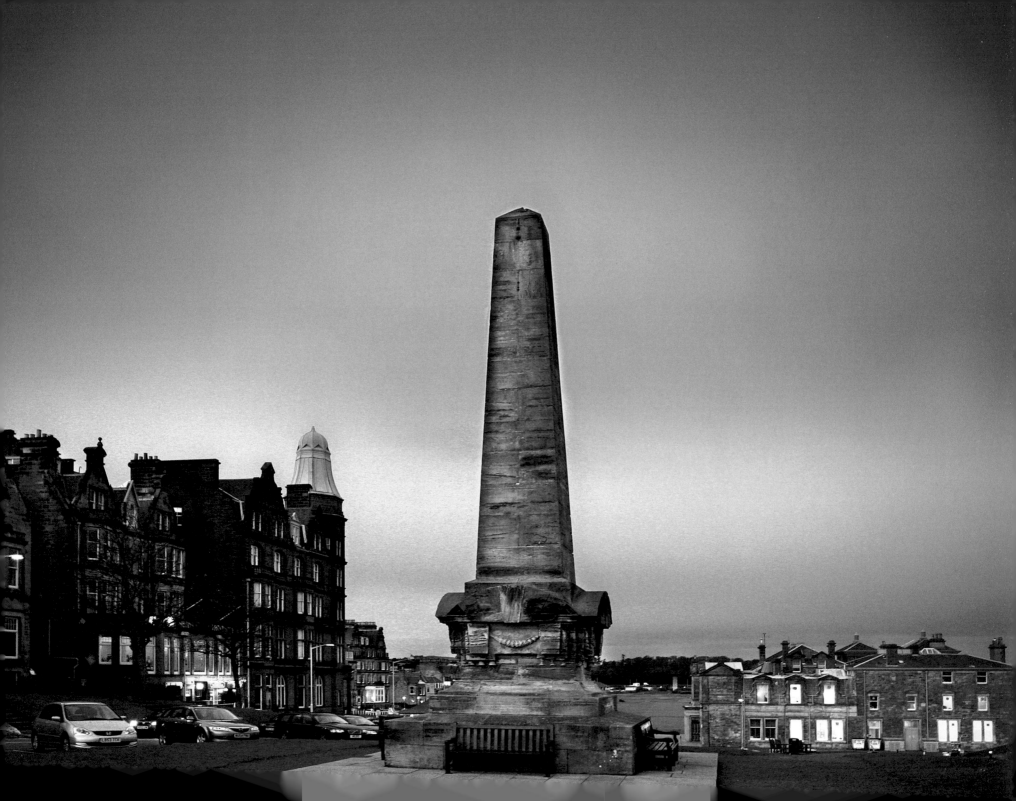

planned. Rather, it emerged. At some unrecorded date, Scots tried lofting a small ball from one undulating link to another into natural or scooped-out holes. Hazards along the way were obvious, naturally formed and to be avoided: bunkers appeared where sheep huddled together in swales against the wind, scuffing out sandy bases; deep, ragged potholes of sand appeared where rabbit warrens had collapsed; dunes held evil gorse or 'whin' and heather to ensnare the ball.

Other countries had similar sports. The word 'golf' is connected to the German word *kolb*, a club, and historians have long debated whether or not the ancient French and Low Countries games with comparable names, especially *kolven* (a game played on open ice to a peg target, not a hole) truly fathered the modern game. Robert Browning's authoritative tome *A History of Golf: The Royal and Ancient Game* notes that these continental pastimes seemingly bore only general resemblances to golf, which sets itself doubly apart:

It was the Scots who devised the essential features of golf, the combination for hitting distance with the final nicety of approach to an exiguous mark, and the independent progress of each player with his own ball free from the interference of his adversary [except in the case of the now obsolete stymie].

Left: Martyrs Monument on The Scores, commemorating Patrick Hamilton, Henry Forrest, Walter Myln and George Wishart, all executed in St Andrews for defying the Catholic Church in their Protestant beliefs. In the end their cause succeeded and Scotland became Protestant in the Reformation of 1560.

Suffice it to say there was some inevitable cross-fertilisation of the mainland European and Scottish games during early merchant trade between countries.

Golf had grown so popular in Scotland by the fifteenth century that James IV tried to ban it, anxious that his army be battle-ready should the English decide to invade. In 1491 his parliament decreed:

It is statute and ordained that in na place of the Realme there be used Fute-ball, Golf, or other sik unprofittable sportis [for] the common good of the Realme and defense thereof.

Golfers ignored him and the game flourished, eventually with the royal seal of approval. James V took up the game, as did his daughter Mary Queen of Scots. The patronage continued in 1603 when his successor, James VI of Scotland, ascended the throne of England as James I, making the game fashionable throughout the realm.

By the seventeenth century, generations of St Andrean golfers had walked their town's Links, sharing the sandy wasteland with rabbits, grazing sheep, children playing, washerwomen drying and bleaching their clothes on the whins, and even the odd archer practising his aim. The men who played most of the golf and made the rules were landed gentry, as few working men could afford to buy the hand-crafted 'featherie' balls that were leather-stitched and filled with tightly compacted boiled feathers. In 1754, 22 noblemen and gentlemen of Fife founded 'the Society of St Andrews Golfers' that would become the Royal and Ancient Golf Club of St Andrews (known by golfers everywhere

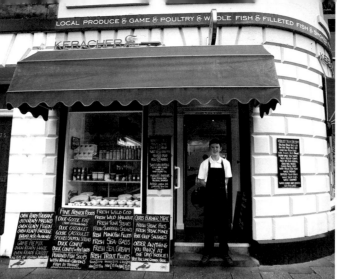

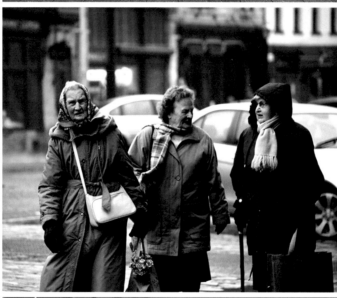

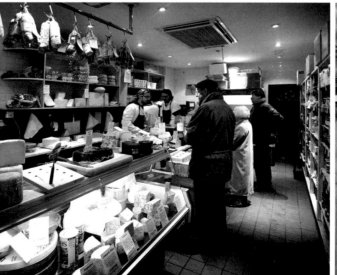
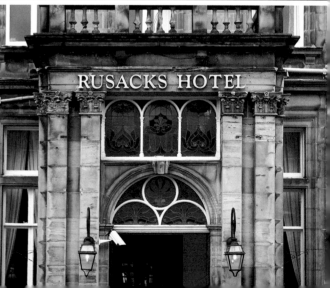

simply as the R&A) 80 years later. St Andrews may not have been the first place in Scotland where golf was played, but the R&A's original minute refers to the town and its Links as the 'Alma Mater of the Golf'.

Most of the golf played in those days was matchplay rather than strokeplay. Gentlemen would challenge each other as to who would win the most holes, either in one-on-one contests (singles) or two-man clashes (foursomes). They and any spectators would bet various sums, sometimes extremely large ones, on the outcome. The poor caddies would follow behind their employer, respectfully carrying clubs underarm – young urchins or salty old seadogs hoping to earn a bit of money to keep their families from starving or themselves in drink.

The decline of the town as a religious and educational centre from the late sixteenth century was reflected in the Cathedral's decay and the University's dwindling population. By the end of the eighteenth century, St Andrews' finances had virtually reached a state of penury. Looking for a way out, the town council sought regeneration by selling the townspeople's birthright – St Andrews Links, in those days known as 'Pilmour'. It was a deed that would be condemned as an illegal transaction and eventually righted a century later, with the land returned to its people.

Opposite page, clockwise from top left: whisky barrels in the Old Course Hotel bar; Keracher's fishmongers and poulterers; fish of the day; evening light on the Old Course Hotel beside the 17th 'Road' hole of the Old Course; Rusacks Hotel entrance; I.J. Mellis cheesemongers; the Seafood Restaurant; J&G Innes bookshop and stationers; hitting the shops.

Up to 1912 golf was free for all, but a green fee was then introduced for visitors not of the town; and it was only in 1946 that locals thereafter had to pay a nominal annual fee for their golf. 'Under an Act of Parliament dated 1974, and following the demise of the St Andrews Town Council', noted an official R&A booklet in 1984, 'ownership of the links has been vested in the North-East Fife District Council, but the courses are separately administered and maintained by the St Andrews Links Trust, assisted by a Management Committee, on both of which bodies the R&A has representation.' Today the Links Trust – made up of members of the local council, the R&A, Scottish government, and St Andrews' golfing community – oversees the running of all six eighteen-hole courses and one nine-hole course on the Links. This book will look in detail at the history and evolution of each layout, along with those of four other major private courses in the local area.

After St Andrews had suffered almost 300 years of puritanical neglect following the Reformation, the town's renaissance came from its most beloved pastime – golf. As the British Empire expanded towards the end of the nineteenth century and the rapid evolution of the railway network allowed easy access to the fabled seaside links, golf's popularity boomed. The Victorian dynamism of Provost Sir Hugh Lyon Playfair, who was a Captain of the R&A and did much to clean up the town, was also a positive factor in St Andrews' fortunes. Furthermore, the invention of the rubber-cored 'Haskell' or 'gutty' golf ball, which was made of inexpensive gutta-percha and was much more durable than

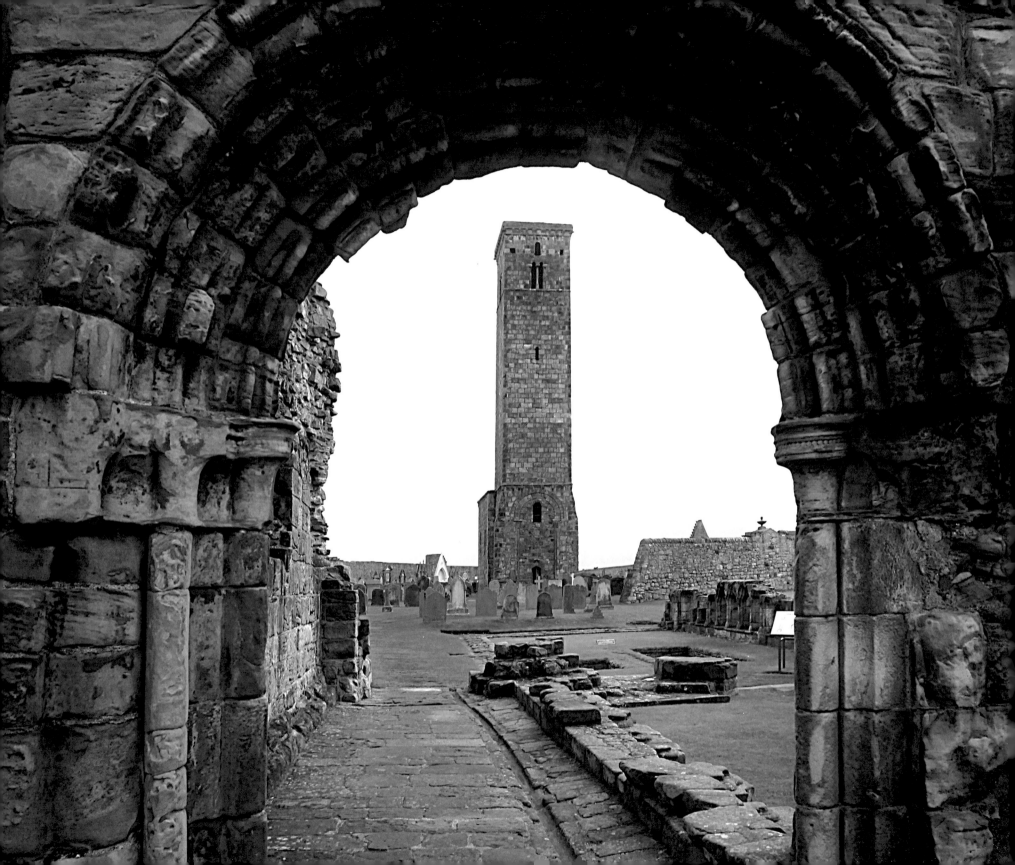

the featherie, brought the game within reach of many who previously could not afford to play. As the appeal of golf grew, so the Old Course became more and more crowded and the creation of the town's other courses became necessary.

Despite its small size and population, St Andrews today has an international reputation as both the Home of Golf and as a worthy destination in itself. This is in part thanks to the R&A, which for so many years has been looked to as a guiding hand in the game's popular spread across the globe, and also due to its regular hosting of golf's oldest and most coveted competition – The Open Championship. But it is also the spirit of St Andrews' people that makes the place extraordinary. Their progressive outlook coupled with an ability to embrace the visible bonds of their city's ancient past makes ambling around St Andrews so atmospheric for locals and visitors alike. The medieval, Georgian and Gothic streets fanning out from the Cathedral's ruins are alive with restaurants, hotels and shops; and each place is bustling with students, golfers, artisans, travellers and locals.

In 1874, the Scottish judge and travelling biographer Lord Henry Cockburn noted that St Andrews locals 'have a pleasure of their own which is as much the staple of the place as old colleges and churches are. This is golfing which is here not a mere pastime, but a business and a passion, and has for ages been so, owing probably to their admirable links.' Some things never change. At St Andrews, that thing is an obsession called golf.

Left: Looking through a Cathedral wall archway to St Rule Tower, built circa 1130. The tall building was perhaps intended to draw pilgrims to the shrine of Saint Andrew.

Double green shared by the Old Course's 5th and 13th holes.

CHAPTER TWO

THE OLD COURSE

'If I had ever been set down in any one place and told I was to play there, and nowhere else for the rest of my life,' said the great Bobby Jones in his later years, 'I should have chosen the Old Course.' But when Jones first came to St Andrews as a young man to play in the 1921 Open Championship he, like many first-time visitors, was less than impressed by what he saw. The continuous ribbon of low, crumpled linksland has few guiding physical features and hides many of its hazards from view. Jones initially found the layout haphazard, the blind pot bunkers and huge double greens puzzling, and the myriad devious swales that can deflect well-intended shots infuriating. Too much of a good score around the Old was left to chance, he thought. It was not until almost a decade later, after many rounds and much diligent study of the course's idiosyncrasies, that Jones came to love the place; to unlock its secrets and realise that in order to master it, shots must be placed with local-knowledge precision rather than simply hit vast distances.

Jones took his love of the Old Course back to Georgia with him, where, with the help of the famed golf course architect

Dr Alister MacKenzie, he created his own personal homage to St Andrews – Augusta National. MacKenzie, too, was similarly moved and influenced by the Links. As a member of the R&A, he surveyed and depicted the Old Course in 1924 and presented a plan to the Club. It remains the most popular and reproduced golf course plan ever drawn. Today, the original hangs in the R&A clubhouse on the wall of the Secretary's office. MacKenzie's ardent admiration of the Old Course is continually apparent in his book *The Spirit of St Andrews*, which was written towards the end of his life:

In describing ideal holes it is extremely difficult to get away from the Old Course. I was much enamoured of the strategy of the course when I wrote some articles on ideal holes nearly twenty years ago, but today I am still more amazed at its subtlety.

This beguiling mixture of strategy and subtlety about which MacKenzie rhapsodised is the essence of the Old's charm. Each hole presents the golfer, whatever their standard of play, with a range of alternative options, especially in a stiff breeze. When a good, well-thought-out shot is executed it is

rewarded; when an ill-conceived, poor stroke is played it is appropriately punished. By thinking a round out hole by hole, knowing when to take on a more daring stroke and when to play with caution, and by playing within the limits of one's own abilities, the Old Course brings endless surprise and enjoyment to golfers of all ages and skill levels.

At St Andrews, as with the other early links in Scotland, little was done to maintain the course. Prior to the formalised eighteen-hole layout the number of holes and route of play varied according to the size and topography of the terrain. 'The early links at Leith and Musselburgh had five holes each,' note Geoffrey Cornish and Ronald Whitten in their seminal book *The Golf Course*. 'North Berwick seven, Gullane thirteen and Montrose twenty-five.' St Andrews had 22 greens as late as 1764, when the opening four holes were merged into two. By the Open Championships of the late 1850s, it became accepted that one round generally consisted of eighteen holes — nine outward and nine inward.

Until the middle of the nineteenth century the actual area played on was much smaller than it is today. Sir Guy Campbell remarked in *A History of Golf in Britain* that the St Andrews Links was:

So narrow a strip that ... there was room only for single greens; at first eleven and later nine. Accordingly in a full round, eventually of eighteen holes, golfers had to play the same holes both going out and coming home.

By 1832 such a tight course was becoming very crowded, so over the next few years greenkeepers — local professionals and caddies like Daw Anderson, Allan Robertson and later his protégé Old Tom Morris — were given responsibility for the general upkeep of, and early changes to, an otherwise natural Old Course. Robertson added the notorious 17th 'Road' hole to the layout, widened the fairways and converted eight of the small greens into huge shared or 'double' greens. Two holes were cut to differentiate between outward and inward nines, allowing separate matches to take place simultaneously, easing congestion and speeding up play. (Today, all but four holes — 1, 9, 17 and 18 — on the Old Course share double greens.)

With Robertson's passing in 1859, Old Tom Morris later took up the mantle of Keeper of the Greens of the Links, becoming greenkeeper to the R&A in 1865 having previously been lured to Prestwick for more than a decade. He tirelessly supervised the maintenance of the Old Course, preserving the character of the turf and forbidding play on the Sabbath. 'Nae Sunday play,' he is remembered to have often said. 'The course needs a rest if the gowfers don't.' Morris was to remain in the post until 1904 when he retired aged 83. Such was the general respect for the 'Grand Old Man' of golf that he was elected Honorary Professional of the R&A, and after his death in 1908 the 18th hole was named 'Tom Morris' in his honour.

Another revolutionary change came in 1870 when a new 1st green was created. Prior to that, the present 17th green had served as the putting surface for both the 1st and 17th holes, therefore enabling the course to be played in a left-hand clockwise or 'reverse' direction to the one we know today.

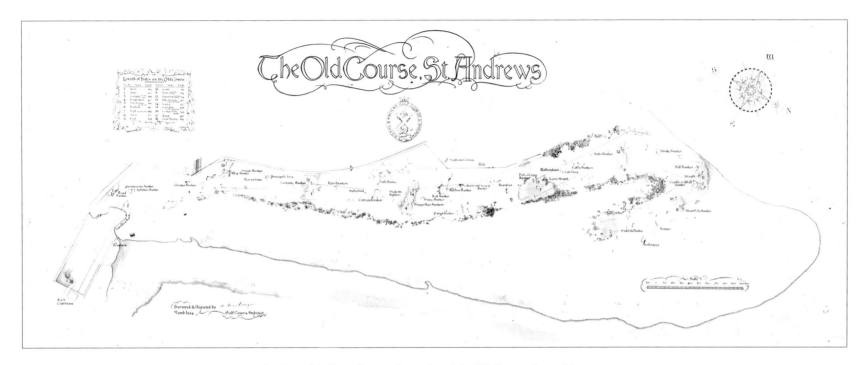

Dr Alister MacKenzie's magnificent plan of the Old Course, depicted in 1924.

Each route had its own supporters, but in the end the right-hand route won and has been customary ever since. However, one effect of permanently switching to this direction of play is that many of the original bunkers seem out of place or are blind, especially at the 12th hole where the fairway, though strewn with bunkers, looks free of trouble from the tee. In more recent times, increasing historical interest has led to an annual event being held over the disused route, playing from the 1st tee to the 17th green, then on to the 16th and so on, reawakening a course that had been lost for generations.

Whether playing it for the first time or as a seasoned regular, the Old Course always has a sense of occasion to it. Every golfer who is lucky enough to be picked from the ballot and allotted a tee time cannot help but feel a shiver of nervous excitement when the starter announces their name on the 1st tee and the surroundings are taken in: behind looms the monumental R&A clubhouse; before you lies the huge shared fairway of the opening and closing par-four holes; off to the left, the tall grey buildings of the town are held back from the course by Links Road. Emerging from the terrace comes

Granny Clarke's Wynd, the thin road crossing the fairway that gives access to the glorious long beach of West Sands. Further on up the left – where the line of shops, golf clubs and private houses ends – the Swilcan Burn, which gives the hole its 'Burn' title, snakes into view across the fairway, winding under the iconic little Swilcan Bridge and directly in front of the 1st green en route to the sea. 'It is an inglorious little stream enough,' said Bernard Darwin. 'We could easily jump over it were we not afraid of looking foolish if we fell in, and yet it catches an amazing number of balls.'

With the burn – the only water hazard in the round – safely negotiated on the opening hole, the routing swings gently right to face north-west. The next six holes, made up of par fours and a par five, run straight up the middle of the narrow thumb of linksland jutting out into St Andrews Bay. (Most of the Old Course is flanked on its seaward side by the New and Jubilee courses, and on the landward side by the Eden Course.) The 2nd 'Dyke' hole sets the tone for much of the front nine. The right-hand side of this par four runs thick with gorse, thus tempting golfers to drive down the left side of its hummocky fairway where there is more room. Playing to the right edge of the fairway through a corridor of mounds is more risky, but leaves an easier route into the green. A similar choice waits at the par-four 3rd 'Cartgate-out' hole (the 15th 'Cartgate-in' shares the green), where a string of pot bunkers down the right side of the fairway are noticeably in play, but an approach shot from the left must tackle the formidable greenside bunker that gives the hole its name.

Holes 4 to 6 are made up of two par fours sandwiching a par five, and effectively share their expansive fairways with the 15th, 14th and 13th coming back the other way. This stretch of links is rippling with contours, calling on strategic thinking for solid scoring: the putting surface at the 4th 'Ginger Beer' is protected by angled humps ready to deflect weak shots; the 568-yard 5th 'Hole O'Cross-out' has such a large double green sitting on

The Swilcan Burn runs right along the front edge of the 1st green.

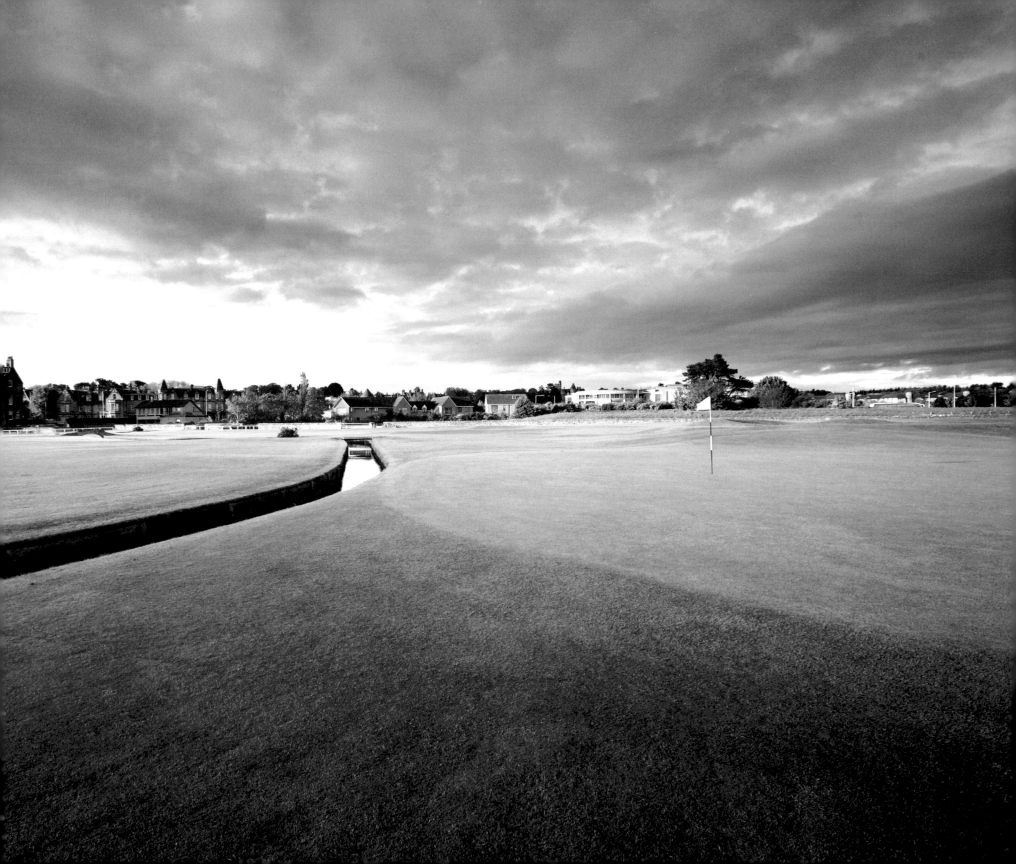

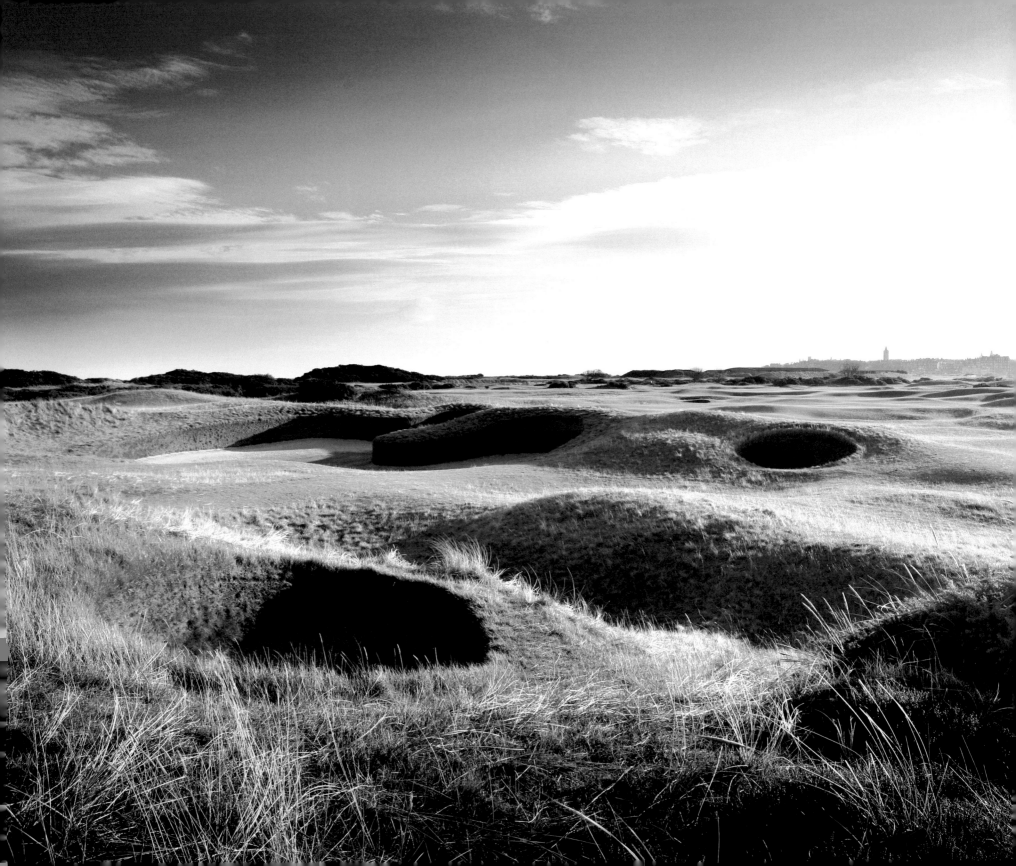

a plateau that cautious play can often leave your ball far from the pin in dangerous three- or even four-putt territory; and the 6th 'Heathery-out' is beset by a deep hidden swale before the green.

Often described as resembling the shape of a shepherd's crook or bishop's crozier, the Old Course layout is not strictly out-and-back, but includes a loop of holes between the 7th and 12th at the far end of the course. The 7th 'High-out' is a par four doglegging gently to the right, a little under 400 yards from back tees. Walking uphill to the fairway after a semi-blind tee shot, many of the low-set features and sense of bleak isolation that have so far dominated the round suddenly disappear, to be replaced by fine views of the surrounding holes tightly packed at the hook of the crook. After an ideally placed drive, the approach shot at the 7th calls for a delicate fade over Shell Bunker to a raised green.

Good scores on the Old are usually forged over the next five holes, which consist of two par threes and three short par fours. The first of the one-shot holes, the 8th 'Short', is a relatively straightforward test of 175 yards up to a semi-blind raised green, while the only other par three comes at the 11th 'High-in' – a notorious and much-feared hole that shares its back-to-front sloping green with the 7th. Protecting the front of the green are two fearsome deep bunkers called Hill and Strath, while beyond runs the Eden estuary. Interlaced with these holes are the short par fours: the 352-yard 9th 'End'; the switchback 10th 'Bobby Jones', running parallel in the opposite direction and nameless until 1972 when it was given the title of St Andrews' favourite adopted son; and the 12th 'Heathery-in', which shares its devilish two-tiered green with the 6th and can be driven only if the ball is threaded through a bundle of concealed pot bunkers.

Looking towards the Old Course's 14th green, with Kitchen Bunker in the foreground and the dreaded Hell Bunker looming large beyond.

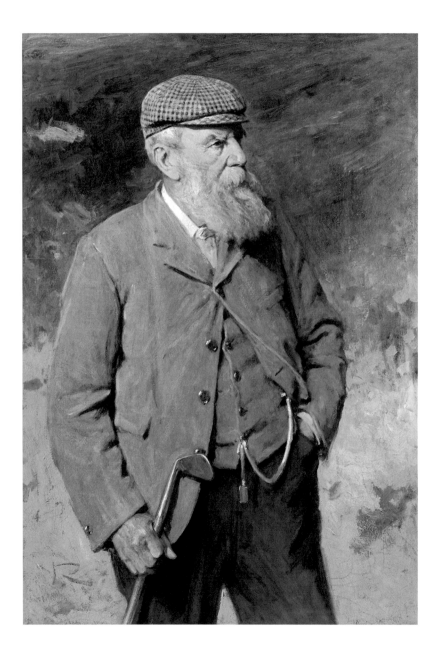

As the direction of the course heads south-east for home, the Old provides a truly wonderful closing stretch of holes to rival anywhere in the world in terms of strategic playability and character. The 13th 'Hole O'Cross-in' is a strong par four with a huge raised green that is shared with the 5th hole. Along the centre of the fairway lurk a series of ominous bunkers including Coffins, Cat's Trap and Lion's Mouth. Then comes the second and only other par five on the course, the 14th 'Long', requiring a careful drive into the Elysian Fields – a haven of fairway between the Beardies Bunkers and the gigantic Hell Bunker. Playing the hole in safe regulation, a common line for the lay-up approach shot is left of Hell, around Benty, Kitchen and Grave bunkers, before pitching on to the kidney-shaped double green.

The 15th 'Cartgate-in' and 16th 'Corner of the Dyke' are two classic par-four links holes. The large Cottage Bunker on the 15th lies about 170 yards from the tee along the left side of the fairway, providing few problems for most golfers. Rather, it is the little pot bunker beyond it called Sutherland that catches many out. The hazard was named after an R&A member whose ball found the sand there so often that in 1885

Left: Tom Morris, painted for the Royal and Ancient Golf Club of St Andrews by Sir George Reid, R.S.A.

Right: Behind the 3rd green looking back towards St Andrews. The position of the foreground greenside bunker is clear evidence of the reverse routing that was sometimes played over the Old Course.

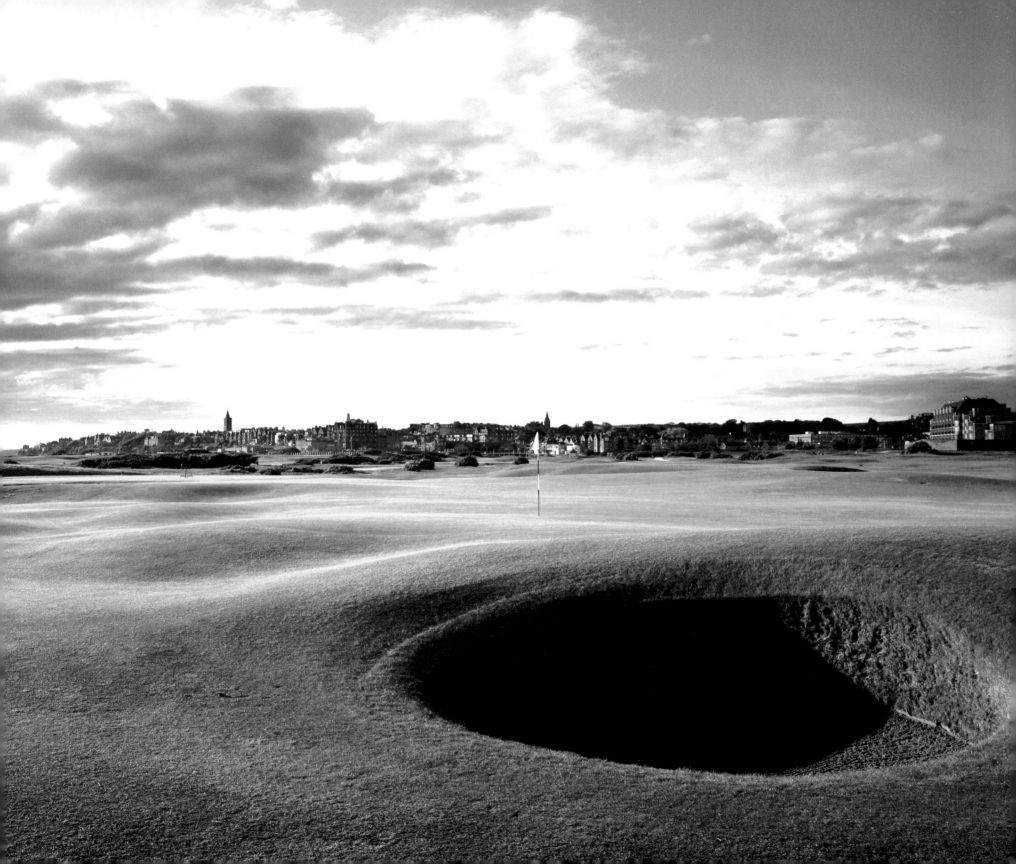

he had it filled in by the Greens Committee. Other golfers objected to this and had the bunker reinstated by stealth, digging it out in the dead of night. The 16th holds similar dangers — a cluster of three bunkers called the Principal's Nose, with Deacon Syme Bunker just beyond, run up the centre of the fairway. When playing off the tee, some golfers prefer to take the tighter driving line to the right of these bunkers, flirting with out-of-bounds and opening up the green; others choose to aim left of trouble from the tee, but must then play their approach shots in over Grant's and then Wig Bunker cutting into the putting surface.

Then comes the most famous and feared hole in golf, the par-four 17th 'Road' hole. At over 490 yards from the new Open Championship tee it is only just under the general length given to par fives and is laden with trouble. No single hole in the history of the game has wrecked more scorecards or dashed so many championship hopes. The drive from the tee is blind, with the double dogleg fairway blocked out of view from the right by low railway sheds (replicas of originals from a bygone age) protruding from the grounds of the Old Course Hotel. A perfect drive cuts over the corner of these outbuildings, flirting dangerously with the hotel and out-of-bounds, before finding the rolling fairway and an open view of the green. The target is a long, thin plateau raised obliquely to the line of play, guarded at the front by the chasmic Road Bunker and by a road and a stone wall directly behind.

The 17th epitomises risk-and-reward golf. A safer route left off the tee makes getting close to the pin in two shots virtually impossible. On this cautious line, Scholar's Bunker and the abutting Progressing Bunker come directly into play short of the green, as does the Road Bunker eating into the raised plateau of the putting surface. Patric

The par-three 11th hole defended by the large Shell Bunker and Strath, a vicious greenside pot bunker.

Dickinson noted in his book *A Round of Golf Courses* that the Road Bunker is 'so perfectly placed that it dominates play even from the tee, and by the sheer force of its spidery personality drives its victims either to avoid it too carefully and chance the road, or play too safely, and so come into its parlour.' Prudent golfers play short of the bank in front of the green in two, hoping that a good up-and-down will sneak a par. Most people who play the hole are happy to walk away with a five.

There is no place on earth richer in golfing history and heroes than St Andrews, and nowhere in the round is this legacy more keenly felt than when walking back over the Swilcan Bridge and up the Old Course's finishing hole. The 357-yard 18th 'Tom Morris' takes its name from the Grand Old Man of golf and it seems to welcome you with open arms. The expansive, inviting fairway shared with the 1st hole and the green framed against the town's buildings make for a wonderful grandstand arena. The traditional line to take from the tee is the clock of the R&A clubhouse or the obelisk pillar that is Martyrs Monument on The Scores road. In front of the green, a deep and deceptive swale — the Valley of Sin — must be chipped through or pitched over before any round on this most extraordinary links can come to an end.

'St Andrews still retains its pristine charm,' wrote Alister MacKenzie in *The Spirit of St Andrews*. 'I doubt if even in one hundred years' time a course will be made which has such interesting strategic problems and which creates such an enduring and increasing pleasurable excitement and varied shots.' Perhaps it is best to let Bobby Jones, who experienced such rollercoaster emotions on the Old Course, have the last word:

The more I studied the Old Course, the more I loved it; and the more I loved it, the more I studied it.

'Spidery personality' — the brilliant, terrible 17th green and Road Bunker.

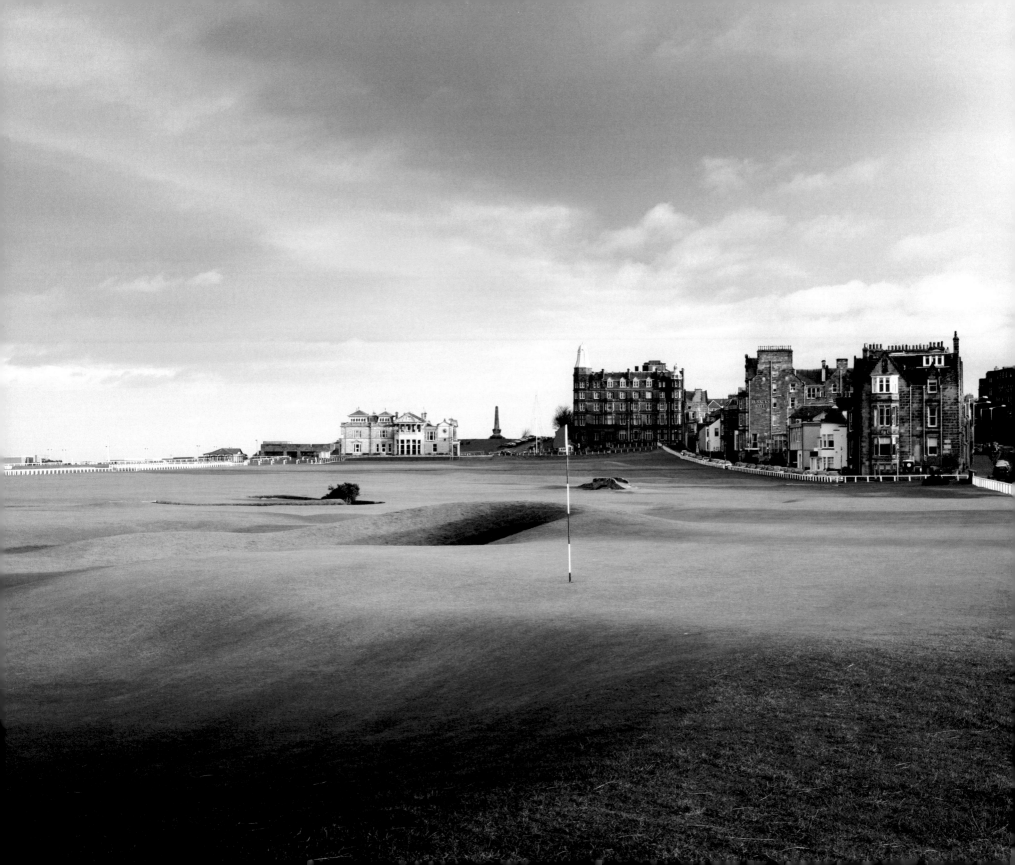

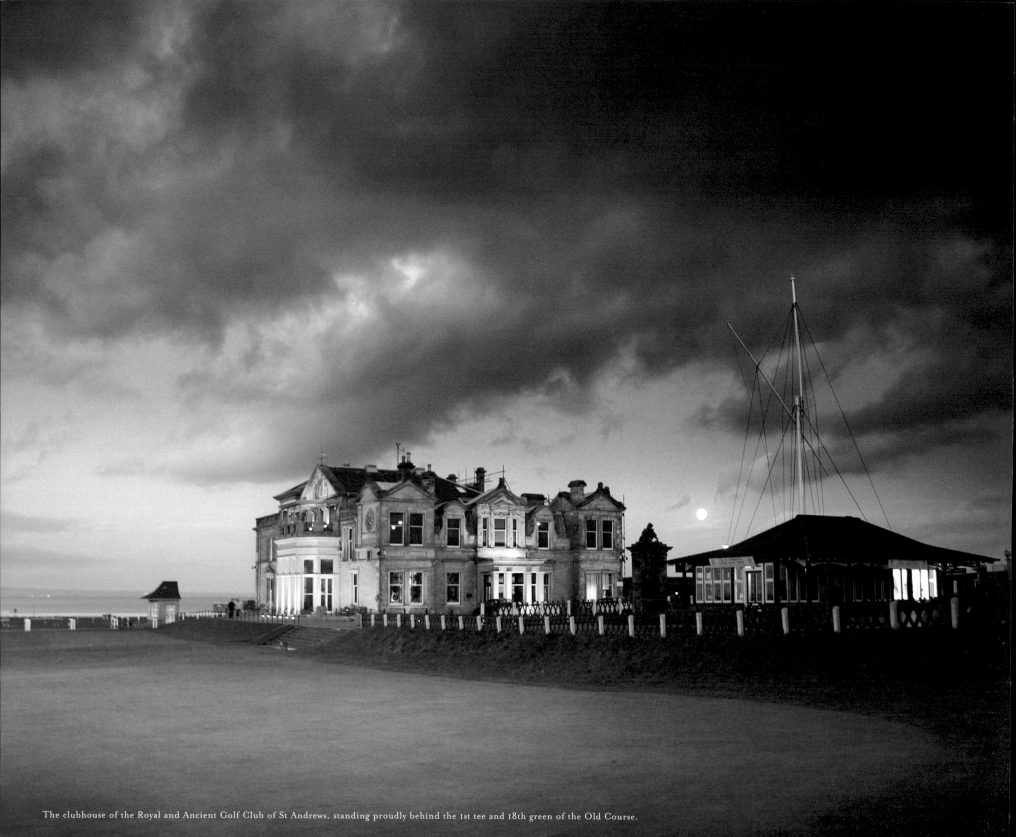

The clubhouse of the Royal and Ancient Golf Club of St Andrews, standing proudly behind the 1st tee and 18th green of the Old Course.

THE ROYAL AND ANCIENT GOLF CLUB OF ST ANDREWS

Behind the 1st tee of the Old Course stands the unmistakable clubhouse edifice of the Royal and Ancient Golf Club of St Andrews, known by golfers everywhere as the R&A. Largely constructed during the nineteenth century in an era of British imperial might, the stately Victorian building of yellow-grey sandstone occupies a prime location that gives unblemished views across the Old Course and St Andrews Bay. This commanding physical position also reflects the authority that the Club held over the game of golf for almost 250 years.

Founded on 14 May 1754 by 22 noblemen and gentlemen of Fife, the R&A is one of the oldest and most venerated golf clubs in the world. Originally calling themselves 'the Society of St Andrews Golfers', this small band of wealthy and influential gentry, united by a love of golf, presented a club of silver bearing the cross of Saint Andrew to be played for annually over the Links. The winner became 'Captain of the Golf' for the ensuing year and marked his victory by appending a silver ball to the Silver Club.

At that time there was no august clubhouse in which to meet, relax and convivially settle playing wagers. Early gatherings took place in town at old taverns like Baillie Glass' and the Black Bull. In 1806 the Club began playing for a new prize, the Gold Medal, and by then the office of Captain was allocated by election rather than as a result of golfing ability. However, a spirit of competition remains with the post to this day, kept alive by the driving-in tradition that each new Captain must undertake in order to 'win' the Silver Club.

Every year, at eight o'clock of a September morning, the Captain-elect stands on the 1st tee of the Old Course surrounded by an entourage of former captains, R&A members and a gallery of spectators. Caddies line the fairway and wait in anticipation. Addressing the ball teed up for him by the R&A's Honorary Professional, the Captain-elect proceeds to strike a drive, synchronised to the boom of a small ceremonial cannon, that will automatically make him Captain. The lucky caddie who manages to retrieve the

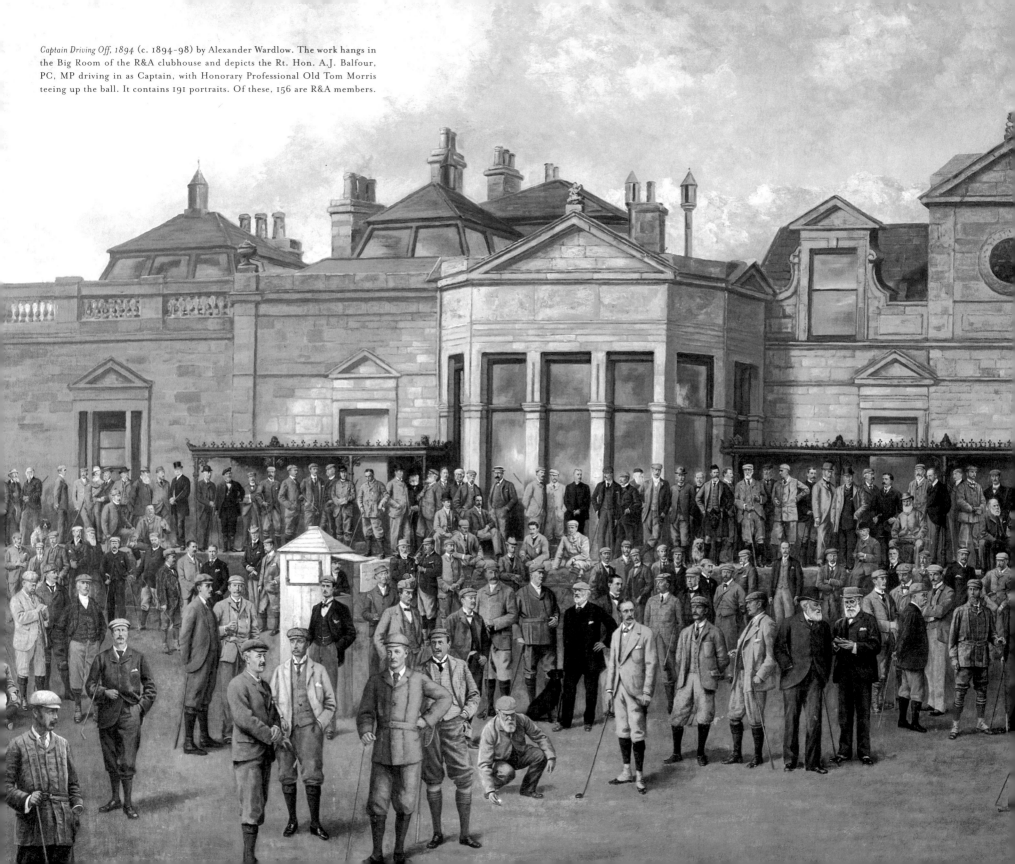

Captain Driving Off, 1894 (c. 1894-98) by Alexander Wardlow. The work hangs in the Big Room of the R&A clubhouse and depicts the Rt. Hon. A.J. Balfour, PC, MP driving in as Captain, with Honorary Professional Old Tom Morris teeing up the ball. It contains 191 portraits. Of these, 156 are R&A members.

ball from the chaotic scramble that ensues receives a gold sovereign for their efforts.

In 1834 King William IV consented to become the Club's patron and bestowed upon it the distinguished title of 'Royal and Ancient Golf Club of St Andrews'. Three years later, in the year of his death, King William presented members with a gold medal known as the Royal Medal, to be played for in perpetuity as a challenge trophy. It remains the top competition prize of the annual Autumn Meeting. After the death of the monarch, the widowed Queen Adelaide became patroness of the R&A and in 1838 bestowed a gold medal bearing her name, with the request that it be worn by the incumbent Captain on all public occasions. From 1853 onwards the Captain, as the only entrant in the 'challenge' for the Silver Club, has been awarded the Queen Adelaide Medal when driving himself in.

In 1835 Major Sir Hugh Lyon Playfair, the retired army officer who had moved to St Andrews and was subsequently Provost, formed the Union Club for the purpose of archery, but it also included many members who also belonged to the R&A. It ran its small clubhouse from the Union Parlour, on which site now stands the prominent red sandstone building that towers over the Old Course's 18th green. In 1853 work began on a new clubhouse a few yards away, behind the 1st tee of the Old Course. The following year the building was completed, and it continued to be known as the Union Clubhouse until 1877 when the Union and the R&A clubs formally merged under both one roof and the Royal and Ancient banner.

Today, the inside of the clubhouse holds many rooms including a library, a billiard room, a dining room, a committee room, administration offices and members' changing rooms. In the front porch sits the small cannon that is wheeled out for service when a newly elected Captain drives himself in. Members' dogs are often to be seen lying about the field gun, patiently waiting for their owners to emerge from inside. Lining the entrance hall are ceremonial wooden lockers belonging to golfing titans who have been made honorary members of the Club, such as Peter Thomson, Jack Nicklaus and Gary Player. At the centre of this wall of champions is a cabinet displaying some of golf's most precious trophies: the original Open Championship Belt, won outright by Young Tom Morris in 1870; The Claret Jug that replaced it; and the Amateur Championship trophy. In the nearby Trophy Room, the array of regalia continues with an exhibition of three Silver Clubs laden with silver golf balls — gold in the case of royal captains — that have been attached by successive captains during their year in office.

The main room on the ground floor is the aptly named Big Room. It is large and comfortable, with a stately bay window giving views down the opening and closing holes of the Old Course. On the walls hang many fine paintings, including one of the Queen, the R&A's patron; Edward VIII, who as Prince of Wales was Captain in 1922 (his brothers the Duke of York — later King George VI — and the Duke of Kent followed suit in 1930 and 1934 respectively); and *Captain Driving Off*, which depicts A.J. Balfour driving in as Captain in 1894, his ball being teed up by Old Tom Morris who was Keeper of the Greens for many years. Underneath these pictures the theme of lockers belonging to distinguished members continues from the hall, skirting the walls like wainscotting.

Golf's original rules — thirteen in total — were drawn up by the Gentlemen Golfers at Leith when they formed what is widely regarded as the world's first golf club (now the Honourable Company of Edinburgh Golfers) in 1744. Ten years later the rules were quickly appropriated by their peers in St Andrews upon foundation of the R&A. 'A natural development would have been for the Honourable Company to emerge as the responsible body,' noted James K. Robertson in his comprehensive book *St Andrews: Home of Golf*. 'But, as the St Andrews Society prospered and expanded, there was a decline in the Honourable Company with a waning interest in golf around Edinburgh, most of their members appearing to prefer the highly suitable amenities of St Andrews.' By the 1830s such a loss of cohesion was enough for the R&A to gradually and unintentionally become the leading administrator of the game. 'It was this Society of Golfers which became, without seeking, the ruling body of golf,' continued Robertson. 'The responsibility was thrust upon it.'

By the end of the nineteenth century the game of golf had become so popular around the globe that golf clubs everywhere looked to the R&A for leadership and the provision of a universal constitution. As a result, the R&A established its first Rules of Golf Committee in 1897 and from that moment on became the governing body of golf throughout the world, apart from Canada which is affiliated with the R&A, and the USA and Mexico which are controlled by the United States

Golf Association (USGA). From the 1950s there was ever-increasing synergy between the R&A and the USGA, with both powers meeting every four years to revise the rules and make them more uniform in the face of the modern game's evolution and technological advancements.

Confidence in the R&A's ability to direct golf was further cemented in December 1919/January 1920, when by popular consent the other host clubs of the Amateur Championship and The Open Championship – Prestwick, the Honourable Company of Edinburgh Golfers, Royal St George's, Royal Liverpool and Royal Cinque Ports – asked the R&A to take over the running of both events. This resulted in the Club forming a Championship Committee that saw its responsibilities grow over time to include the orchestration of the Boys' Amateur Championship, the British Mid Amateur Championship and the Senior British Open Championship; as well as playing a part in the selection of the Great Britain and Ireland teams for matches such as the Walker Cup, the Eisenhower Trophy and the St Andrews Trophy.

For over 80 years the R&A ran all the events with which it was charged, and did so with aplomb. However, being first and foremost a private members' club it was decided in 2004 that the Club should relinquish its main public responsibilities of governance: administering the rules of golf; the running of The Open Championship and other key events; and developing the game in existing and emerging golfing nations. These duties were passed over to a separate, newly formed group that adopted the Royal and Ancient abbreviation to become The R&A, and which is made up of eight committees: 'Rules and Equipment', 'Course Management', 'Championship', 'Amateur Status', 'Golf Development', 'External Fund', 'General' and 'Research'.

As a separate entity, the Royal and Ancient Golf Club of St Andrews remains and thrives as a private men's golf club with a membership of around 2,400. Over the years a diverse cross-section of people have been made members – from captains of industry and leading politicians like George H.W. Bush to golfing greats such as Bobby Jones and Francis Ouimet. Every year the Club's Spring (May) and Autumn (September) meetings see hundreds of members flock to St Andrews from around the globe, coming together to fix matches and play for splendidly named trophies like the Kangaroo's Paw, the Manaia Trophy, the Calcutta Cup (made from melted-down rupees) and the Pine Valley Plate. Such occasions are often followed by hearty, fraternal dinners in the clubhouse and around town.

A common misconception about the Royal and Ancient Golf Club of St Andrews, given the prominence of its clubhouse, is that the Club owns the Old Course. In fact, not one of the town's seven courses is under its control, as they are all public. The Club must share tee times with members of the other local golf clubs, visitors, students and residents alike. So many parties wanting to exercise their rights over the ancient Links could inevitably breed tensions. 'In the past there had been conflict between the town and the Club, particularly about control of the Old Course,' noted John de St Jorre in *Legendary Golf Clubs of Scotland, England, Wales and Ireland*. Today two independent bodies called the St Andrews Links

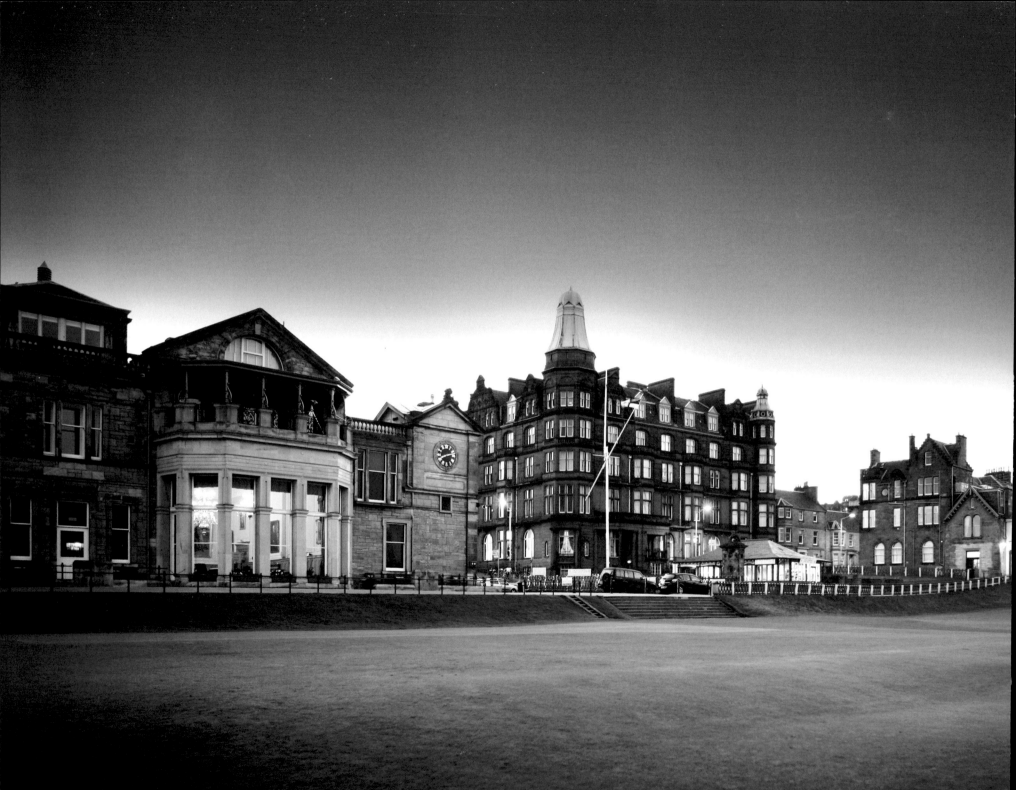

Trust and the Links Management Committee oversee the running of the town's courses, and, as we have seen, are composed of members of the local council, The R&A, the Scottish government and St Andrews' golfing community.

Thanks to the formation of the St Andrews Links Trust in 1974, the relationship between the town and the Royal and Ancient Golf Club has mellowed greatly over the years. During the Autumn Meeting, which lasts for three weeks, the Club competes with all other St Andrews golf clubs in a day-long competition over the Old and New courses, demonstrating the positive civic effects this charitable organisation has had in running the Links.

At the dawn of the new millennium, the Royal and Ancient Golf Club of St Andrews could look back at two and a half centuries of rich history – a period in which golf evolved from being a quaint Scottish pastime into one of the world's most popular sports. Such a development of the game would not have been possible without the willingness of the Club's members, many of whom devoted countless hours of their own time over the years, with no commercial interest, to ensure the continual safe passage of the game. The Club's responsibilities may recently have become more introspective, but its existence is woven into the very fabric of the most famous place in all of golf. For many people, the Royal and Ancient remains an institution symbolising the traditional qualities of *esprit de corps* – fellowship and integrity – that are as much a part of the game as ball and club.

Evening falls on St Andrews and light from the Big Room of the R&A clubhouse spills out onto the 1st tee of the Old Course.

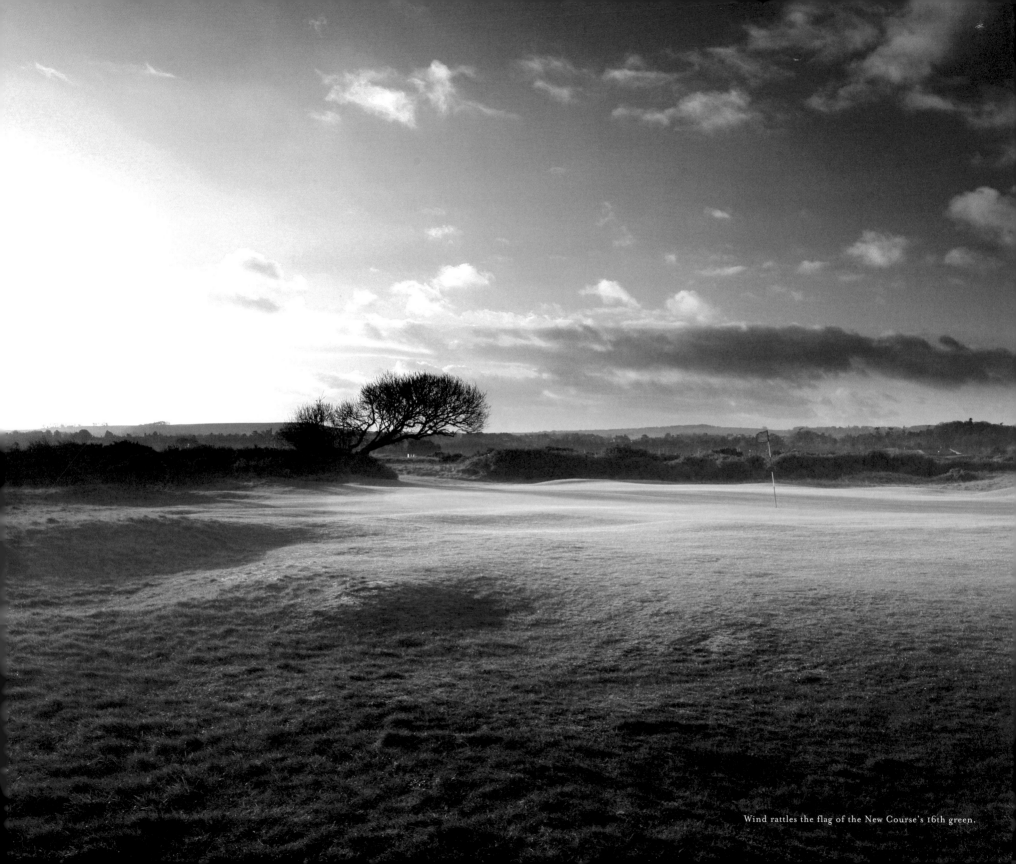

Wind rattles the flag of the New Course's 16th green.

THE NEW COURSE

Lying on a thin strip of linksland to the east of the Old Course's storied fairways sits the New Course. As with its prestigious neighbour, the New winds out towards the Eden estuary in close proximity to the other course. So close, in fact, that any ball struck onto one course from the other is not considered out-of-bounds. There is a great bond that exists between the two courses, most probably because the New was originally designed to harness the essential characteristics and natural attributes that made the Old such a marvel. That said, the New Course's designers ended up building a slightly different golfing challenge and aesthetic picture. With fewer double fairways and more bunkers clearly visible from the tee, each hole on the New has a more marked and defined 'shape' than those on the Old Course, meaning that there is most often a clear strategy to consider from each tee. The obvious tactical demands of the holes do not make them any easier to play, however, as the New's length and tight angles make it a very tough test.

The R&A proposed the construction of a second, 'New' golf course on the St Andrews Links in 1883, and in 1894 a bill was passed that afforded them the right to purchase the land and take responsibility for its design and construction. The large number of golfers crowding to play the Old Course had become a concern for the R&A, and the construction of the New Course was considered necessary in order to divert the flow of footfall to a separate location. The required land was leased from the town council for the sum of £125 a year over a period of 60 years and the original proposal suggested that the course should occupy the majority of land available between the Old Course and the sea. However, the town council objected to this on the grounds that it would leave no room for the public to exercise their right to walk over the Links.

Once concessions had been successfully negotiated by Mr B. Hall Blyth, a civil engineer from Edinburgh, the management of the project was passed on to Mr R.A. Duff, Old Tom Morris and foreman David Honeyman. The course that they produced measured 6,440 yards and opened for play on 10 April 1895. Before they were able to complete the project, an agreement had to be made with the Volunteer Rifle Corps, as

their range needed to be removed from the landward to the seaward side of the sand dunes to avoid any disastrous accidents. Sandy Herd won the first professional tournament to be held on the New in June 1895, and with it a cheque for £15.

After a period of steady success for the New Course, the town council and the R&A commissioned Colt, Alison & Morrison Ltd in 1938 to appraise the layout and recommend ways in which it might be improved to keep pace with the rapidly evolving technology in the game. Although their appraisal did not lead to any further work, it did add weight to a growing feeling that the course had to be made more challenging in order to retain its championship quality. That feeling continued until new tees were added to create a championship length of 6,781 yards at the turn of the millennium.

The modern course offers a stern test of golf, with a superb flow to the out-and-back routing. A calm opening stretch is followed by a solid mid-section of par fours and a fierce closing run that is almost as tough, though not as majestic, as the Old Course's world-class finish. The intricately contoured greens regularly feature false fronts and vary in size, while steep-faced bunkers are maintained to a high quality throughout.

The most interesting holes of the front nine include the 3rd, where players are confronted with the first par five of the course and also the first sight of a shared green. Twinned with the 15th, it is cleverly defended by a deep depression on the front left corner and thick gorse waiting to catch any shot that goes long. Although reachable in two by longer hitters, it is very hard to carry the hollow at the front and stop the ball before it falls off the back.

Other great areas are the 4th and the 6th, which both require high levels of skill and strategic know-how. The 4th is a dogleg left that tempts longer hitters to cut the corner. Players are then faced with an approach that falls away gently to a green that is guarded

Thick rough and gorse flanking the demanding 13th hole.

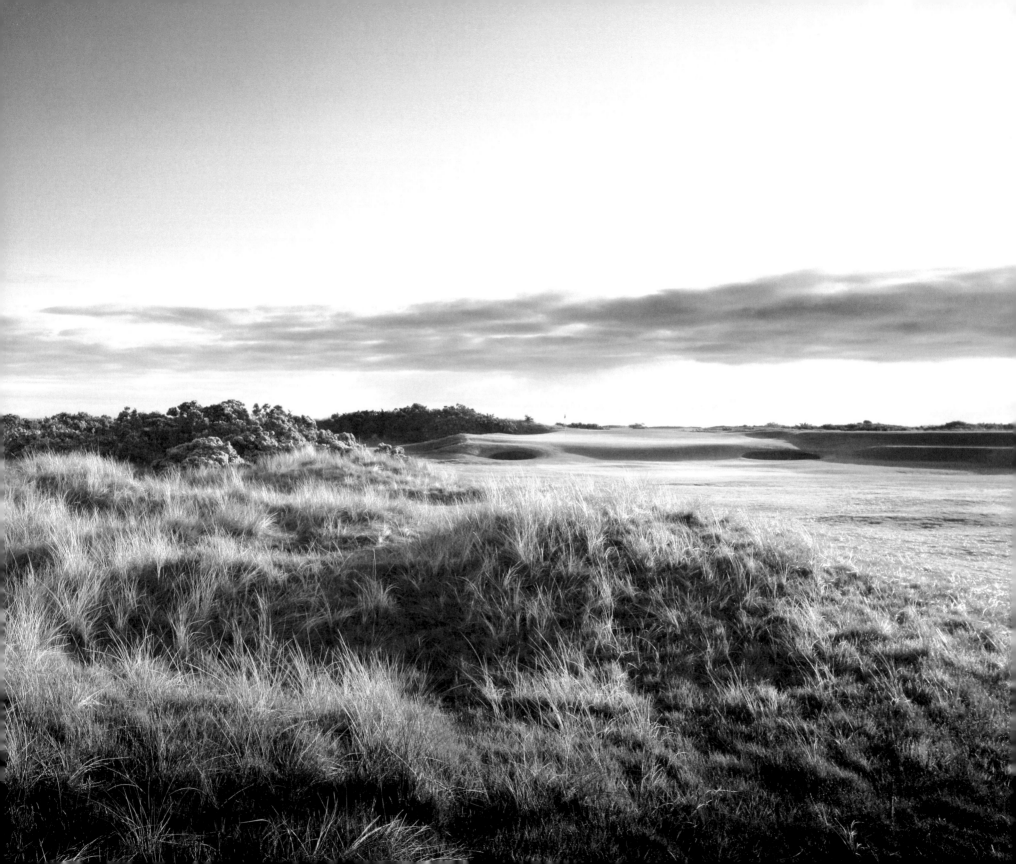

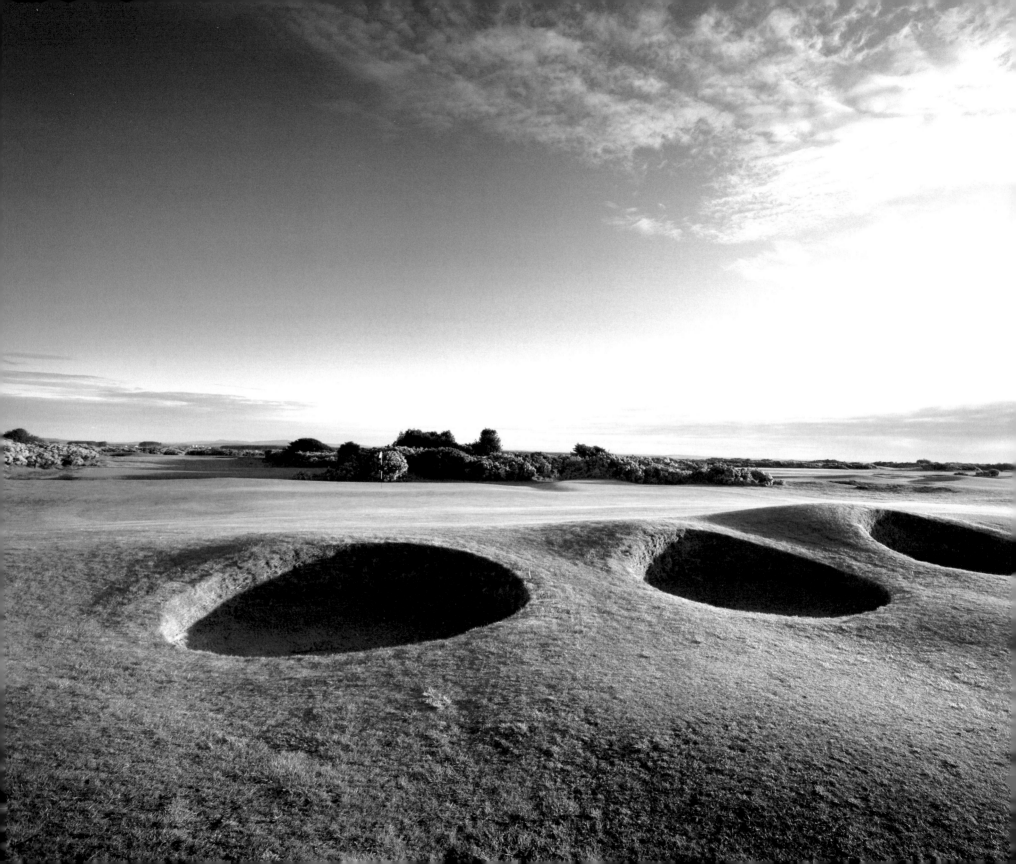

by three pot bunkers. It is a pretty hole, and a terrific risk-reward challenge. The long par-four 6th is made especially hard by gorse and broken ground cutting into the fairway's right side from the tee. The green itself slopes down from the back, meaning that approaches must be hit solidly to threaten certain pin locations.

The New Course's four par threes are well scattered, the first coming at the 5th. It is a pleasing hole for its simplicity and symmetry, played to a shallow, away-sloping green framed by a blanket of gorse. Much as with the long 3rd, a weakly hit approach will fall back down a slope towards the tee. Though perhaps the most challenging short hole is the 17th, measuring a daunting 211 yards. Players have to be careful to avoid the steep-faced greenside bunker on the right, but must also be aware that shots pulled too far left may get caught up among humps, hollows and thick rough.

The turn comes at the far boundary of the course, with the Eden estuary lapping against the left-hand edge of the par-three 9th. This bunkerless hole relies on a series of low ridges to deflect poor shots and prevent them from reaching the sunken bowl-shaped green. Standout moments on the back nine include the demanding blind drive at the 464-yard 10th, which plays downhill over a rough hillock to a landing area opening out on the right-hand side. The good tee shot, however, takes the tighter line up the left, avoiding a large bank to the right of the bottlenecking fairway and giving an easier approach into the green. Even though the putting surface is not bunkered, it is only easily accessible with a well-placed tee shot.

The green on the short par-four 15th is also exceptional, angled 45 degrees away from the direction of play and full of cunning breaks. The only portion of the target that is easily visible from the fairway presents a big false front on the left edge, feeding weak approach shots dangerously close to a greenside bunker. The closing stretch is very strong,

The New Course's well-guarded 4th green.

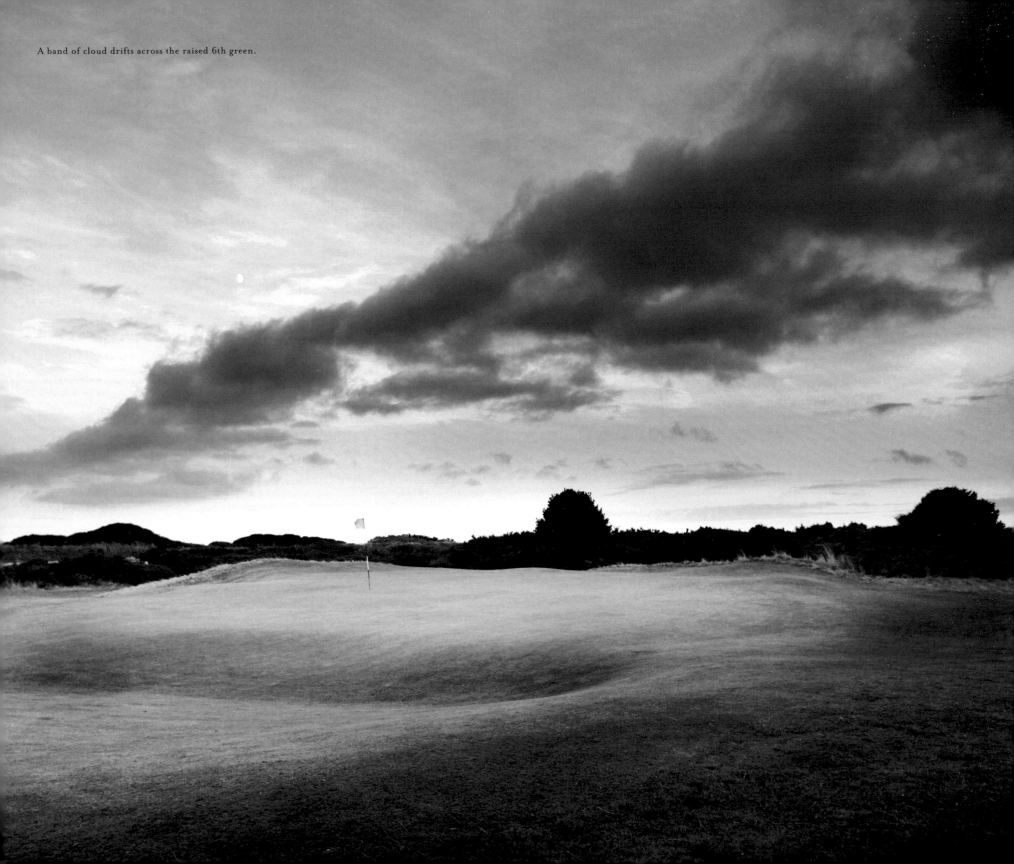

A band of cloud drifts across the raised 6th green.

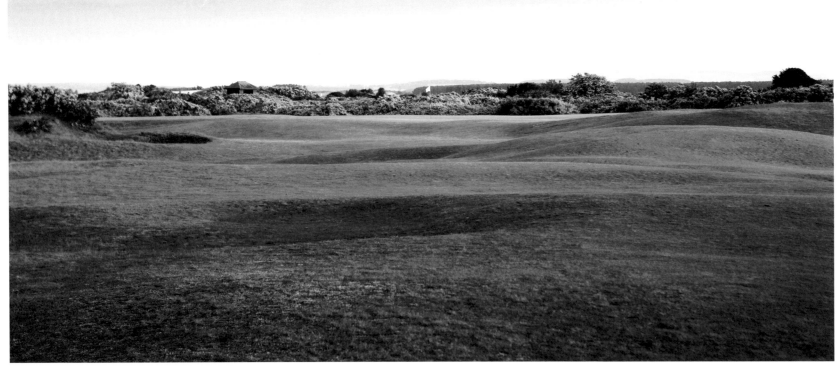

The bumpy approach on the par-five 3rd hole makes it one of the New Course's sternest tests.

particularly the testing 18th with its fairway tapering at around 250 yards from the tee, heavy rough tracking the approach from both sides, and visible greenside bunkers protecting a boldly contoured green complex.

Although the abutting Old Course is in many ways more charismatic, thought-provoking and accessible, for skilful golfers the New Course provides a thorough examination of their ability to hit precisely and putt well.

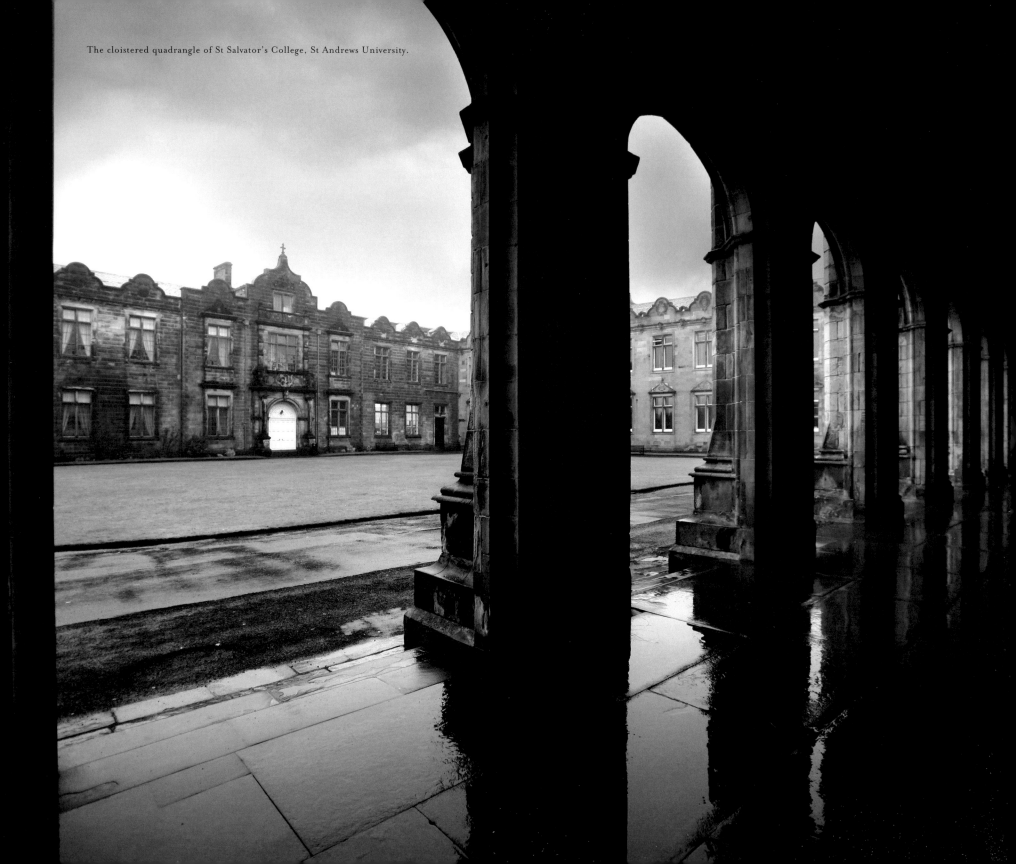

The cloistered quadrangle of St Salvator's College, St Andrews University.

ST ANDREWS UNIVERSITY

Bishop Henry Wardlaw first issued a charter to found St Andrews University on 28 February 1412. It was to be the first of its kind in Scotland, and a place for 'the venerable men, the doctors, masters, bachelors and all scholars dwelling in our city in St Andrews ... [to study] ... divine and human law, medicine, and the liberal arts and faculties'. Wardlaw was a highly learned man of the Scottish Church, having been educated at Oxford and Paris before being consecrated as the Bishop of St Andrews in 1403. He was also a powerful and well-connected figure, and when his originating charter was delivered to Pope Benedict XIII for papal authorisation, it arrived with the strong petitioning support of the Scots Parliament.

On 28 August 1413, the Pope issued his bull of foundation for the University, which stated that 'considering the peace and quietness that which flourish in the said city of St Andrews and its neighbourhood, its abundant supply of victuals, the number of hospices and other conveniences for its students, which it is known to possess, we are led to hope that this city, which the divine bounty has enriched with so many gifts, may become the fountain of science, and may produce many men distinguished for knowledge and virtue'. The decree was greeted with great celebrations in St Andrews, and shortly afterwards a procession to the high altar of the Cathedral was concluded with a rousing rendition of *Te Deum*.

The University did not officially own any property until 1419, when a small site on South Street was purchased and developed to provide a base from which masters of theology and arts could meet and lecture. In 1430, the University grew further, as in that year Bishop Wardlaw established a new school for the Faculty of Arts on a neighbouring site. Although principally an extended teaching facility for the Faculty of Arts, the new building also provided accommodation for members of the other faculties of the University.

The University's next natural evolutionary step was to establish a collegiate system, similar to the great European universities upon which the constitution of St Andrews was based. James Kennedy, the new Bishop of St Andrews following Wardlaw's death, founded the first of these in 1450 and it was named the College of St Salvator. It was the first fully endowed and structured college, incorporating into its

Above and opposite page: ornamental college stonework and University signs.

design a sumptuous collegiate church. In 1512, Alexander Stewart, Archbishop of St Andrews, and John Hepburn, Prior of St Andrews, founded the University's second college – the College of St Leonard. Lastly, in 1538, Archbishop James Beaton reorganised Bishop Wardlaw's old school as a seminary for the training of secular priests in Arts, Theology and Canon Law under the title of the College of St Mary. Certainly, by the latter half of the sixteenth century, St Andrews had developed a strong and well-funded trinity of colleges upon which to base its growth.

The coming of the Protestant Reformation to Scotland in around 1560 threatened to disrupt the University's steady progress and expansion. Although it altered the face of St Andrews significantly, with the Cathedral being reduced to ruins and a number of statues dismantled, the University remained resolute despite its papal consecration and Catholic origins. It has been theorised that the University survived partly thanks to its policy of educating those of all faiths – it listed among its alumni Catholics and Protestants alike.

M R H
1621

UNIVERSITY OF ST. ANDREWS
ST. REGULUS HALL

DUM SPIRO SPERO
CURSUS APRI RECALIS

ST MARY'S COLLEGE
LIBRARY

D B
MISERICORDIA

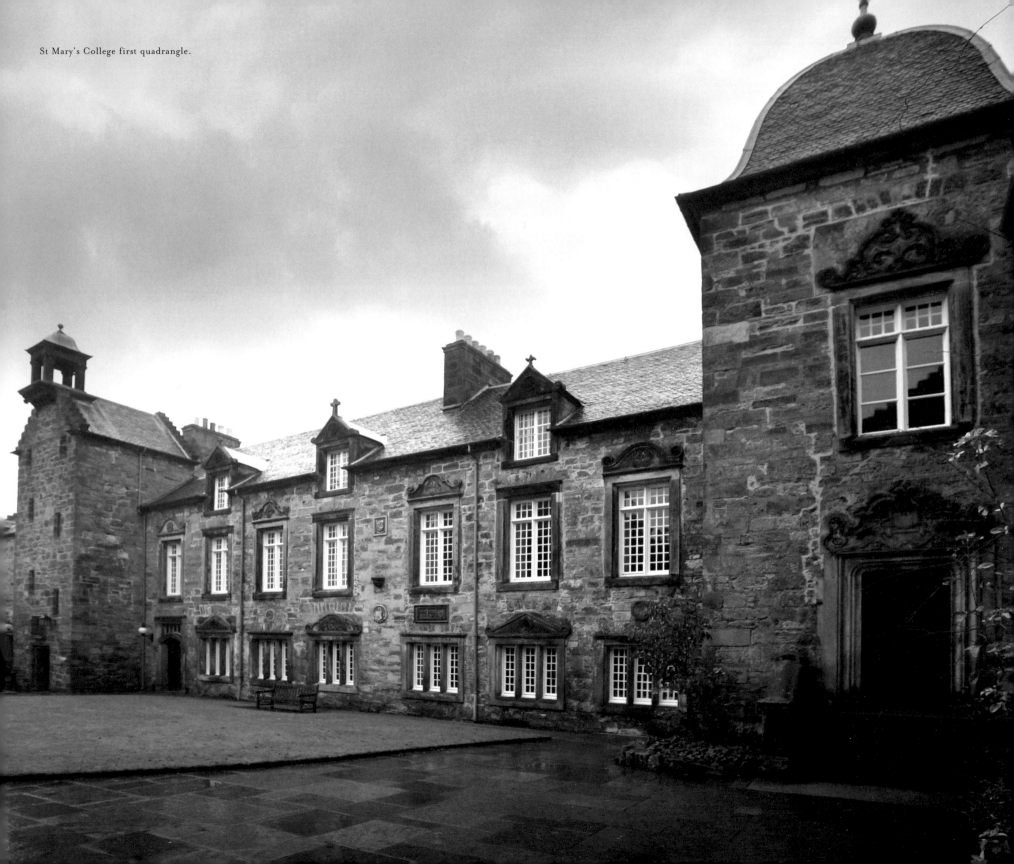

St Mary's College first quadrangle.

Even though the University survived the reform movement, it endured mixed fortunes up to the nineteenth century. In 1617, when James VI of Scotland (then also James I of England) made a royal visit to St Andrews, he reasserted its place as the ecclesiastical and educational capital of Scotland. St Andrews also stood alone as the only major city to avoid the Great Plague that swept Scotland in 1645. However, it had many serious and growing problems. Primary among these was that the Presbyterian system of church government had become firmly established – the Archbishops of St Andrews had departed and the city had lost its status as the ecclesiastical capital. The 1707 Act of Union, which saw Scotland incorporated into a United Kingdom governed in London, also pushed the governing influence south and accelerated the downward fortunes of the University. Certainly at that time it was becoming an outpost of diminishing stature, and its meagre student population of 130 was almost forced to move to Perth at one point due to civil unrest.

Even though the University was struggling, it was still closely aligned with global affairs. Three of its alumni, John Witherspoon, James Wilson and Benjamin Franklin, were signatories of the 1776 Declaration of Independence. Indeed, Wilson was one of only six people to sign both the Declaration of Independence and the Constitution of the United States of America. In the 1880s, a number of significant changes were made to the University's own constitution, splitting it into four faculties – Arts, Divinity, Science (including Engineering) and Medicine – to which degree courses in Education, Dentistry and Law were later added.

In 1892 the developments continued as female students were admitted for the first time, while the first all-female hall of residence was opened in 1896. When women were admitted, male students went down to the pier and threw their mortarboards off it as a sign of protest. To this day, mortarboards are not worn at graduation ceremonies.

At the dawn of the 1900s, the University was assuredly beginning to increase its size and affluence once more, and throughout the twentieth and twenty-first centuries it has continued to flourish, becoming one of the most esteemed seats of learning in Britain while still retaining the hallmarks of its rich history. Current students at St Andrews regularly celebrate this heritage in a number of ways and with fervour.

The most renowned traditional event in the University calendar is the Kate Kennedy Procession, which usually takes place during the second week in April. The origins of a spring procession can be found in ancient pagan and Christian festivals celebrating the rites of spring and their connections to beliefs in immortality. Early Fifers celebrated *cath cinneachaidh*, which is Gaelic for 'struggle for growth' or 'return of spring'. The earliest known celebration practised by St Andrews students was a pagan spring procession in 1432, condemned by University authorities as 'useless, unprofitable, dangerous and damnable'.

In the fifteenth century, the celebration really began to take off and the existing festival of spring rites was integrated into a celebration of Kate (Katherine) Kennedy – the niece of Bishop James Kennedy – to form a huge event. Katherine

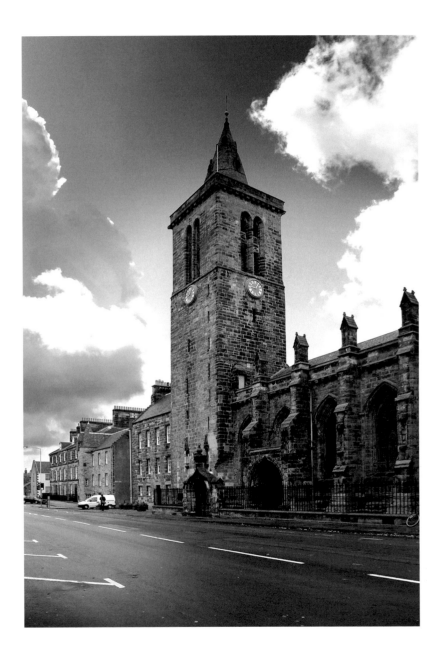

was renowned for being tall, fair and beautiful, adored by her uncle and idolised by the students. During the mid-fifteenth century, when Katherine came to visit her uncle in the springtime of each year, the people of St Andrews would gather on the day of her arrival to celebrate her youth and beauty. As a result, the two celebrations became a single annual event, the Kate Kennedy Procession, when students processed through the streets and enjoyed themselves.

By the nineteenth century the Procession had begun to degenerate into a somewhat decadent and drunken affair that often overstepped the mark of civil behaviour. On 5 March 1881 it was finally banned by the University Senate. Folklore says that a cruel blizzard swept over Scotland that day and St Andrews Bay was lashed by a furious storm. The story goes that the ships *Harmonie* and *Merlin* were driven onto nearby rocks and the would-be revellers streamed down to the bay to lend their aid, leaving the procession to fade into the annals of history. The University officials seized upon the mournful occasion to suppress the festival, which had steadily become more unpopular with members of staff.

Left: The University church, St Salvator's, seen from North Street.

Opposite page, clockwise from top left: male undergraduates in their scarlet gowns line the ruined parapet of St Andrews Castle; an early Kate Kennedy Procession. 'Kate' is escorted by a University professor and her uncle, 'Bishop Kennedy', seen with a crozier; (inset) a poster for the 2008 Procession; 'Kate' and 'Bishop Kennedy' riding through the streets of St Andrews in a horse-drawn carriage; the Raisin Weekend finale in St Salvator's quad; the Gaudie ceremony on the harbour pier.

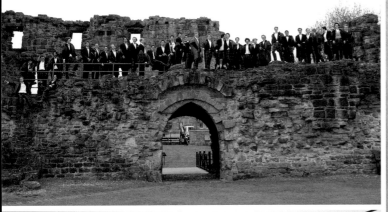

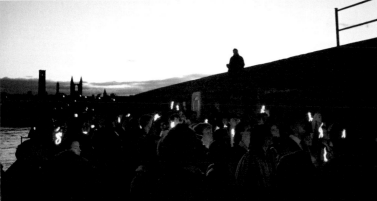

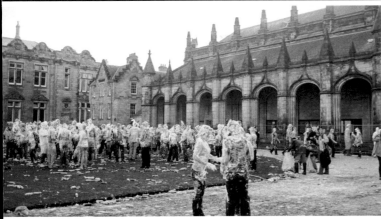

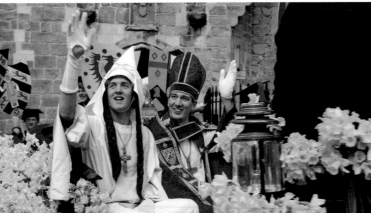

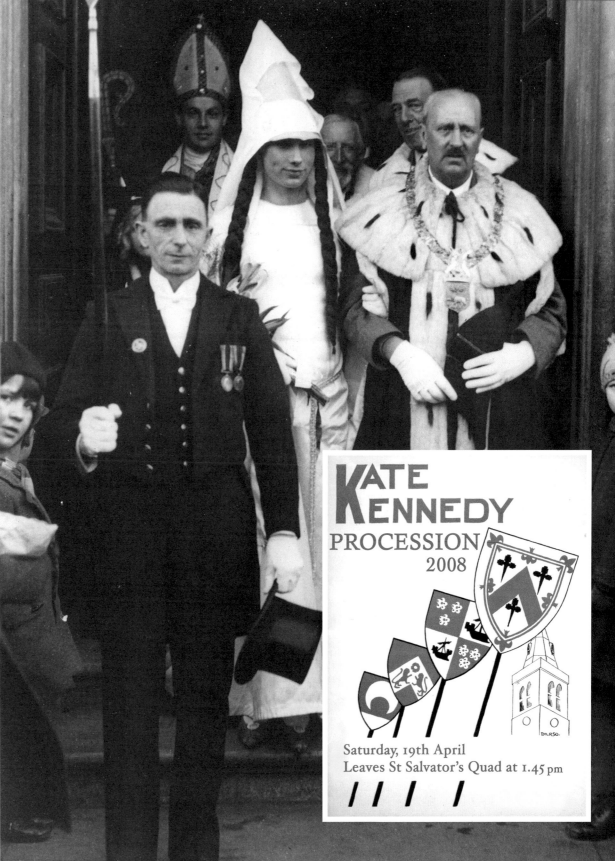

KATE KENNEDY
PROCESSION
2008

Saturday, 19th April
Leaves St Salvator's Quad at 1.45 pm

In 1926, after many years without the procession, two students named Donald Kennedy and James Doak were inspired by J.M. Barrie's rectorial address to the University on 'Courage'. They set about reviving the Kate Kennedy festival to turn it into a celebration of the rich history of St Andrews and its people. Kennedy and Doak decided to send an organised procession of costumed characters through the town, with many participants riding on horseback and performing amusing acts to commemorate the figures' historic deeds. It was a huge success, and to this day students and notable members of the St Andrews community still play all of the characters, winding their way through the cobbled streets of town with great fun, pomp and pageantry.

The procession is led by someone dressed as Scotland's patron saint, Saint Andrew, who carries the cross of martyrdom and is closely followed by the University shield and a triumvirate of Highland pipers. King Robert the Bruce is one of many royal characters mounted on horseback, as he attended the consecration of St Andrews Cathedral in 1318, when he rode his horse domineeringly up the central aisle. Mary Queen of Scots joins him in fine robes, accompanied also by Pierre de Chasteland, a young French courtier who travelled with Mary from Calais and wrote lyrical verses about her. He boasted that Mary was his mistress and, a week after being discovered under her bed by a maid, was executed in St Andrews. He is depicted in the procession as a love-struck poet who is regularly dragged away from Mary and executed throughout the day.

Scottish poets and St Andrews alumni William Dunbar (a poet laureate), Sir David Lindsay and Gavin Douglas (the first man to translate Virgil's *Aeneid* into Scots) all stroll through the streets with ancient-looking books, while scientific professors John Napier and James Gregory (a close friend of Isaac Newton and the inventor of the telescope) carry suitably experimental-looking objects and implements.

Various notable Lord Rectors of the University also process in celebration through the town. These include Douglas Haig, J.M. Barrie, Rudyard Kipling and *Monty Python* actor and comedian John Cleese, who walks along in a decidedly silly manner. J.S. Mill, a former Rector who was often regarded as a brilliant but arrogant man, is uniquely portrayed by his refusal to walk through The Pends, as there is an old superstition that the archway would collapse if the cleverest man in the world ever walked under it.

Following on from the Lord Rectors is the martyr Patrick Hamilton. On 29 February 1528 he was burnt before the gates of St Salvator's College, and legend suggests that it took him six hours to die. To this day, there is a commemorative monogram of the initials PH in the cobblestones outside the college chapel in the place where he was supposed to have been martyred. Nowadays, it is considered bad luck to walk over the initials as this will supposedly lead to failure of one's degree. The only hope of redemption is doing the 'May Dip' on 1 May, a tradition whereby students swim in the North Sea at sunrise while madrigals are sung by the University madrigal group. Keen observers will notice a face etched into the wall of St Salvator's, at the spot where it is believed that a vision of Hamilton's face appeared as his spirit left his body.

The penultimate group to pass through the town includes famous citizens of the Royal Burgh of St Andrews. These include the great golfer Old Tom Morris and Bobby Jones, the legendary amateur golfer who was only the second American to be awarded the freedom of St Andrews, after Benjamin Franklin. 'If I could take out of my life everything but my experiences at St Andrews,' remarked Jones upon receiving the great award, 'I would still have had a rich, full life.' A man of rare dignity and skill, Jones was the first player to win the Grand Slam of golf by holding The Open, the British Amateur, the US Open and the US Amateur titles in a single year. Today, there is an exchange scholarship bearing his name that exists between the University and Emory University in Atlanta, Georgia, where he studied law.

Bringing up the rear in a horse-drawn carriage is Lady Katherine Kennedy herself. She is always played by a male member of the Kate Kennedy Club (the all-male student club that organises the festivities) and is escorted around the town wearing a fetching pigtailed wig. A rare honour, it is the responsibility of the Kate Kennedy Club member who is selected as Kate to organise the following year's procession.

Other traditions of the University include Scotland's most ancient archery competition, 'The Silver Arrow'. An early university legend from 1628 purports that the Marquis of Montrose, while an undergraduate at St Andrews, sent an arrow flying over St Salvator's Tower to hit the hat of an unharmed Dean of Arts in the main quad. For this miraculous feat he was awarded a Silver Arrow. The competition, which to this day still involves loosing an arrow into the University's main quad, has had many distinguished winners over the centuries.

Originated more recently, a torch-lit procession along the pier known as 'The Gaudie' takes place at the beginning of May in remembrance of an heroic student named John Honey. On 3 January 1800, Honey had been attending a service in St Salvator's Chapel when the congregation learned that the small ship *Janet of Macduff* had run aground in the East Bay near the harbour. Five men were stranded out at sea and there was no lifeboat stationed in the town. Aged only nineteen at the time, Honey got the other students to tie a rope around him and dared to swim out to the ship in the treacherous conditions. He went out five times, returning with a member of the crew on each occasion. For this courageous deed he was presented with a civic reception at which he was awarded the freedom of the city. His health, however, never recovered after his heroics and he died at the age of 32 following a prolonged period of illness, thought to have been linked to injuries he sustained on his final trip when he was struck across the chest by a falling mast. The Gaudie ceremony remembers these efforts in prayer and the singing of the University song.

It has often been suggested that the traditional Sunday Chapel Pier Walk is also in remembrance of the heroic acts of John Honey. However, it is more likely that the regular stroll stems from the time when students used to walk down to the pier after the Sunday chapel service to wave off visiting preachers who had arrived by boat at the harbour. Both customs are atmospheric and beautiful, especially as all of the participants are required to wear the University's famous gown.

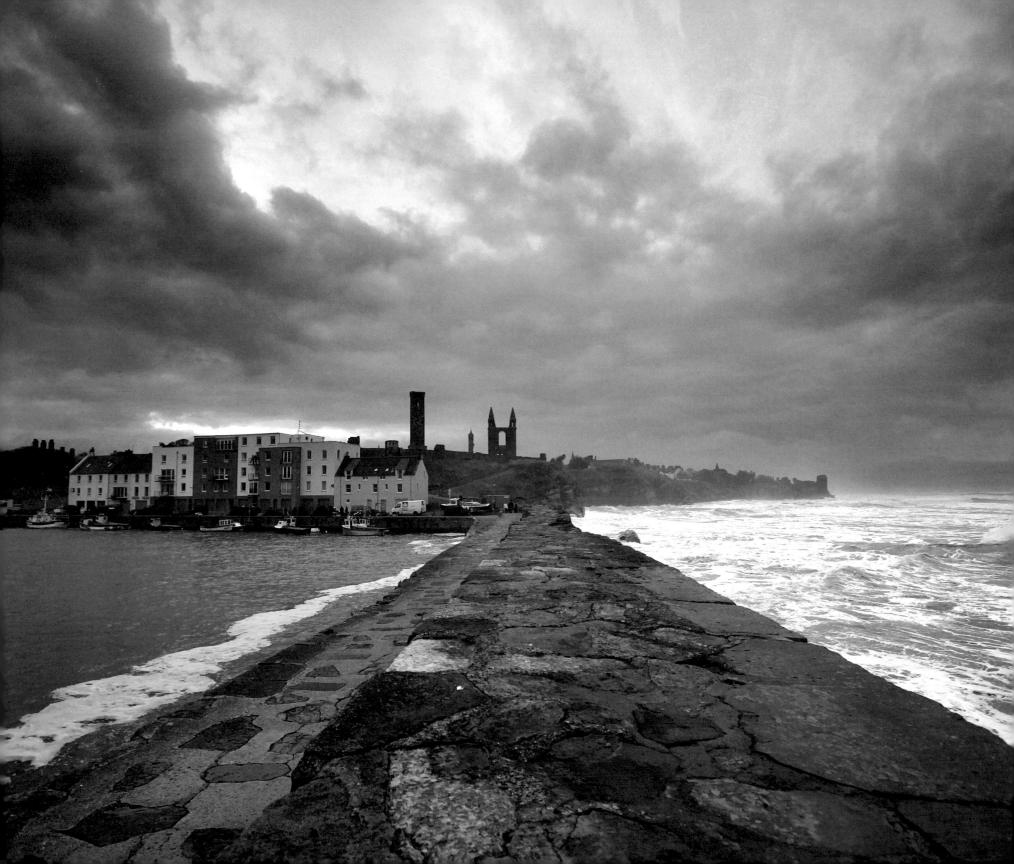

The scarlet undergraduate gown is in itself probably the most easily recognisable convention at St Andrews. Originally introduced after the Reformation as a way to identify students in the town and prevent them from drinking in the local pubs, it is still customary for students to remove their gowns when entering such watering holes in order to go unnoticed. A bejant or bejantine (first-year male/female student, deriving from the French word *bec-jaune* meaning 'yellow beak', or 'fledgling') wears the gown high on both shoulders, a semi-bejant (second year) wears it slightly further back on the shoulders, a tertian (third year) wears it off the left shoulder if an arts student or the right if a science student, and a magistrand (fourth year) wears it down off both shoulders. Tradition has it that students will fail their exams if they fasten the clasps around the neckline.

Finally, Raisin Weekend is possibly the most anticipated event in the calendar of rituals. Held annually over the last weekend of November, first-year students are entertained by their academic 'parents' (older student mentors), normally consisting of a tea party thrown by the 'mothers' and then a tour of pubs conducted by the 'fathers'. Its origins hark back to a ceremonial rite of passage into academic life at the University, in which a first-year is mentored by older students. Historically, the bejant(ine) brought a pound of raisins to present to his or her academic parents, and it is from this that the event takes its name. In more modern times, however, the pound of raisins has been replaced by a bottle of wine. The weekend culminates in a gathering in the quad of St Salvator's on the Monday morning, where students indulge

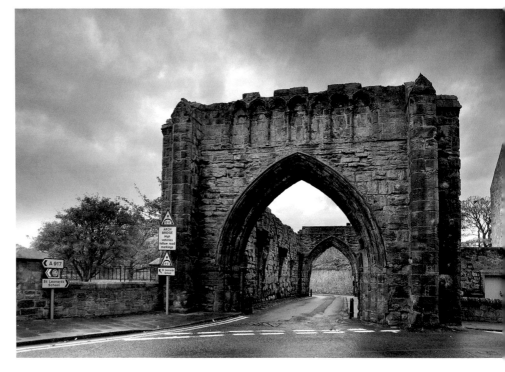

Above: The gateway of The Pends, which Rector J.S. Mill refused to pass through.

Opposite page: St Andrews pier looking back towards the harbour and town; the ruined east end of the Cathedral and St Rule Tower stand prominent on the skyline.

in a shaving foam fight. Again, the shaving foam is a modern addition, as historically students just came together to sing the 'Gaudie', whose words — *Gaudeamus igitur, iuvenes dum sumus* — mean 'we are only young once so if we are going to have some fun, now is the time'.

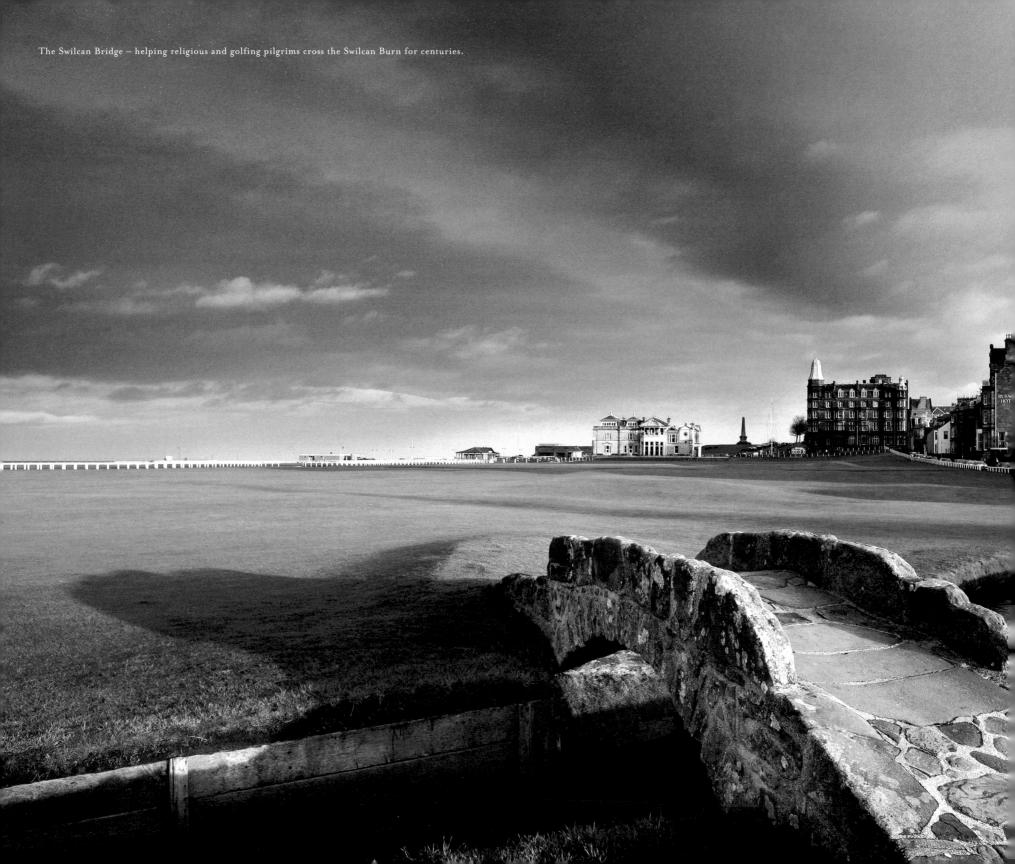

The Swilcan Bridge – helping religious and golfing pilgrims cross the Swilcan Burn for centuries.

THE SWILCAN BRIDGE

For golfing pilgrims on a visit to the Home of Golf, no journey is complete without having crossed the Swilcan Bridge. This ancient little sandstone arch strides the burn of that name that winds across the 1st and 18th fairways of the Old Course before running out into the sea at the southern end of the West Sands beach — the setting where that infamous opening scene of *Chariots of Fire* was filmed.

It is estimated that the humped bridge has been in existence since the twelfth century, making it one of the oldest structures in St Andrews still in constant use. Initially it was not built for the convenience of golfers; rather it served as a gateway into the tiny bustling city for religious pilgrims and traders with packhorses who approached from the town's old harbour in the Eden estuary.

Setting foot on the iconic bridge often sends a chill of excitement down golfers' spines. Among the countless numbers to have walked across it during its long history include virtually every great golfer there has been — from Old Tom Morris and Harry Vardon to Jack Nicklaus and Tiger Woods.

The Swilcan Bridge has been the site of many legendary goodbyes in tournament golf, but no more stirring or fitting ending to a professional career was seen than Arnold Palmer's exit from The Open Championship in 1995. (The word 'palmer' derives from the medieval Latin *palmarius* or 'pilgrim' who travels to shrines.) Playing the 18th hole in his last-ever round in Major golf, Palmer stood atop the old bridge and waved farewell to the applauding galleries and generations of fans who proudly called themselves 'Arnie's Army'.

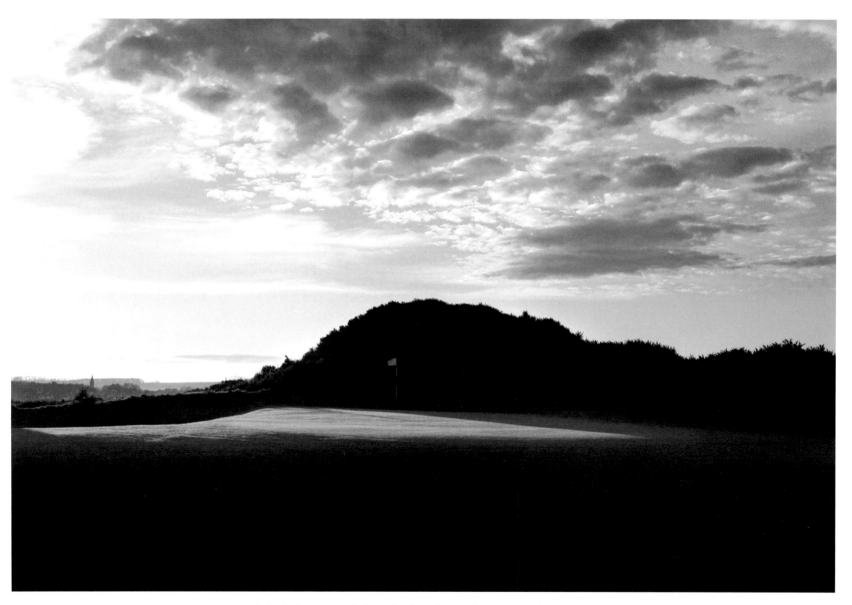

A shard of evening sunlight strikes the 15th green flag on the Jubilee Course.

THE JUBILEE COURSE

The Jubilee Course is sandwiched on bumpy ground between the New Course and the North Sea, with the broad shimmering beach of West Sands visible over the eastern boundary of the Links and the New's pot-bunkered fairways flanking the opposite side. Laced around a spine of dunes, and with prominent high tees giving compelling views at the turn, the Jubilee is a fine course that would be more widely applauded if it did not lie in the shadow of its older, more distinguished relative, the Old Course. Today, it is considered to be one of the toughest tests of golf on the Links, thanks to recent work by the architect Donald Steel, and without doubt it has a varied and interesting history.

Following the Links Act of 1894, the town council had always planned to build a third course at St Andrews to alleviate the increasing strain on the popular Old and New courses. In March 1897 a committee compiled a report recommending the construction of a twelve-hole course between the existing New Course and the beach. After less than a month, the committee requested a quote from one John Angus Jr., who submitted a remarkable proposal to lay down

the twelve holes and have the course ready for play in only twelve weeks at a cost of less than £200. It was an attractive plan that also left room for further development to produce a full eighteen holes. Happy with the proposal, the committee immediately hired Angus.

Towards the end of the first month of construction, it was reported that the predicted completion date for the course was 22 June 1897, by coincidence the designated day for the celebration of Queen Victoria's Diamond Jubilee — upon hearing this news, it was decided that the layout be called the Jubilee Course.

Partly owing to the accelerated construction schedule, the Jubilee was very basic and possessed only limited greens complexes when it opened. Golfers at the time suggested that in order to negotiate the scruffy blemishes of the putting surfaces it was advantageous to use a mashie or an iron on the greens. In 1905 Old Tom Morris' assistant David Honeyman proposed to implement Angus' original suggestion that the Jubilee could be extended to incorporate a full eighteen-hole layout. Again, the proposal was accepted and more fairways soon flowed out among the low sandhills — the opening four holes and closing

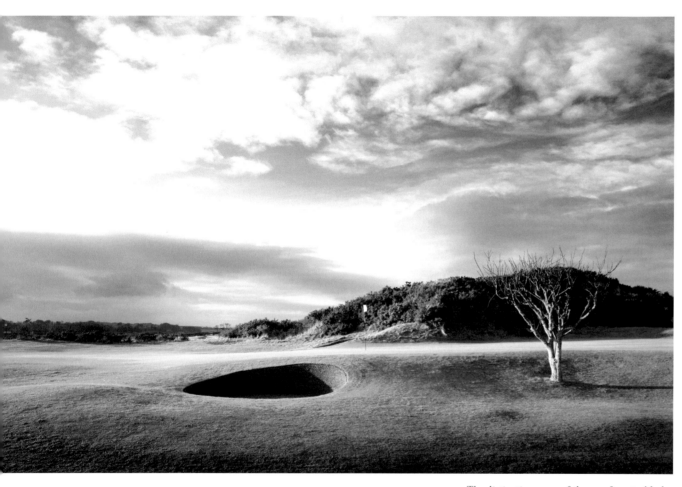

The distinctive green of the par-four 2nd hole.

five holes of the revised design were situated on the landward side of the dune complex and could be played as an accessible nine-hole loop for beginners; the other holes covered the seaward side and were set over more rugged topography with an abundance of bent grass.

Following the conclusion of the Second World War, the course was further developed under the watchful gaze and steady hand of the great Willie Auchterlonie – 1893 Open

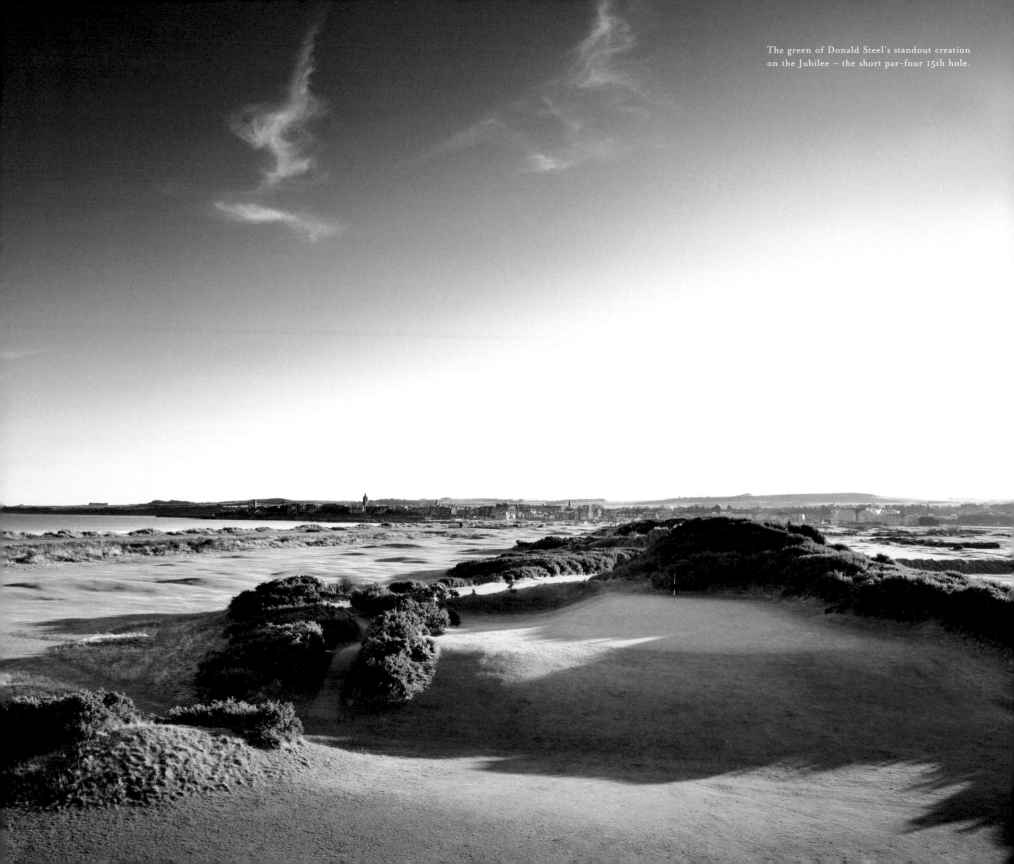

The green of Donald Steel's standout creation on the Jubilee – the short par-four 15th hole.

champion and Honorary Professional to the R&A – in an attempt to make it a course of championship quality. It was officially reopened when Auchterlonie himself struck a ball from the first tee, although on that day the 6,200-yard course was still some way short of the high standard he had envisaged, and had not yet been fully bunkered. Auchterlonie acknowledged as much in his remarks during the ceremony, saying that it was 'another step towards the creation of a top class course ... it won't be in my day, but some day this will be a championship course.' He died in 1963 at the age of 91.

Two decades after his passing, Auchterlonie's prediction came a step closer when the firm of golf course architects Cotton, Pennick, Steel and Partners was commissioned to make further improvements to the layout. Donald Steel led the project and produced an extended course of 6,805 yards. Steel made skilful use of the dunes, which he used like a trellis around which to weave the fairways, and recognised the benefit of elevating certain teeing areas to allow some holes to be exposed to the buffeting winds of the North Sea. This gave the added effect of panoramic views of the Eden estuary and landward Links area. The redesigned course was officially opened in September 1989, when the reigning US Open champion Curtis Strange drove a ball from the first tee.

The course as it appears today has certainly achieved the championship status that Willie Auchterlonie predicted it one day would. The opening hole is, fittingly, named after him and requires an accurate tee shot to bisect two fairway bunkers, followed by a drawn mid- to short-iron approach to a green that is protected by sand at the front and back. As

with many courses at St Andrews, the opening hole is a gentle introduction when compared to the challenges that await.

The Jubilee has a set of terrific par fives and the 3rd hole is the first of four that exist on the course. It is of good length at 546 yards and is named 'The Skelp', as in Scots slang a player who wishes to reach the green in two needs to give the ball a good 'skelp', or slap. It is the first hole to reach the seaward boundary of the course, and the wind often howls in from the North Sea right-to-left across the fairway. A three-shot strategy can be just as risky as a try for the green in two, as a pair of dangerously positioned fairway bunkers between 30 and 80 yards from the putting surface can ensnare a misjudged lay-up. Also memorable are the back-to-back par fives at the 11th and 12th, the first of the pair arching left to a green densely surrounded by bunkers before the routing switches back and runs parallel in the opposite direction. The 12th is the tougher of the two long holes and doglegs sharply left about 100 yards from the narrow, stepped green.

Pitched nicely between the muscular long holes is a selection of fine par threes. The 5th has a rather unique two-tiered green, making the hole very changeable depending on the pin position – it becomes a far harder challenge when the flag is perched up on the elevated left portion. Another standout one-shotter is the 192-yard 9th, which represents the classic features of the Donald Steel redesign. The elevated tee gives stunning views across St Andrews Links and opens up the hole to some gusting seaside winds. Two greenside bunkers lie short of a putting surface that tilts steeply to the right, and they regularly catch approaches that have been misjudged in the breeze.

The back nine starts with a straightaway par four at the 10th that gives a lovely panorama of the St Andrews skyline and is rightly called 'Spires'. Following that are the two good par fives already mentioned, a testing little par three and a long par four. But unquestionably the most outstanding section of the course comes at the home stretch, starting with the signature 15th. It is regarded as one of Donald Steel's most remarkable designs and from the card the 356-yard hole might jump out as a potential birdie opportunity. From the tee, however, the playing corridor looks like an altogether tougher proposition. An imposing gorse-covered dune runs up the right side of the fairway for the first 220 yards and dominates the sightline, while the more open left side suddenly drops sheer away into the parallel 3rd fairway. A walk towards the semi-blind green complex from that left edge reveals the beautiful and treacherous putting surface, tucked away on a plateau behind a large sand dune. In front of the green is a dangerously deep gully that will run any short approach shot back 60 yards down to the bottom of the fairway.

The par-four 16th is almost as quirky as the previous hole, bearing sharp right through a channel cut into a tall, diagonally running dune ridge before straightening its course again. The tee shot is blind and should be aimed a third of the way up the left-hand dune to find the ideal landing area on the fairway. The round closes with an aggressive par three measuring 211 yards, followed by a strong two-shotter of 437 yards. Here the 18th runs long and straight over crumpled ground before rolling up to a green that slopes towards the golfer, meaning a bold approach shot can be made. The hole

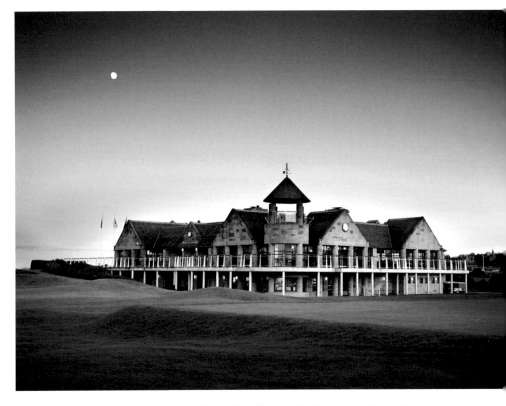

The final hole on the Jubilee Course, like the New Course, finishes back at the well-appointed St Andrews Links Clubhouse, which has a restaurant and amenities enjoyed by golfers and non-golfers alike.

is named 'Honeyman's Howe' after the man who suggested that the Jubilee could be enhanced to an eighteen-hole layout. In many ways the entire Jubilee Course is a testament to his vision, and this hole pays fitting tribute to him, just as the 1st hole pays homage to Willie Auchterlonie, another believer in the course's true potential.

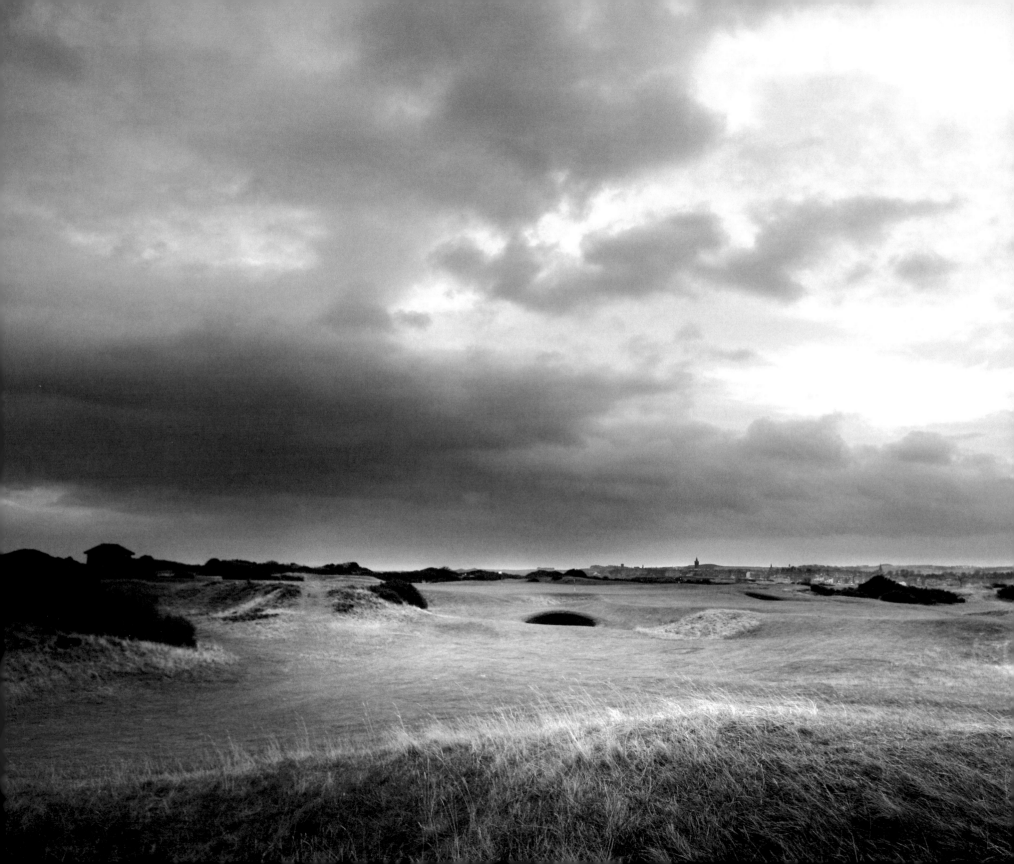

Sunrise over St Andrews.

THE ST ANDREWS THISTLE GOLF CLUB

Imagine a windy September day in St Andrews, 1819; grey, low-scudding clouds roll in with a bitter chill off the North Sea and rainy squalls begin to sweep across the desolate linksland. A small group of Scottish gentlemen — uniformly dressed in green jackets emblazoned with an upright thistle in silver lace and silver buttons — walk out of the Black Bull Inn. Fortified by the recent whisky still firing their bellies, they turn up their black velvet collars against the weather, gather their clubs, and head stoically for the Links. The third annual meeting of the Thistle Golf Society has just drawn to a close and its important medal competition is about to get under way.

Among that hardy group setting out all those years ago was John Buddo, whose 'fine' score of 120 strokes was enough to win the medal. However, being victorious had its drawbacks, as the winner was not allowed to play in the competition again for four years to allow other members a chance. Rewarding golfing skill in such a way was clearly unpopular, and by 1839 the Society had disbanded. It was not until 1865 that a group of twenty local golfers, mainly men of trade as opposed to gentlemen, decided to re-establish the Society under a new code. The constitution was redrawn and the name changed to The St Andrews Thistle Golf Club.

This was ready-made golf at its best, played over the ancient Links. A clubhouse? Why would you need a clubhouse when you had numerous taverns and town meeting halls in which to arrange matches? The relaxed approach and unstuffy nature of 'The Thistle'

The crest of The St Andrews Thistle Golf Club.

made it a favourite with local artisans and shop workers, who usually took Thursday as a half-day to play golf. It is a tradition that survives to this day: weekly Thursday competitions run throughout the year; Club matchplay ties have to be completed by that day of the week; the AGM is held on a Thursday in February; and the annual dinner and trophy presentation is held on a Thursday in November.

As with the R&A, The St Andrews Golf Club, The New Golf Club and the XIXth Hole Golf Club, The St Andrews Thistle Golf Club does not have lady members. (St Andrews' lady golfers have three clubs exclusively for themselves – the Ladies' Putting Club, The St Rule Club and the St Regulus Ladies' Golf Club.) And as with all of these institutions, The Thistle does not own any of the town's public courses. It does, however, enjoy the right to play over the Links at certain times, and more recently the new Castle Course has been incorporated into the rota for monthly medals.

For most people The Thistle is not a first club but a place to join later in one's golfing career. Today's membership numbers over 200, with a large proportion of that figure drawn from men who already belong to one or more of the other local clubs. Nevertheless, it commands great loyalty and the standard of play among its golfers has long been competitive. One member, Willie Fowlis, had a handicap of plus-6, while his son of the same name was a 1923 Scottish international. The past Open and Masters champion Sandy Lyle is an honorary member. There are regular inter-club St Andrews matches and outings to clubs that are further afield such as Elie, Scotscraig and St Michaels.

As The Thistle has never had a fixed abode, the location of its meetings, dinners and prize-giving presentations is dependent upon members' strong pre-existing connections to other golf clubs. Often such events are held at The St Andrews Golf Club, whose clubhouse overlooks the final fairway on the Old Course. But ask any Thistle veteran whether the lack of a tangible home matters and the response will be a resounding 'no'. For them, it is the members and their love of golf that make up the heart and soul of the club. That and the fact that they have the linksland of St Andrews to play on is treasure enough.

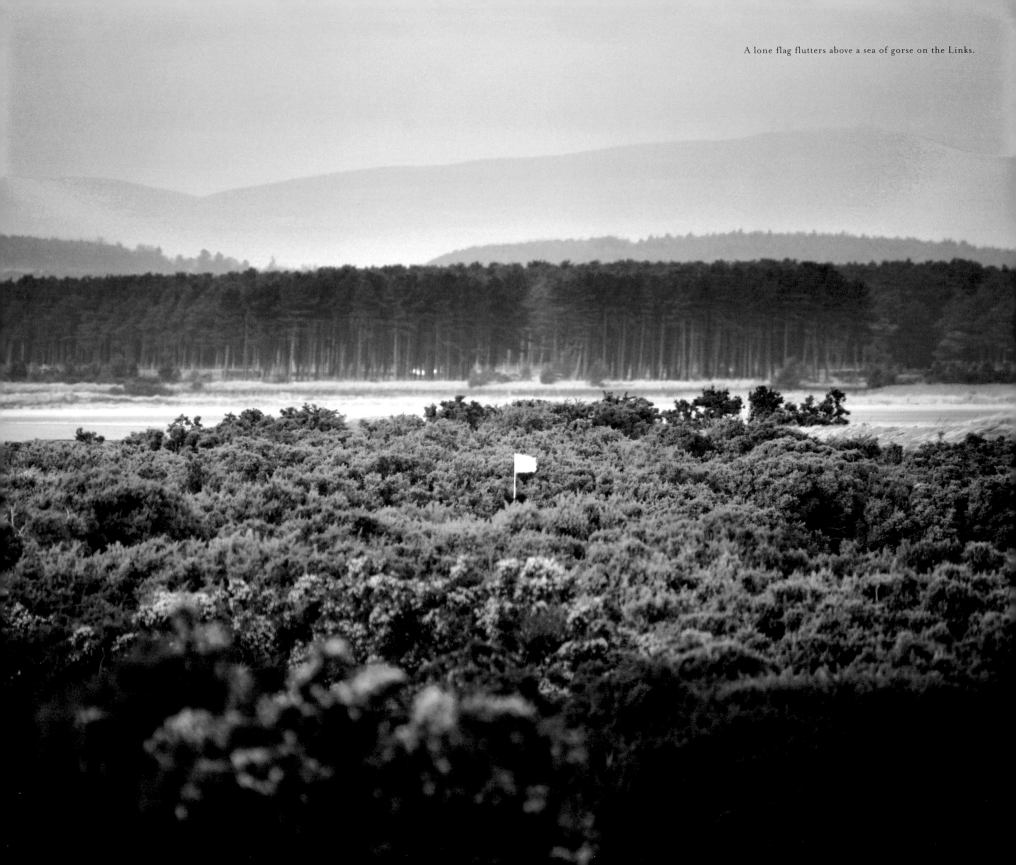

A lone flag flutters above a sea of gorse on the Links.

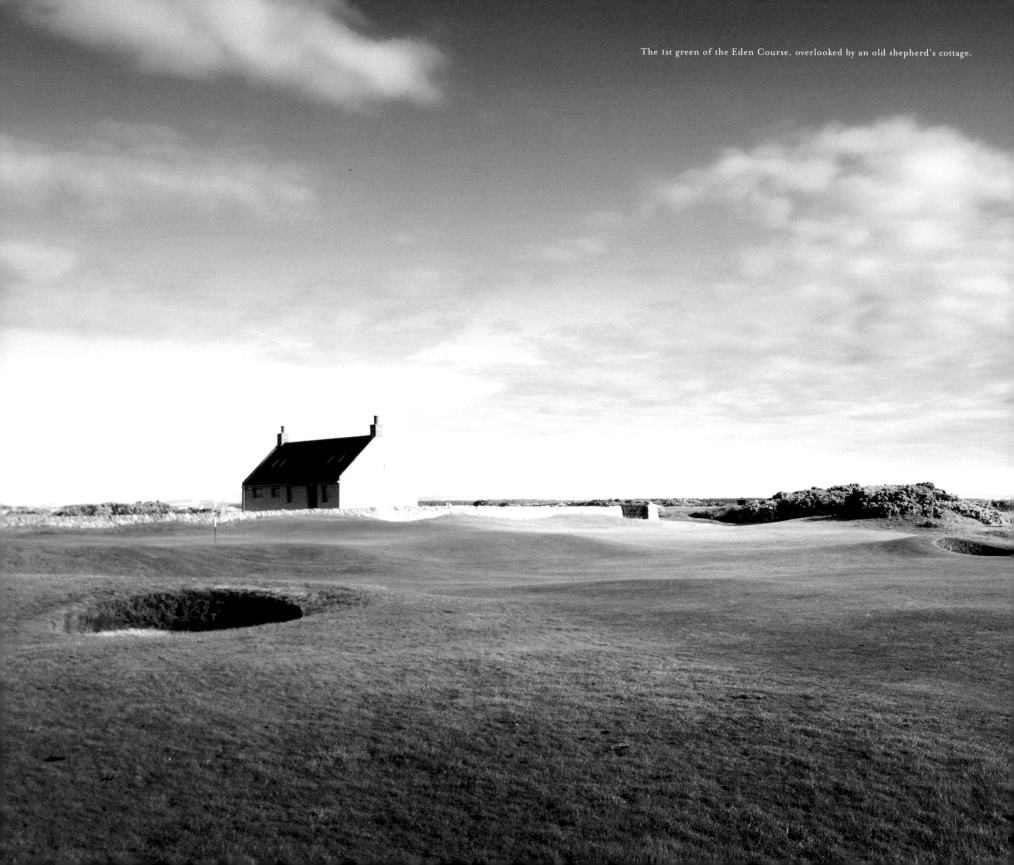

The 1st green of the Eden Course, overlooked by an old shepherd's cottage.

THE EDEN COURSE

The Eden Course has a unique character that makes it a particularly special part of St Andrews Links. With its famous pink shepherd's cottage behind the 1st green and the trace of the old railway line haunting most of the back nine, the Eden represents a fine example of a classic golf course with real integrity, built out of clever routing and design. Being shorter than the Old and New courses, it strikes a compromise between the stern challenge of championship layouts and the wide accessibility of shorter courses, such as the Strathtyrum. Nevertheless, deft touches from the golfer are still required to negotiate the tight gorse-lined fairways and tricky greens that the Eden presents.

It was an agreement known as the 1913 Act that first gave St Andrews town council the opportunity to begin work on a fourth golf course on the Links. In the original proposal, the course was to be built upon a piece of property that was bounded to the north by the 12th and 13th holes of the Old Course and to the west by the arching coastline of the Eden estuary. The southern boundary was to roughly follow the path of the railway line that was in use between St Andrews

and Leuchars. It was envisaged that holes would be built on both sides of the tracks.

Acquiring the appropriate land was an awkward process. While the council already owned a small, scrubby parcel to the south of the Old Course, the critical land around the railway line was under the ownership of James Cheape of Strathtyrum. When a deal was finally struck for the council to lease Cheape's five fields (three to the north and two to the south of the railway) from him for a price of £130 a year, Harry Colt was commissioned to design the golf course on the basis of his esteemed work at Sunningdale and Swinley Forest. As an R&A member himself, Colt was well aware of the rare privilege that the commission represented, and gratefully accepted the opportunity to add his signature to the sacred linksland. With the help of his foreman, Claude Harris, he agreed to complete the work on the Eden using predominantly local labour.

The suitability of the land that Colt had to work with was mixed, for although there were numerous natural plateaus around which to form hard, fast greens, there were also many

flat and scrubby areas with partially buried field boundaries. Sir Guy Campbell, the noted player and golf course architect who tinkered with Colt's first design at Rye, suggested the difficulty of the task by saying:

True, there was good golfing ground around, but there was also much that, at a cursory glance, appeared highly unsuitable – flat, featureless, sodden and at one end arbitrarily constricted.

The course was officially opened on 4 July 1914, just months before the outbreak of the First World War. Mrs Herkless, wife of Provost John Herkless, struck the opening drive. The ball that she hit was later mounted and kept in a showcase at St Andrews Town Hall. At some point the ball was lost and remained so for many years, only to be rediscovered in an English antique shop in 1985, when it was purchased by the R&A for £200. Also taking place on the opening day was a competition between a team from the R&A and a 'Team of Local Talent' in order to promote good relations between the Club and town. The match – won by the R&A – was such a success that it has continued as a permanent fixture in the R&A's Autumn Meeting schedule ever since.

Colt's design, which required him to construct two artificial greens and position 61 bunkers on the property, won great acclaim for its finesse and innovative use of space, most notably from Campbell, who eulogised that the Eden was:

A monument to the genius of Harry Colt ... he contrived a course of character, great interest and wide variety, that not only provides an annual test of searching severity, but maintains year by year an undisputed popularity among golfers of both sexes and all ages and handicaps.

In 1936, after 22 years of great success for the Eden, the town council agreed to fully purchase the Eden property from the Cheapes. Harry Colt was asked to return to the site and advise upon improvements to the course, but could find very little wrong with the original layout. Significant alterations were first made to the course as late as 1969, when the railway line into St Andrews was finally closed, meaning that players did not have to cross the bridge by the old 2nd green any longer.

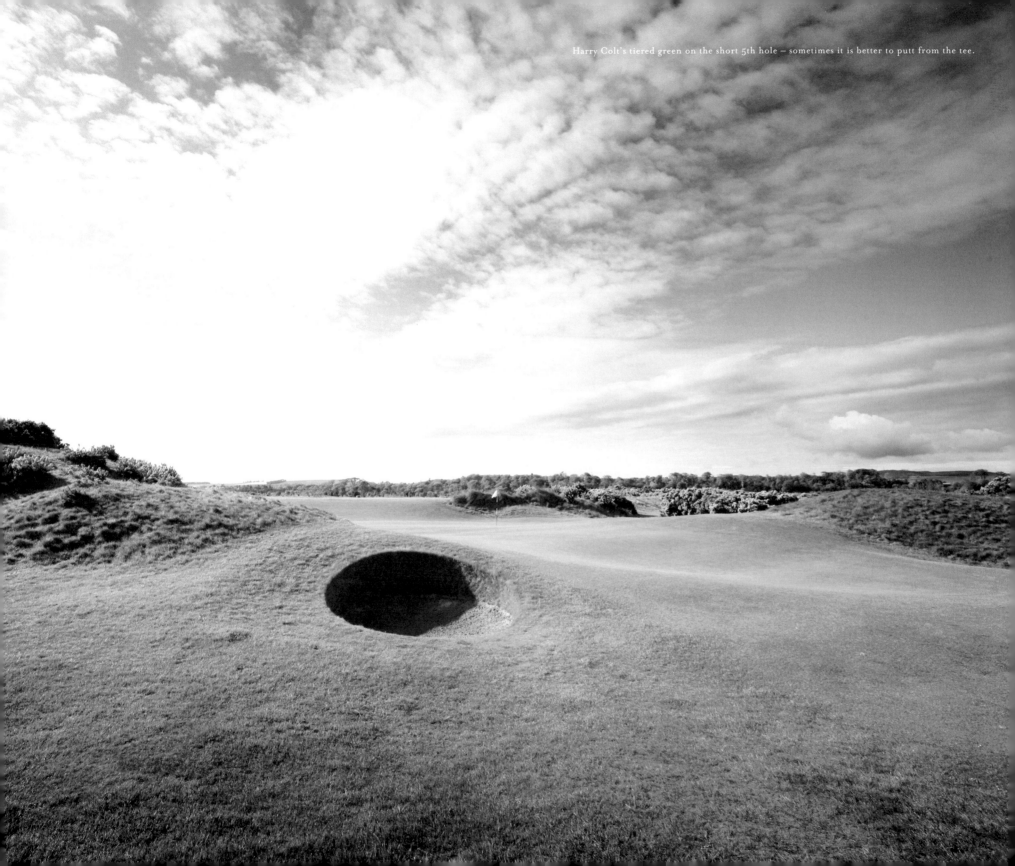

Harry Colt's tiered green on the short 5th hole – sometimes it is better to putt from the tee.

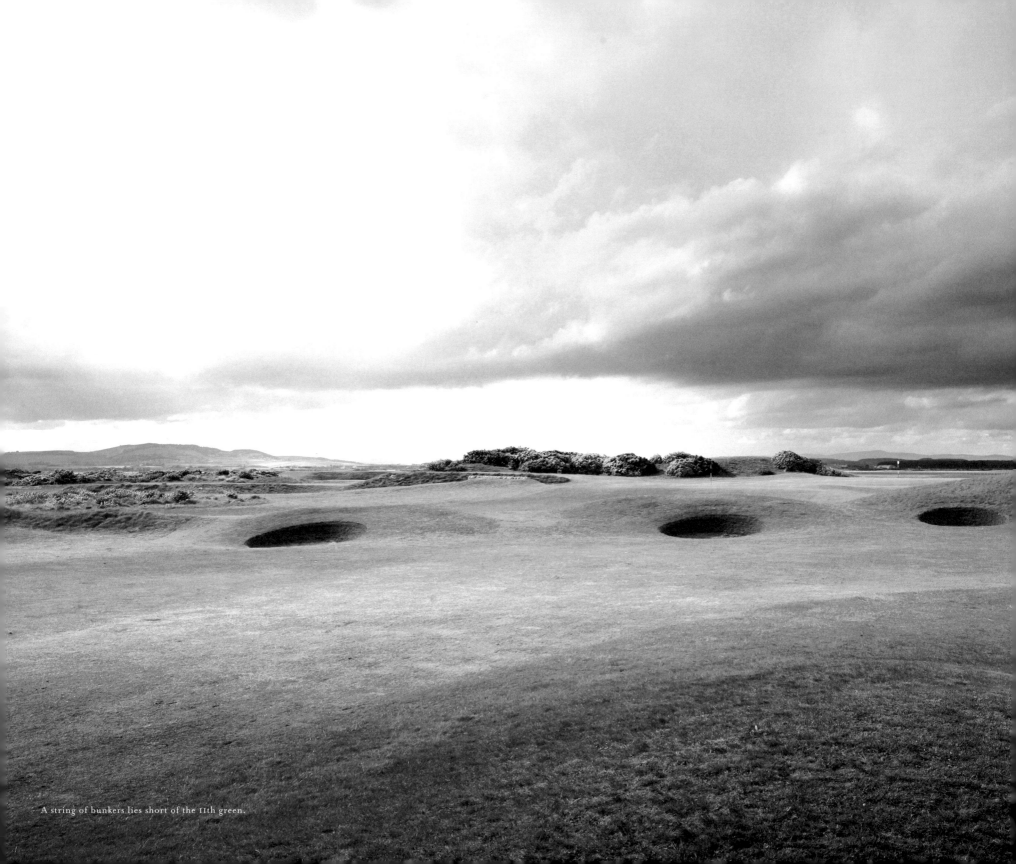

A string of bunkers lies short of the 11th green.

More profound changes came to the course in 1987, when arrangements were made to accommodate improved practice and Major-tournament facilities. Golf architects Cotton, Pennick, Steel and Partners took on the redesign, which incorporated large alterations to the two opening and two closing holes, as well as the addition of a pond at the south-western corner of the property at holes 14 and 15. Owing most of its major structural changes to Donald Steel, the revised layout was opened in 1989 and played as a par 72 course measuring 6,423 yards. More recent work has meant that the course now plays as an enjoyable 6,250-yard par 70.

From start to finish the Eden throws up character-building shot options and some excellent green complexes. The opening holes have the Old Course for company on the right as golfers head out towards the estuary. The 1st is a lovely short par four running along a narrow fairway. Any pulled shot risks finding either a pot bunker or the punitive gorse that encroaches from the left. A good tee shot to the right-centre of the fairway provides a nice approach angle to the gorgeous, undulating green.

Of the remaining outward holes, the strongest section comes through the latter stages of the front nine in a looping sequence that takes players from the par-three 5th, around a couple of switchback par fours that touch the Eden estuary, through to the short 8th. The 144-yard 5th is especially good, with a severely false-fronted two-tier green that lies on a natural plateau. The best way to navigate this par three's hazards is to play slightly long, safe in the knowledge that the slope at the back of the green will act as a backboard for any over-clubbed approach. However, contrary to this method of play – and somewhat remarkably – a local golfer once got a hole-in-one here by using his putter from the 5th tee in a howling gale.

Completing the short loop, the par-three 8th begins from just next to the 5th tee box. It too has a green set high on a plateau, although the slope at the front of the green here is far more severe and punishing than anything previous to it. When the bunkers at the front of the green are taken into consideration, it is always sensible to play an extra club or two to avoid problems.

With the front nine holes returning players to the clubhouse, the back nine leads out towards the estuary, hugging the old train line. The disused track path acts as a spine for all but the 11th and 12th holes on the latter half of the course. The opening hole of the back nine is the 196-yard par-three 10th, which has a long, narrow green rising up from front to back. The best way to score well is to play short of the pin to avoid a terrifying putt down the slope.

Along with the ubiquitous sight of the old railway line, the most noticeable difference between the Eden and other nearby courses is the presence of the pond at the 14th and 15th holes, designed by Donald Steel. It lies at the south-western corner of the property, is the only man-made water hazard on the entire Links, and seems bizarrely misplaced in its surroundings. The holes themselves are rigorous tests of accuracy, as the old railway track forms a tight out-of-bounds line up the right of the par-four 14th while the pond is dangerously close to the green on the left. The short 15th plays back over the same hazard. As all of the trouble here is short – four greenside bunkers and the water stand ready to catch any weak shots – caddies often advise an extra club.

The Eden finishes with a flourish at the close of the round. Many consider the long and curving 17th the hardest hole on the course. Again, the disused railway line forms a constricting out-of-bounds line up the right, while the left side of the fairway is scattered with driveable bunkers. The shorter but expertly defended par-four 18th has its direct line to the green obscured by sand and a gorse bush jutting out from the left rough. The safe approach is played through an attractive channel from the right to a long green.

Renowned for being charming, the Eden Course's varied holes offer some strategic lines and the chance to attack or hit fun recovery shots when out of position. As a test it may not have quite the majesty of its cousins, but for regular play and friendly competitive golf the overall experience takes some beating.

The Eden Course's 7th green leads right to the water's edge.

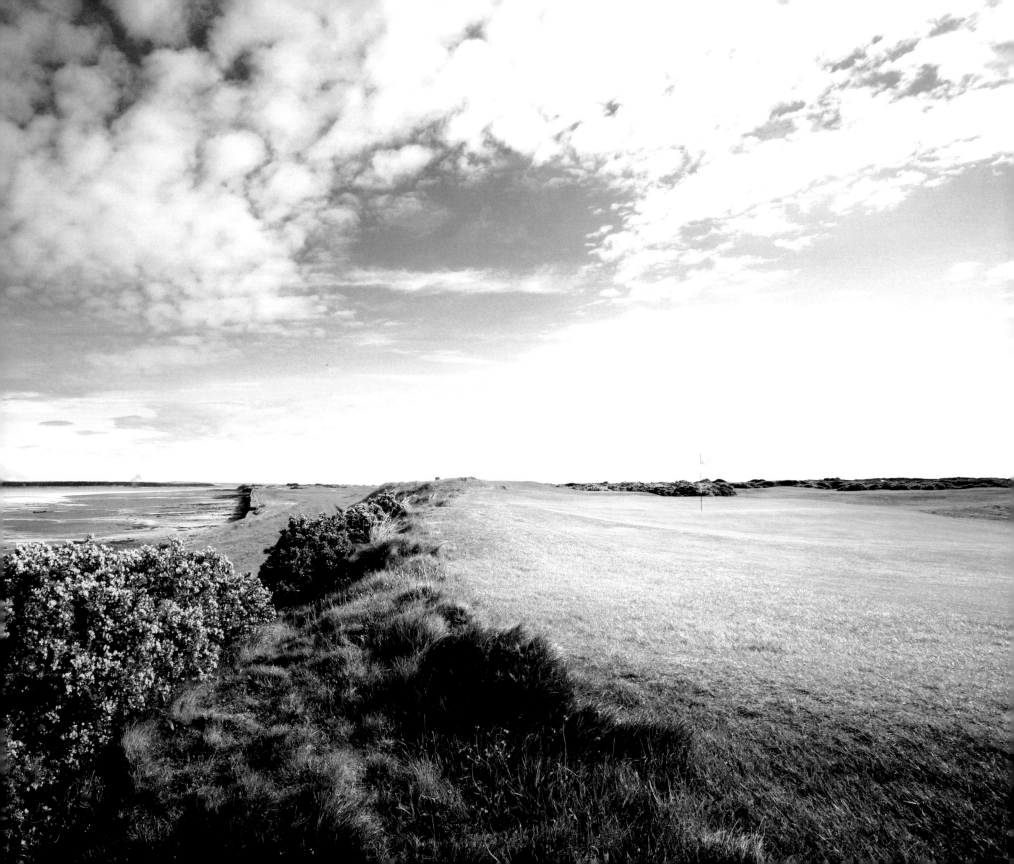

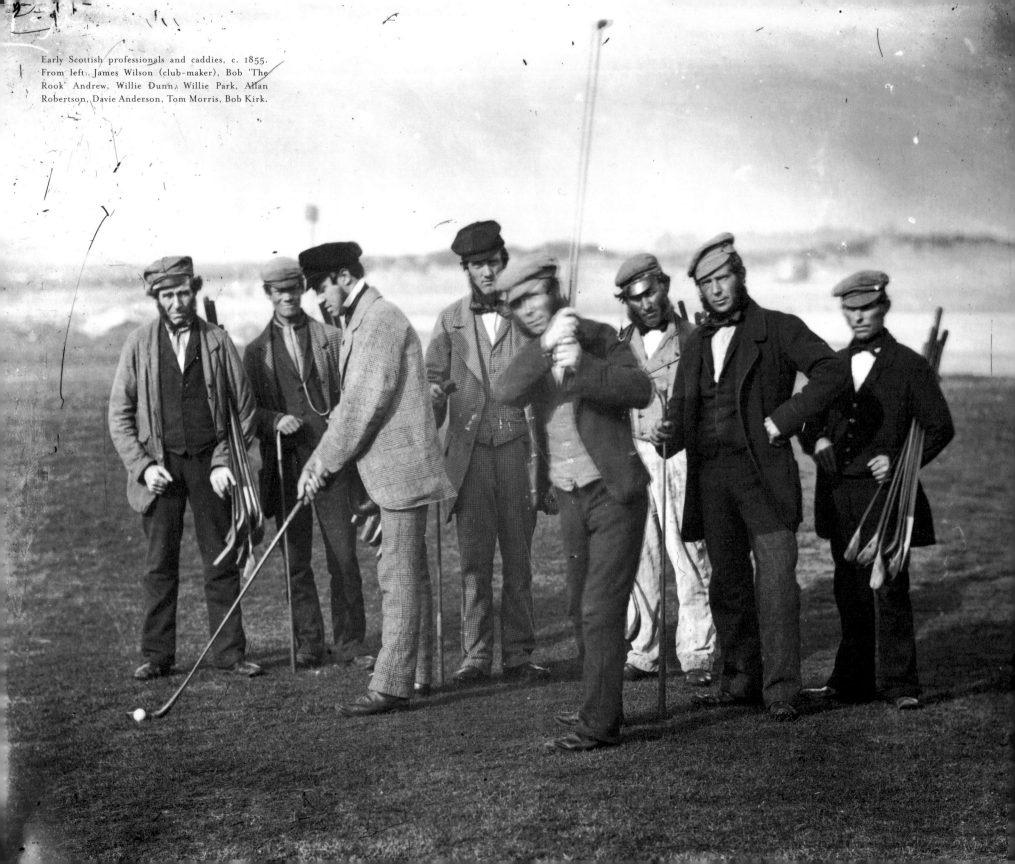

Early Scottish professionals and caddies, c. 1855. From left: James Wilson (club-maker), Bob 'The Rook' Andrew, Willie Dunn, Willie Park, Allan Robertson, Davie Anderson, Tom Morris, Bob Kirk.

A GOLFER'S 15TH CLUB

A golfer who does not take a caddie at St Andrews denies himself the wine of the country.

Herbert Warren Wind

Sadly, at many golf clubs these days, caddies are an endangered species. Most members carry their own bags or use hand- or battery-powered trolleys, while touring professionals bring their own caddies. In America and the hotter parts of Europe, where the golf buggy is king, the caddie's purely physical purpose is virtually obsolete — although a few of the more exclusive clubs will have caddies to assist their visitors as much as their members. Thankfully, at St Andrews the services of a real caddie are still in great demand, although their ride through history has not always been a smooth one.

Mary Queen of Scots is often credited as the source of the name. She frequently played golf while being schooled in France, where her clubs were carried for her by students or porters — *les cadets*. The name became incorporated into the game as it grew and developed, soon becoming a universal term. In St Andrews the caddie, whatever his moniker, has been a part of golf for as long as the game has been played there. More often than not he was a fisherman of rugged build and craggy face, filling in time and getting a bit of money between tides. But he was no mere club carrier; he was

an expert in the game from whose kind the original professionals of golf emerged. For instance, in their early days as professionals, Allan Robertson and Old Tom Morris often caddied for R&A members when they were not partnering them in a wager match. Although the professionals too had their own favourites: Davie Anderson always carried for Robertson, while Tom Morris had Bob Kirk.

The caddie was there to help his employer — his 'man' — get around the undulating, capricious linksland, with its lack of visual features, blind pot bunkers and rolling double greens. He would guide his man, club him, even dragoon him around the links, trying to ensure match victory. Often a rapport between player and caddie would establish itself to the point where many regular R&A members always took the same right-hand man. James Balfour noted in his 1887 booklet *Reminiscences of Golf on St Andrews Links* that Sandy Pirie always carried for Sir Hope Grant, while Sandy Herd (grandfather of the 1902 Open champion of the same name) was the unchanging man for John Whyte-Melville. What is more, many of these early caddies were characters, as Balfour continues:

Three golfers discuss a game while weather-beaten caddies wait to carry for their 'man'.

Perhaps the greatest character was 'Lang Willie'. He was very tall, about six feet two, with bent knees and a slouching gait, a tall hat, swallow-tailed blue coat, and light trousers. His look was rather stupid, but he was in reality wide awake. He used to insist that he drank nothing but sweet milk, greatly to Allan [Robertson]'s amusement, who knew better ... On one occasion he was teaching one of the Professors of the University the noble game. But the said Professor was not a promising pupil. As he hammered away, sometimes 'missing the globe', sometimes topping the ball, or cutting up large divots of turf, Willie fairly got out of patience, and said to him, 'You see Professor, as long as ye are learning thae lads at College Latin and Greek it is easy work, but when ye come to play golf ye maun hae a heid!'

Caddie tales, true and fictitious, are myriad but there is room for one or two more here. A typical illustration of the

caddie who regarded himself as more of an expert than his employer is the story of Rex Hartley – the 1930s English Walker Cup player – who took his St Andrews caddie to Gleneagles for the Silver Tassie. When Hartley was reaching the end of his round, with a good chance of winning the trophy, he asked for a 3-wood at one hole, saying that it would cut nicely into the wind and see him to the green. 'Ye'll tak your iron, and hit it straight', barked the caddie. 'Whit dae ye think ye're playing in? A pantomime?' Hartley took the iron, as instructed, and won the Silver Tassie.

Then there were caddies renowned for their dry wit, such as the fine St Andrews professional Andra Kirkaldy, who often carried bags in his early years. One poor golfer was trapped in the Old Course's Hell Bunker and, after going through several different clubs trying to get his ball out, asked Kirkaldy what he should do next. 'If I were ye,' came Andra's reply, 'I'd tak the 9.40 train oot o'St Andrews.'

After the Second World War, the role of the caddie in St Andrews began to change. In 1949 Lord Brabazon of Tara took the first golf trolley round the Old Course, causing much concern among locals at the time. There is no doubt that the new invention led to a decline in demand for caddie services in the amateur game, but those stalwarts who remained in service refused to let it worry them. Indeed, for professional golfers the caddie's imperturbable nature, ability to read the golf course and well-timed sagacity were psychologically supportive traits to be prized.

Two men at St Andrews who upheld the best traditions of their trade were Wallace 'Guy' Gillespie and James 'Tip' Anderson. Gillespie twice trundled alongside Peter Thomson

around the Old Course during The Open, which he won in 1955. Tip Anderson caddied for Arnold Palmer whenever he was in Britain, 'partnering' him in two Open wins at Birkdale in 1961 and Troon the following year. When the 1964 Open returned to St Andrews, Palmer could not attend but recommended Tip carry for his good friend Tony Lema, who promptly won the Championship. 'He was far more useful to me than a club,' said Lema of Tip. 'Without his help I doubt if I could have won it. It amazed me the way he just put the club in my hand.'

After Lema's tragic death in an aircraft accident in 1966, Tip continued to carry for Palmer. It was a relationship that lasted for over 30 years. Palmer tried and failed repeatedly to get him to cross the Atlantic, saying that he was a 'sea of calm in the storm of an Open Championship'. Tip was often to be found sitting in the bar of the Dunvegan Hotel on Pilmour Place (a memorial plaque is fixed above his favourite seat) or in the long-gone Golf Hotel by the Old Course's 18th green with his friend Henry Longhurst, the great television commentator. Respectful, diligent and polite, Tip always addressed his man as 'sir' despite invitations to use first-name terms. Those who knew Tip said that he always prepared his employer to get the most from his game. He passed away on 2 January 2004.

By the 1980s, golf trolleys were banned on the Old Course for the damage they were causing to the turf, and the demand for caddies from visitors subsequently increased. Today, caddies both male and female are employed on the Links and come from diverse backgrounds. Quite often the town's university students get involved, earning some good pocket money during the summer vacation. Although there might not be quite the

The Dunvegan Hotel – its bar remains the watering hole for many a St Andrews caddie.

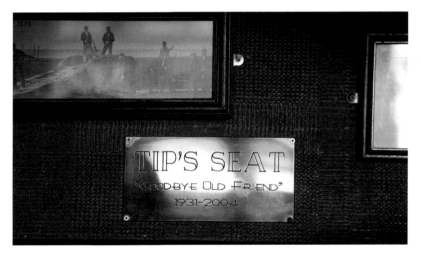

Commemorative plaque to 'Tip' Anderson in the Dunvegan bar.

same number of weather-beaten characters so richly versed in course lore as there used to be, the race is certainly not extinct in St Andrews. Whether young or old, caddies are still much in demand by golfers who want to recapture something of the traditional experience of the game in its homeland.

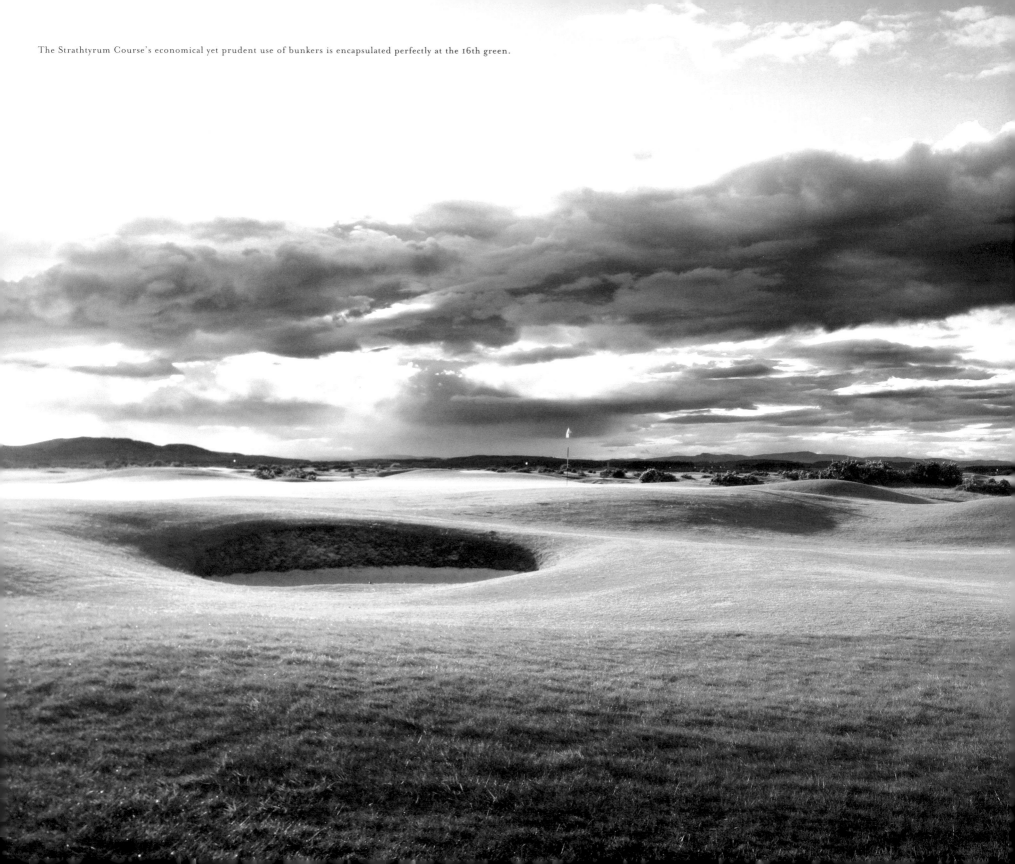

The Strathtyrum Course's economical yet prudent use of bunkers is encapsulated perfectly at the 16th green.

THE STRATHTYRUM COURSE

Named after the adjacent estate from which the land was purchased, the Strathtyrum Course opened for play on 1 July 1993 and was the first new eighteen-hole course at St Andrews for almost 80 years. The Strathtyrum was designed by the highly regarded architect Donald Steel at the same time as his nine-hole Balgove course next door and, like its neighbour, was built with beginners and relaxed golf in mind.

Set on a relatively flat slice of land between the Eden Course and a main road leading into St Andrews, the course barely exceeds 5,500 yards off medal tees but it has a genuine links feel nonetheless. Many of the greens are small, sloping targets built upon low plateaus and surrounded by subtle undulations, placing a premium on accurate iron play. Although there are only fifteen bunkers on the course, they are shrewdly placed and when the prevailing westerly winds blow, the chances are that sand will be found at some point in the round.

The Strathtyrum is arranged in two loops of nine, starting and finishing at the Eden Clubhouse and a charming starter's hut. Aside from the good, firm turf and the attractive back-drop of spindly trees and distant rolling hills that surround St Andrews, the strengths of the course are the opening and closing stretches and its tricky par threes like the 3rd, 8th and 13th, the latter playing 148 yards to an enticing green entrance whose contours and chipping area are nicely tied in to the sweep of the surrounding bunkering.

Temptingly short par fours like the 261-yard 4th and the 270-yard 15th are balanced out by two par fives, one on each nine, at holes 5 and 11. Greens across the course are typically undulating and in summer can reach a decent pace. The run home is good, particularly the two par fours to finish at the 17th and 18th. Both holes have plenty of fairway width and generously proportioned greens, but they are cleverly shaped to play more complicated than they appear.

Many local residents of St Andrews use the Strathtyrum as a relaxing change to their regular game and it can be played around at a stroll in two and a half hours. Although the course is ideal for mid-to-high handicappers, it is also excellent for honing the short game of all golfers, making it a very popular addition to the Home of Golf.

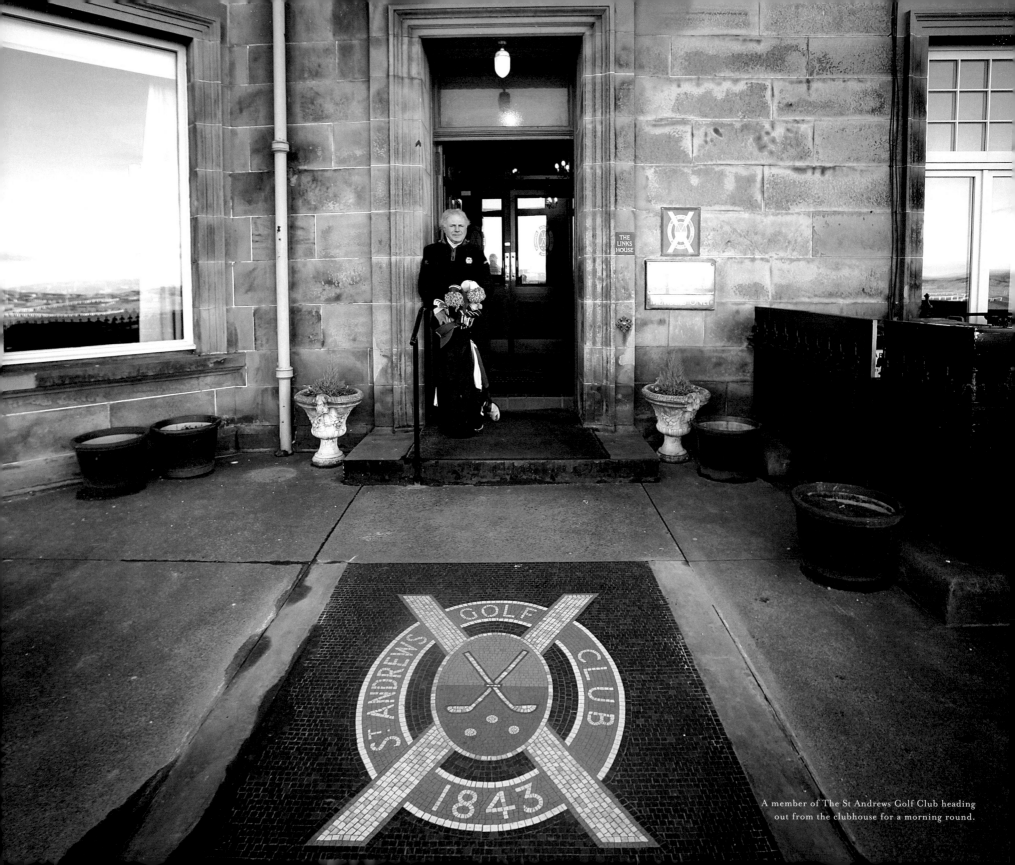

A member of The St Andrews Golf Club heading
out from the clubhouse for a morning round.

THE ST ANDREWS GOLF CLUB

The St Andrews Golf Club was traditionally seen as a poor relation of the R&A, its august neighbour. It carries no royal title, its first captain was a painter rather than a 'gentleman', and for the first 62 years of its life it had no distinguished clubhouse. Yet its lineage is long – it was founded in 1843 – it can parade no small amount of club silver, and it has an illustrious scroll of home-grown champions almost unparalleled by that of any other club in the world.

The Club flourished from the start, mainly because of its artisan founders who were passionate local golfers: William Ayton, cabinet-maker; James Herd, mason; John Keddie, joiner; John Lynn, tailor; Adam McPherson, plasterer; James McPherson, dancing master; George Morris (Old Tom's older brother), butler; Robert Paterson, slater; and David Todd, painter. It was called the St Andrews Mechanics Golf Club until 1851 when the word 'Mechanics' was removed from the title.

One of the most prominent early members was also the greatest golfer of the day and the game's first true professional, Allan Robertson. He was Captain of the Club in 1853 and his house once stood on the site of the Golf Hotel (now private residences) from where he crafted the finest quality 'featherie' golf balls and clubs. On New Year's Day 1847, the St Andrews Club's first medal competition was played and won by James Herd with 105 strokes. That original medal now forms part of the Captain's chain of office. Robertson also presented a prize that day, and was keen to create handicap divisions across the membership with his protégé and fellow member Tom Morris; these came into effect two years later.

For many years the St Andrews Golf Club members would meet at places like the Cross Keys Hotel, but as with the R&A which used the Union Parlour before building its present clubhouse in 1854, they were keen to procure their own premises. Several attempts were made to reach agreements with the hotelier Mr Rusack and local landowner James Cheape of Strathtyrum for a suitable plot of land, without success. Finally, in 1905 the Club managed to buy a house in Golf Place (now the site of Auchterlonies shop) for £800, and it is worth noting that the R&A donated £50 to the cause.

To mark the occasion of moving into their new home, the Club made the St Andrean and 1902 Open champion Sandy

Herd an honorary member. In 1922, the building was extended with the purchase of a property next door. A still more excellently situated and expansive structure was found in 1933, when the present clubhouse overlooking the Old Course's 18th green was bought. The rooms of this substantial Victorian townhouse were converted into superb amenities for golfers, with more excellently appointed rooms than its members could fill.

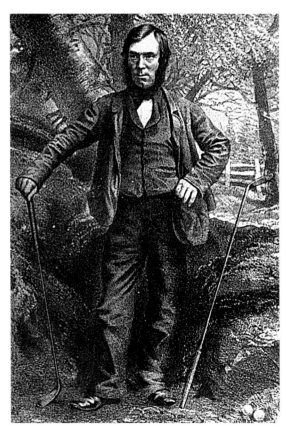

Allan Robertson, golf's first professional.

The entrance hall is an almost baronial atrium lit by natural light from a skylight, with a sweeping staircase and grand rooms opening off it. Allan Robertson's locker, traditionally used by the reigning Captain, stands in the corner. On the wall is an honours board, crowded with the names of Club members who have been winners of national championships. Even before Jack Nicklaus was made an honorary member in 1978, the board displayed winners whose combined haul tallied 21 Open Championships, two Amateur Championships, three US Open Championships and one US Amateur Championship. In a single year, 1898, Fred Herd (Sandy's brother) won the US Open and Finlay Douglas the US Amateur – so both of America's Majors of the time were held by St Andrews Club members.

The principal room of the ground floor is the Members' Lounge. It is a large space, well serviced by a corner bar serving drinks and steaming bowls of homemade soup, and with a generous bay window overlooking the Old Course. Around its walls hang sepia photographs of its most distinguished past members and Open champions including Old and Young Tom Morris, who between 1861 and 1872 each won the Open four times; Alex Strath (1865); Tom Kidd (1873); Bob Martin (1876, 1885); Jamie Anderson (1877, 1888, 1889); Willie Fernie (1883); Jackie Burns (1888); Hugh Kirkaldy (1891); Willie Auchterlonie (1893); Sandy Herd (1902) and Jock Hutchinson (1921). If this weren't already enough of a delight for golf historians, the room also holds a case displaying some fascinating memorabilia, notably Young Tom Morris' pocket watch, his scorecard from the 1870 Open, and

artefacts relating to the Bing Crosby Tournament. (Past Captain J.K. Wilson became a great friend of the American actor, who visited St Andrews many times during his lifelong love affair with the game.)

Upstairs, spread over two more floors, there is a dining room, containing a large trophy cabinet that displays the Club's numerous silver trophies, and doubling as another sitting room; a committee room, with some of the most superb views over the entire Links; the Secretary's office; and the snooker and billiard room. Lining the staircase are various pictures and important framed documents, including awards of honorary membership to Jack Nicklaus, Sir Michael Bonallack, the R&A's past Secretary and one of golf's great amateur players, and Scottish Open winner Paul Lawrie.

Aside from the pantheon of all-time great members, the St Andrews Club remains as it was from the start, a private yet welcoming men's golf club. To become a member of this eminent institution you have to be genuinely interested in golf and be judged a sociable companion for other members, of which there are over 2,000 from across the globe. The golfers who form the core of the Club live within a radius of 30 miles of St Andrews and number 1,200. Of those, about three quarters consider it their 'home' club. There are also thriving juvenile and junior sections, regularly resulting in boys being selected for county and national honours.

'Golf comes first here,' says Tom Gallacher, the present Secretary of the St Andrews Golf Club. 'We have a diverse range of members, from plumbers to professors. And there is a healthy rivalry with the other clubs in town, particularly

The impressive central staircase in the clubhouse.

The New Golf Club which we compete against for the Bute Trophy.' This spirit of competition has a long tradition behind it. The earliest inter-club games were arranged with Leven Golf Club in 1849, Carnoustie in 1873 and Monifieth in 1881. These 50-a-side matches between the top golfers of each club are still contested to this day. Over the years this fixture list has expanded to include regular events, both home and away, against several other clubs including St Rule, St Regulus, Royal Montrose, the R&A and RAF Leuchars.

Old voting box in the clubhouse hallway.

Of the many trophies played for, perhaps the Dr Kyle Memorial Cup is the most highly prized. It is named after a well-known St Andrews medic and Honorary Vice-President of the Club, Dr D. Hamilton Kyle. After his death, the cup and a prize fund were donated in his memory by Kyle's widow in 1930. It was quickly agreed that the cup be used for the Club Championship Competition, consisting of two qualifying rounds over the Jubilee and Eden courses, with the lowest sixteen scratch aggregates moving through to contest the Club Championship by matchplay knockout over the Old Course.

The strength of St Andrews Golf Club is not only its golf but also its people. Whether during the height of summer, when the spacious and comfortable clubhouse is at its busiest, or on a cold and blustery day in winter with only a few groups preparing for a day's play, there is no shortage of camaraderie to be had among its membership. This still consists largely of unpretentious professional and working men, much as it did in the early years after its foundation in 1843. For many of its members, such a down-to-earth club is their spiritual golfing home. Quite simply, there is no other club they would rather belong to.

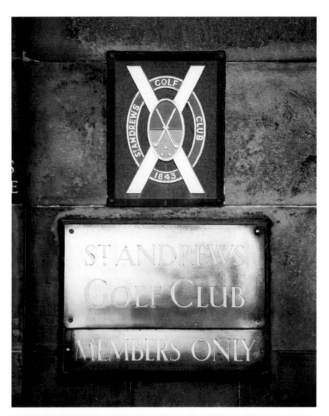

Above right: brass sign and Club crest on the clubhouse wall.

Right: Tom Gallacher, Secretary of The St Andrews Golf Club, on the clubhouse stairs.

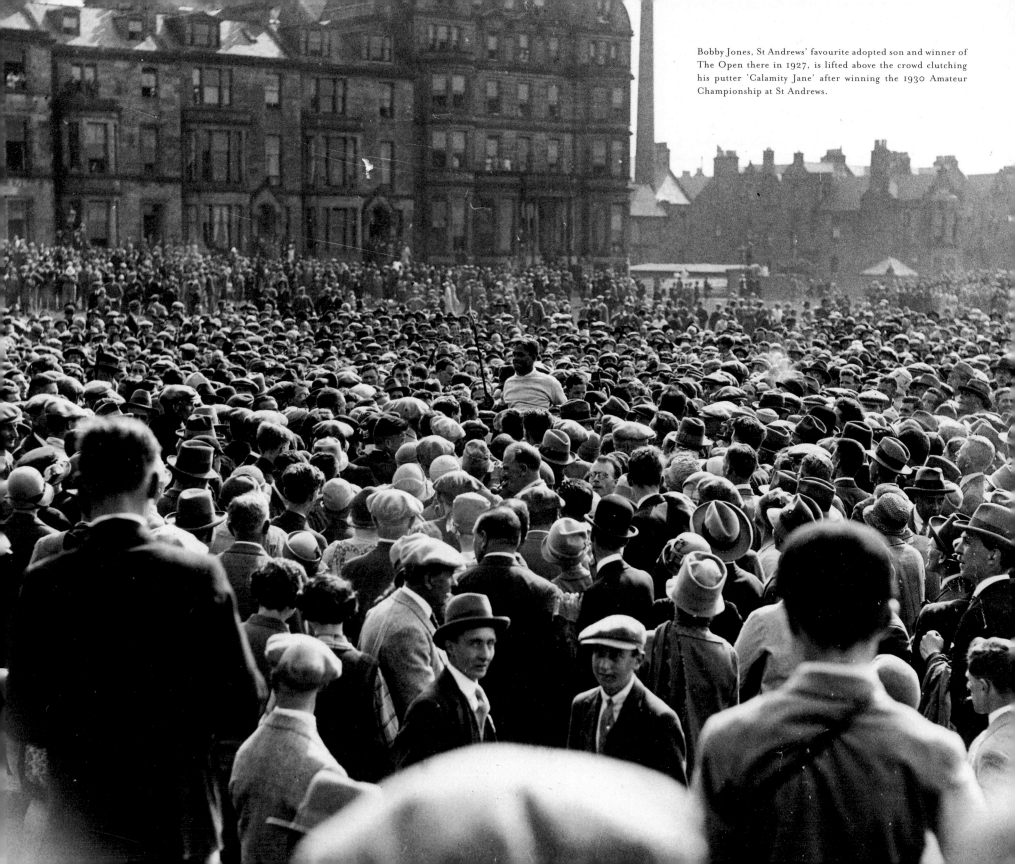

Bobby Jones, St Andrews' favourite adopted son and winner of The Open there in 1927, is lifted above the crowd clutching his putter 'Calamity Jane' after winning the 1930 Amateur Championship at St Andrews.

THE ST ANDREWS OPENS

To see St Andrews at its zenith you must watch an Open Championship when the big tents are erected away

towards the sea and the crowds assemble in their thousands and the stage is set for the crucial test.

Roger Wethered and Tom Simpson, *Design for Golf*, 1952

The Open Championship has a rich history at St Andrews, which has hosted some vintage years of the world's oldest and most prestigious Major tournament. It is where great golfing names have won – James Braid, Bobby Jones, Peter Thomson, Jack Nicklaus, Seve Ballesteros, Nick Faldo and Tiger Woods have all raised The Claret Jug in front of the Royal and Ancient clubhouse after victory on the fairways of the Old Course.

The Open was first brought to St Andrews in 1873 from Prestwick, where the event had been established in 1860. Willie Park Sr. and Old Tom Morris had dominated the early years over on Scotland's west coast, competing for the Open Championship Belt — a beautiful prize made of deep red morocco leather and richly ornamented in silver. Then, in 1868, Morris' son Tommy won the Championship aged just seventeen. He proved himself an even greater talent than his father by going on to win the Belt three times in succession, which allowed him to retain it outright. After an abeyance of one year in which a new trophy had to be found (the Golf Champion Trophy or 'Claret Jug' as it is commonly known), Young Tom won the 1872 Open at Prestwick for a fourth consecutive time, a feat unmatched before or since. Sadly, Tommy never won the Championship over his home course at St Andrews. He died, broken-hearted, on Christmas Day 1875 at the age of 24, just a few months after the death of his wife and unborn child.

When The Claret Jug was played for among a field of 26 players on its first outing at St Andrews in 1873, a young local caddie-turned-player called Tom Kidd took the title with his famously wild and aggressive swing. Torrential rain in the days leading up to the event had left vast puddles of standing water on the course, and as the rules of the time enacted a

Two of the Great Triumvirate – James Braid (second from left) and J.H. Taylor (third from left) – are flanked by Tom Ball (left) and Ben Sayers (right) in an exhibition match, 1910.

At the end of the second round it was found that Tom Kidd was first with a total score of 179 strokes – 91 for the first round and 88 for the second – and he was accordingly declared champion for the ensuing year, and received, in addition to the honour, the first money prize of £11 ... As a whole the play may be characterised as far below the average. The driving was not so bad, but the putting was wretched.

Controversy reigned during the second Open at St Andrews in 1876. Bob Martin won after Davie Strath refused to compete in a play-off. Martin was already in the clubhouse with a total score of 176 while Strath was faced with the proposition of having to complete the final two holes in ten strokes or fewer to take the title. The disagreement came at the 17th hole as Strath hit his third shot onto the green with players still putting on it. His shot struck a member of the party in front and the direction of the ball was altered advantageously away from the potentially treacherous road. He two-putted for a bogey five and then proceeded to make a double-bogey six on the final hole, thus tying the scores. A complaint lodged about the incident at the penultimate hole meant that the R&A Committee ordered a play-off the next day. Strath suggested that a play-off was futile with the complaint verdict still pending and refused to compete any further. The verdict never came, so Martin simply had to complete a statutory walk of the course to become champion.

Martin returned to win the tournament in more conclusive style in 1885, beating Archie Simpson of Carnoustie by a single shot and Davie Ayton, the St Andrews professional, by two. Martin felt himself quite fortunate to have won that year, for reasons he described himself:

one-shot penalty for moving a ball from casual water, there was some very high scoring. Kidd was victorious with a lofty 36-hole score of 179. *The Field* reported his win:

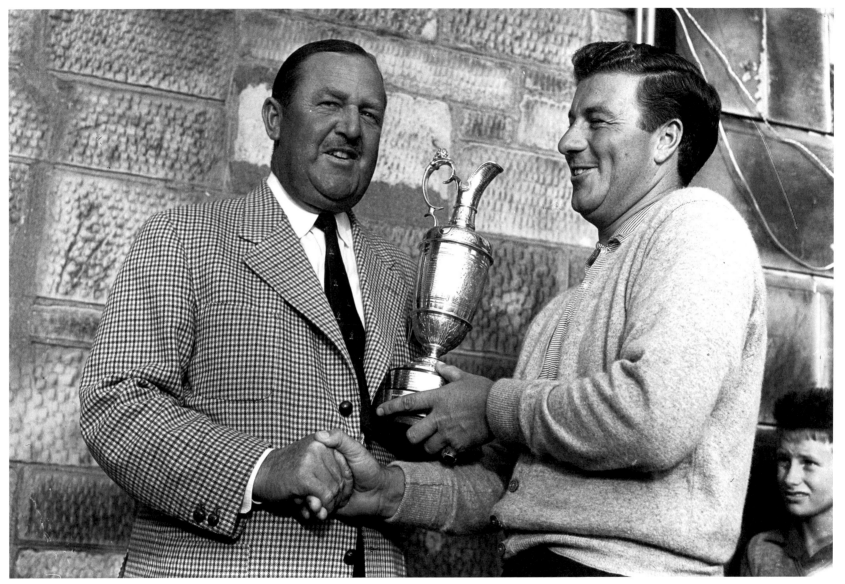

The dominating forces of 1950s world golf, South African Bobby Locke (left) and Australian Peter Thomson, pictured here with The Claret Jug.
Thomson, as defending Open champion, is congratulating Locke on his 1957 victory at St Andrews.

I won the Open Championship twice ... but on the latter occasion I must say I had a bit of good luck, or rather perhaps I should put it that Davie Ayton had it extraordinarily bad. He finished second to me, only two shots behind, and that was after he had taken eleven strokes to the seventeenth hole.

Between Martin's two wins were the St Andrews Open Championships of 1879 and 1882, both of which were won by players who were dominating the game at the time of their victories. The 1879 Open was won by three-time champion Jamie Anderson, who had claimed the previous two tournaments at Musselburgh and Prestwick and was well known for his brisk pace of play, his rock-solid irons and his imperturbable temperament. Anderson's three consecutive Open wins were followed up immediately by the tenacious Bob Ferguson, who won the third of his hat-trick of titles on the Old Course in 1882 and was the first non-St Andrean to win at St Andrews.

The 1888 Championship became known as the 'pencil and rubber' Open, as the outcome of the tournament was just as much down to the sharp-eyed arithmetic of an R&A member as it was to golfing skill. The original scoring had a three-way tie for the lead between Ben Sayers, Davie Anderson and Jack Burns on a score of 172 after the statutory 36 holes. On

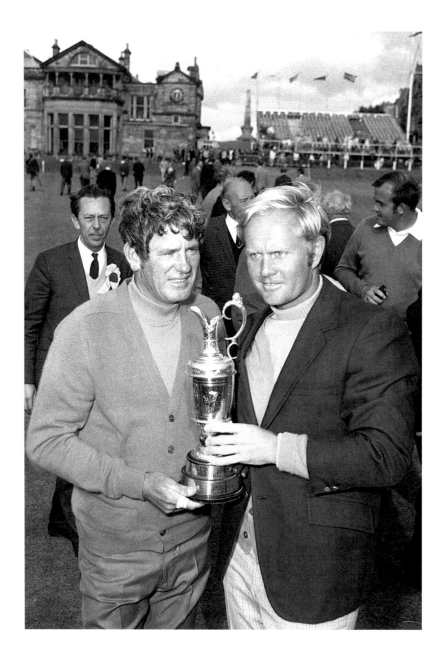

Jack Nicklaus celebrates his Open win of 1970 at St Andrews, holding The Claret Jug with Doug Sanders, who missed a short putt on the 18th green, failing to win the title outright, and subsequently lost to Nicklaus in an eighteen-hole play-off the following day.

closer inspection, however, just before the players were called back for a play-off, it was calculated that Burns' score had been incorrectly added up — he had actually won the tournament by a single stroke. The event was reported in the *Fifeshire Journal*:

It so happened that as a member of the Royal and Ancient Golf Club was looking over the cards in the Clubhouse he found that the figures on Jack Burns' card had through some mistake or other been added up wrongly.

Ever since that event, it has been a rule that players are responsible for ensuring that scores are correctly entered for each hole.

Intense rivalries defined the five Open Championships that took place at St Andrews from 1891 to 1910, as the sibling competition between Andra and Hugh Kirkaldy was followed up by the wonderful challenges of the 'Great Triumvirate' of J.H. Taylor, James Braid and Harry Vardon. A dashing risk-taker, the 1891 champion Hugh Kirkaldy usually took second place to his brother Andra in tournament golf, but he managed to win this most coveted prize of all and achieve something his brother never could. Kirkaldy's win coincided with the last ever Open Championship to be played over 36 holes and ushered in a new era in British tournament golf – an era dominated by Taylor, Braid and Vardon.

Taylor, who won the competition a total of five times throughout his career, took the St Andrews Opens of both 1895 and 1900. In the latter of his two wins, he destroyed the field with a record score of 309 after 72 holes, and his nearest rival was Vardon, eight shots behind. Braid, who also won

the Open five times, was the champion on the Old Course in 1905 and 1910. His remarkable and famous victory in 1905 took place in a tournament that saw the playing field increase to over 150 golfers for the first time, and that was played in treacherous wind. The Old Course had many new pot bunkers in play, and hard, fast greens that had been baked in sunshine. After three rounds of peerless golf that saw Braid tee off for his final round six shots clear of the field, he finally found himself in trouble at the 15th and 16th holes as the railway line encroached up the right-hand side. Braid later wrote of the event:

Going to the fifteenth I sliced my second shot on to the railway. Playing off it I hit a man, and the ball rebounded from him and went to a nasty place where it was tucked up against a bush. The hole cost me six strokes ... But at the next hole the case began to look rather serious ... From the tee I drove the ball right over the Principal's Nose and pitched it into the bunker beyond. I was lying rather well, with the result that I became too venturesome and attempted to put the ball on the green instead of settling for a five ... I got it on to the railway and ... found it lying in a horrible place, tucked up against one of the iron chairs in which the rails rest ... I took my niblick and tried to hook it out but did not succeed, the ball only moving a few yards ... With my fourth I got it back onto the course but ... it went some thirty yards past the hole near to the bunker on the left of the second green ... I had only about a yard to come and go on with a run-up shot ... a bold and very risky shot to play; but ... it came off, the ball running dead, so I got my six.

In all four rounds, Braid felt that his chip-and-run on the 16th was the best shot he played in that tournament, when everything hung in the balance. He scraped home over the final two holes to record a famous victory ahead of Taylor.

After the First World War, a growing American influence was beginning to wrest control of the game away from the famous British professionals. This transition across the Atlantic was neatly encapsulated by the 1921 Open victory of the St Andrews-born Jock Hutchison, who migrated to America and became a citizen there in the year in which he won in his old home town. Hutchison saw some luck in his win, as the fine amateur Roger Wethered accidentally trod on his own ball on the 14th fairway, incurring a penalty. But for that mistake, Wethered might well have won the title.

The 1921 Open was also the first time that the great Bobby Jones competed at St Andrews. He was Jock Hutchison's playing partner in the first round when Jock got a hole-in-one at the 8th hole, before lipping out with his tee shot at the following par-four 9th. Jones' first experience at St Andrews was markedly different. In his third round, Bobby went out in 46 and was deeply frustrated that he could not get to grips with the Old Course's deceptive terrain. After being badly trapped in Hill Bunker at the par-three 11th, he picked his ball up after a third failed attempt to get out and tore up his scorecard — an automatic disqualification. However, after this rare mistake in the heat of battle he did not retreat from the course. Bobby played the rest of his third round and subsequently made a fine score of 72 in the afternoon.

Jones returned to St Andrews in 1927 to win the Championship, having already won it at Royal Lytham the year before. This time around, Bobby exhibited a rare grace, courtesy and integrity that would come to characterise his demeanour. His wonderful, flowing swing struck the ball with consummate perfection and he was crowned the champion golfer of the year in front of an ocean of supporters. His victory in 1927 was a remarkable accomplishment and one that won the hearts of the people of St Andrews, as Bernard Darwin described:

The Championship was over when Bobby Jones was over ... As soon as the last putt was holed the greater part of the multitude (about 15,000 in the area) surged up the slope and enveloped the champion ... Then clasping his famous 'Calamity Jane' tightly in his hand he was hoisted upon willing shoulders while hundreds of hands patted him on the back or any other available portion of him. The crowd swung this way and that with its burden. Bobby's cap was soon irretrievably lost, but still he held his putter inviolate over his head. At long last he was safely on the ground again, and the admiring crowd followed him, gazing and patting until he was safe in his hotel.

He was to compete in a tournament one last time at St Andrews in 1930, when he won the British Amateur Championship as part of his 'Grand Slam' of golf (holding both the Amateur and Open titles of Britain and the USA simultaneously). Six years later, Jones came back to St Andrews for a friendly round of golf and the whole town turned out to wish him well and see him play. In 1958, after an absence of 22 years, Jones returned for the final time as non-playing captain of America in the World Team Championship. While there he was offered the title of Freeman of the Royal Burgh, in effect granting him genuine citizenship of the town, the first and only time St Andrews has extended that honour to an American since 1759. The recipient back then was Dr Benjamin Franklin.

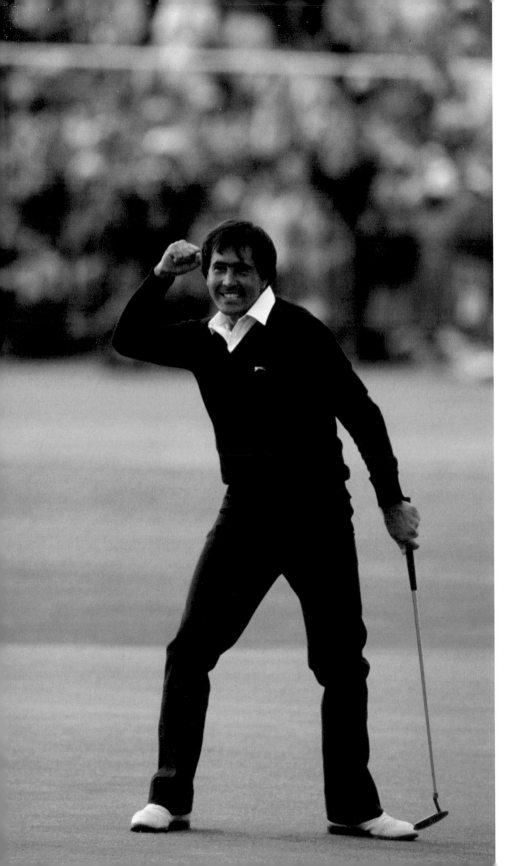

During the moving ceremony in the Town Hall, despite being in great pain from a crippling spinal disease, Jones rose from his seat and spoke eloquently of the warmth and friendship he felt for St Andrews and had received in return from its people:

I just want to say to you this is the finest thing that has ever happened to me ... this occasion at St Andrews shall take first place always. I like to think about it this way that, now I officially have the right to feel at home in St Andrews as much as I, in fact, have always done.

Three years after the peerless Jones had left St Andrews for the final time as a competitive golfer in the Amateur Championship, Densmore Shute was the winner of the 1933 Open held there, and was the last in a long series of American champions. Shute was the beneficiary of a remarkable 'air shot' putt from Leo Diegel on the final green, which allowed him to take the title after a playoff.

In 1939, Dick Burton of Cheshire ended the era of American domination of Open golf at St Andrews that had started with Jock Hutchison almost two decades previously, but was displaced after the Second World War in 1946 by the long-hitting Virginian 'Slammin' Sam Snead, who took The Claret Jug back across the Atlantic. Despite that, it was a time when the general trend saw American dominance

Seve Ballesteros holes out triumphantly for a birdie on the final green to win the 1984 Open Championship at St Andrews.

diminishing and being replaced by a more global pack, fronted by Peter Thomson and Bobby Locke.

The South African Locke had won The Open three times in four years from 1949 to 1953, but the Australian Thomson defeated him a year later at Royal Birkdale and then triumphantly at St Andrews in 1955. The latter win came in the middle of a victorious seven-year period for Thomson, who won a total of five Open Championships, including three consecutive victories between 1954 and 1956. Locke prevented him from making it four in a row in 1957 when the tournament was moved to St Andrews from Muirfield at the last minute. Locke's three-shot win took a dramatic twist on the final green as he failed to return his ball marker to the correct position after moving it to one side so as not to interfere with his partner's putting line. It was not spotted at the time, but the R&A later determined that no unfair advantage had been gained and so he was awarded the title.

Ken Nagle briefly got the title back for Australia in 1960 in the centenary Open on the Old Course, but that tournament was notable for the presence of Arnold Palmer, whose aggressive and exciting style was beginning to dominate the game while also broadening the appeal of golf. American influence was again on the rise, and after Palmer's stylish performance in 1960 he won the Championship at Birkdale in 1961 and Troon the following year. His countryman

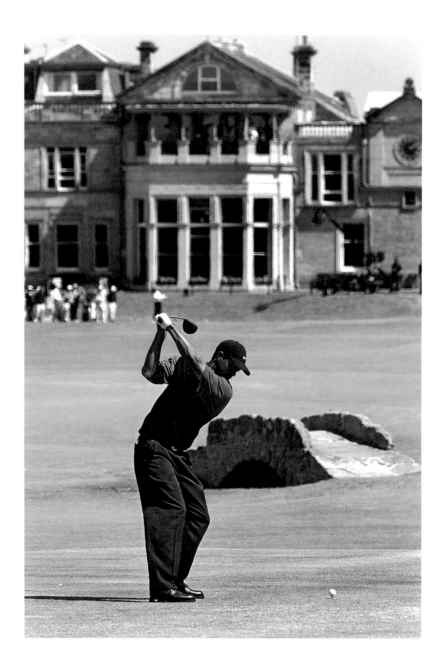

Tiger Woods tees off on the 18th towards the R&A clubhouse at the end of his first round of the 2000 Open Championship.

'Champagne' Tony Lema took the 1964 title back in St Andrews, while Open crowds caught their first glimpse of the great Jack Nicklaus that year — he came back to take The Claret Jug in sumptuous style at St Andrews in 1970 and 1978, and became the first man to win successive titles on the Old Course since Taylor and Braid. Like the other great champions, Nicklaus confirmed his elite status in the annals of the game with his performances at the Home of Golf.

Seve Ballesteros rose to break the American hegemony at St Andrews in 1984 by beating Tom Watson, who would eventually go on to claim five Open Championship victories. Watson never took the title on the Old Course, and on this occasion his hopes faded — like so many before him — at the 17th where he misjudged his approach to leave an impossible chip next to the wall behind the green and road, from where he made a bogey five. Ballesteros, playing ahead of him at the 18th, sank a tumbling, side-door putt that left Watson needing to make an eagle two on the last. He failed, and Seve was crowned the most charismatic of champions — the people of St Andrews took the cavalier young Spaniard to their hearts as they had Jack Nicklaus and Bobby Jones before him.

Nick Faldo continued the European surge in 1990 by conquering the Old Course with careful precision and immaculate concentration, while a player who was in many ways his polar opposite — the brash, wild American John Daly — came from nowhere to win at St Andrews in 1995. Constantino Rocca pushed him all the way to a play-off by making a miraculous birdie on the final hole. Rocca had hit a terrible wedge approach to leave him with what seemed like an impossible 65-foot putt through the Valley of Sin to make the three he needed. In an unforgettable moment of Open history, his ensuing putt snaked across the winding breaks and gullies of the green to drop into the hole, prompting Rocca to fall to the ground in a moment of joyous disbelief. Sadly for him, he could not repeat the magic in the play-off and Daly was crowned the champion golfer of the year.

If American power won the tournament in 1995, then American genius, not seen since the days of Jack Nicklaus, won The Claret Jug in 2000 and 2005. Tiger Woods took the millennium Open Championship at St Andrews without finding a single bunker on all four days of the tournament. He shot a remarkable 269 to win the title by eight strokes. 2005 saw a near repeat performance as he beat Scotsman Colin Montgomerie by five shots. Woods' emergence as the dominant force in world golf was made more poignant as another great said goodbye to the game. Jack Nicklaus played his final competitive round on the Old Course that year, with vast crowds of adoring fans lining the fairway to say an emotional farewell as he lingered on the Swilcan Bridge. At the same moment, Woods was striding purposefully down the 1st fairway at the start of his second round, on the way to another Open victory at St Andrews and the start of a new chapter in championship golf.

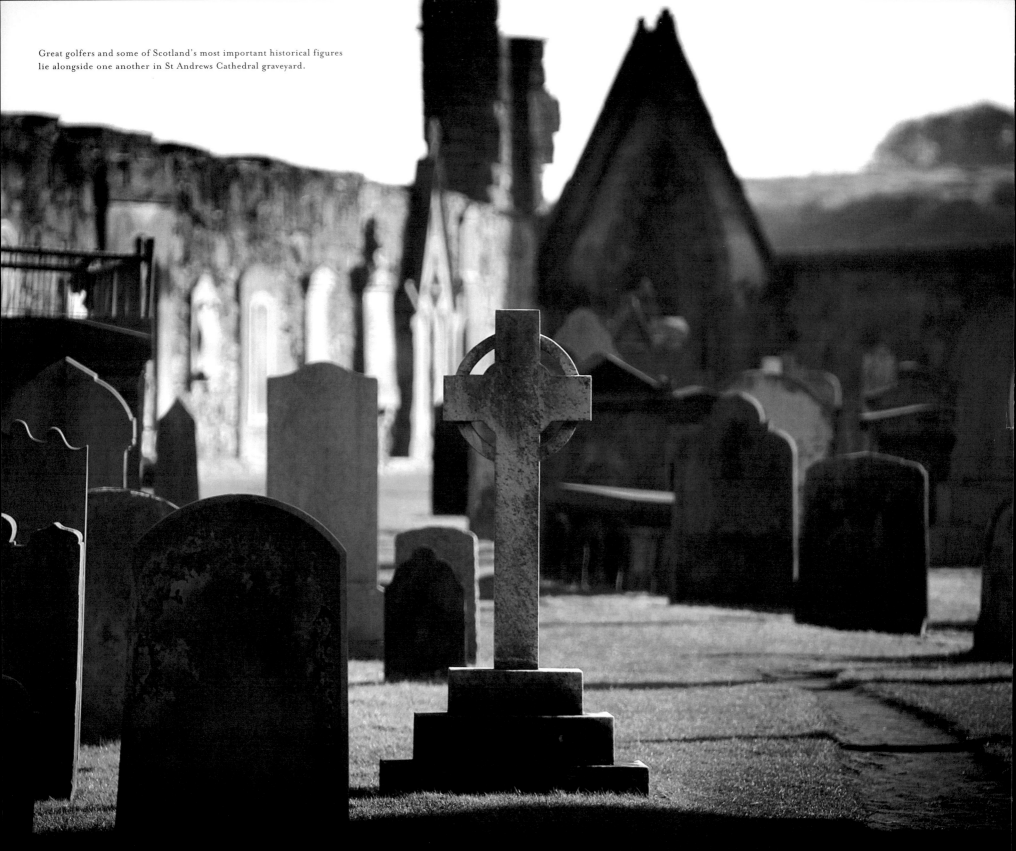

Great golfers and some of Scotland's most important historical figures lie alongside one another in St Andrews Cathedral graveyard.

ST ANDREWS CATHEDRAL GRAVEYARD

The graveyard surrounding the ruins of St Andrews Cathedral is full of notable figures from Scottish history, including bishops, philanthropists, provosts and generals. But alongside these ancient tombs of the great and the good lie the remains of many phenomenal early golfers who were native to the city or its surrounding area.

Directly in front of the entrance to St Rule Tower is a small stone obelisk marking the grave of Allan Robertson, widely regarded as the world's first professional golfer. Born in 1815 to a St Andrews golfing family that had crafted traditional 'featherie' golf balls for generations, Allan had grown up on the Links. He was recognised as the greatest ball-maker of his generation as well as the finest player. Robertson was the first person ever to break 80 around the Old Course, a feat no one had thought possible. Although never formally attached to the R&A, he was supported by its members in challenge matches together with his young protégé and playing partner Old Tom Morris. An image of Robertson's face, its features worn smooth by the elements, can be seen carved into the pillar's stone.

Over by the south wall of the Cathedral grounds rest the famous Morris family. Old Tom, winner of four Open Championships (1861, 1862, 1864 and 1867) took up the R&A's mantle of Keeper of the Greens in 1865, having spent more than a decade at Prestwick. As greenkeeper he tirelessly supervised the maintenance of the Old Course. Morris remained in the post until 1904 when he retired aged 83. Such was the general respect for the 'Grand Old Man' of golf that he was immediately elected Honorary Professional of the R&A, and after his death in 1908 the 18th green was named 'Tom Morris' in his honour.

Morris' son, the brilliant and tragic Young Tom, or Tommy, lies beside him. Tommy was arguably an even more prodigious sporting talent than his father. In 1868 he became the youngest person ever to win The Open, aged seventeen, and went on to win it four times in succession. On his third consecutive victory he was allowed to keep the original trophy, the Championship Belt (a large red leather belt with a silver buckle). After a fallow year in which no tournament was played, the Belt was replaced in 1872 by The Claret Jug. Tommy

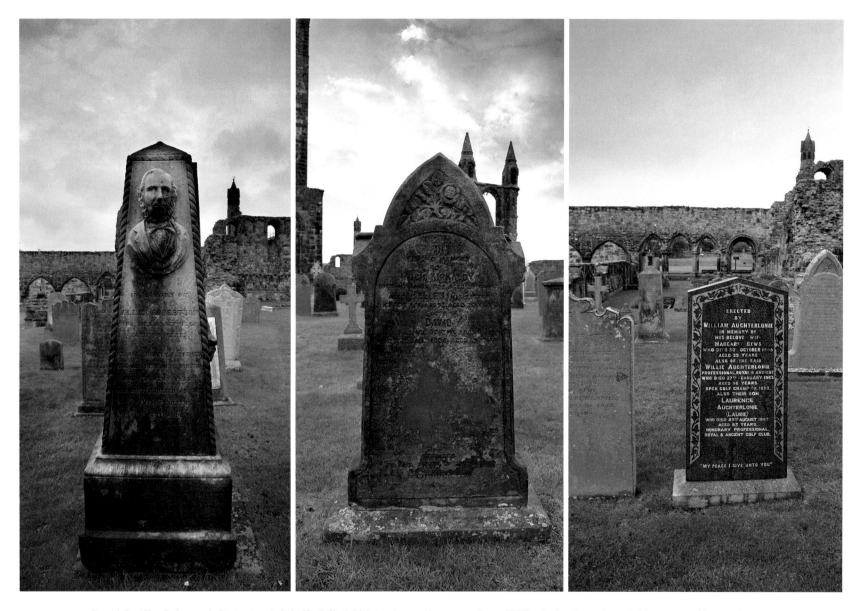

From left: Allan Robertson's distinctive obelisk; Hugh Kirkaldy's headstone; the resting place of Willie Auchterlonie, his wife Margaret, and his son Laurie.

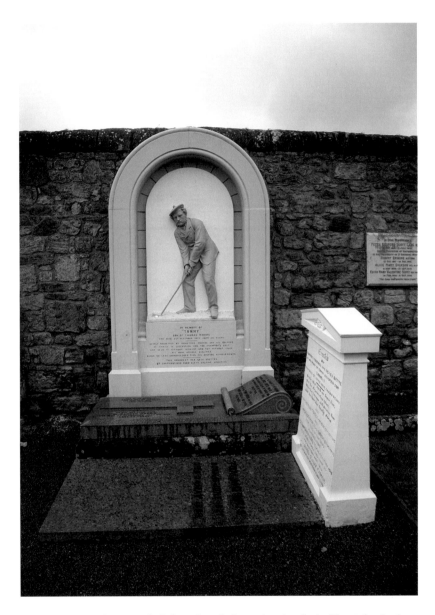

Young Tom Morris' memorial, dedicated in 1878, standing beside the Morris family plot.

won that trophy in its maiden year as well. Sadly, this brightest of golfing stars died on Christmas Day 1875, aged 24, just three months after losing his beloved wife in childbirth. Some say his death was caused by a broken heart. Over Tommy's grave stands a large monument to him 'erected by contributions from sixty golfing societies', as its inscription says.

Another three-time consecutive winner of The Open, Jamie Anderson (1877–9), is buried somewhere nearby, although unlike the grand memorial to Young Tom Morris his grave is unmarked. Similarly, Open winners Tom Kidd (1873) and Bob Martin (1876 and 1885) are interred without plaque or headstone, which seems odd given the six Open titles between the three players. However, champions' burial places that are visible include Jack Burns (1888), Hugh Kirkaldy (1891), Willie Auchterlonie (1893) and Sandy Herd (1902). Hugh Kirkaldy's brother, Andra, also rests in the graveyard. Although never Open champion, Andra performed consistently well in the event, finishing among the top three on six occasions and even tying first in 1889 before losing out to Willie Park Jr. in a play-off. Andra was Honorary Professional to the R&A from 1910 until his death in 1934. A marvellous portrait of the colourful, portly professional hangs on the stairs of the R&A clubhouse.

Taking some time to walk among the Cathedral headstones reveals much about a cast of influential characters in golf's history; pioneers in the birth of the modern game and of Scottish and Open Championship golf. It is also testament to the high regard in which St Andreans hold their heroes of the Links, both in life and in death.

THE BALGOVE COURSE

The Balgove Course was first conceived in the 1960s as the St Andrews town council recognised the need for a course upon which children and beginners could grasp the game. Previously, the Jubilee Course was where learners practised and developed their swings, but when that layout was redesigned there was no longer an appropriate place to hone budding skills. Securing a suitable property proved a difficult task until finally, in September 1971, a deal was struck with Mrs Gladys Cheape for a plot around Balgove Park of almost 27 acres to be purchased for the sum of £12,150.

The site was comfortably big enough for nine holes (a 1935 guidebook map shows the area as being an 'aeroplane landing ground'), with room to accommodate even the most errant of learners' shots. A new entrance road was also built, so that children could have safe passage to the course and would not have to walk along Mussell Road, which ran by the 17th fairway of the Old Course and bisected the Eden Course's penultimate fairway.

The Balgove was officially opened for play in February 1972 as a nine-hole course measuring 2,085 yards. The original layout was not in play for long, however, as Donald Steel's 1989–90 remodelling of the Eden took over a portion of its site. In September 1990, Steel was further commissioned by the Links Trust to draw up new plans for the Balgove. He designed an improved 1,700-yard par 31 course with two greenside bunkers, proper teeing grounds and even a shared green. These features provided the Balgove with many of the hallmarks of the larger courses on the Links, while ensuring it remained approachable for novices. Its fun layout, limited hazards and short rough made it an excellent stepping-stone from practice range to course.

Built simultaneously with the eighteen-hole Strathtyrum Course, the reconstructed Balgove was opened on 20 June 1993 by members of the St Andrews Children's Golf Club. Since that day, the length of the course has been shortened to 1,520 yards and the par reduced to 30, but it has continued to be very successful for fledgling players. Indeed, the Balgove has even proved popular with adults who want to hone their short game – so much so that the Links Management Committee had to introduce a temporary special rule during the school summer holidays effectively stating that adults could play the Balgove only if accompanied by a child!

Ladies from the St Andrews Ladies' Golf Club putting on the Himalayas in the late 19th century.

THE LADIES' PUTTING CLUB OF ST ANDREWS

Women are known to have played golf at least as far back as the time of Mary Queen of Scots in the mid-sixteenth century. However, their appearance on the golf course was not always greeted with acceptance. 'Their right to play, or rather the expediency of their playing the long round is much more doubtful,' remarked Lord Wellwood as late as 1890 in the *Golf* volume of 'The Badminton Library of Sports and Pastimes'. 'If they choose to play at times when male golfers are feeding or resting, no one can object. But at other times – must we say it – they are in the way.'

Such Victorian misogyny was common at the time, with ladies' sports limited to the likes of croquet and archery. However, there were allies and forward thinkers in St Andrews. In 1867 some members of the R&A suggested that an out-of-the-way corner of the Links might be found on which their wives and daughters could practise golf. After all, even Lord Wellwood had stated:

Most ladies putt well, and all the better because they play boldly for the hole without refining too much about the lie of the ground; and there is no reason why they should not practise and excel in wrist shots with a lofting iron or cleek.

And so the pioneering St Andrews Ladies' Golf Club was born, limited to 100 ladies and 50 gentlemen associate members. The piece of land selected for play was located between the Old Course's 2nd tee and the start of the dunes on West Sands beach. Originally it was a short course, crossed by rutted fishermen's paths and pocked with whin and scrubby wasteland. The rule 'prohibiting the use of any club except a wooden putter' made bad lies very difficult to recover from. This led to the present, better-maintained lay-out of the putting course, also called the 'Himalayas' because of its hummocky nature as it rolls across the low sandhills. Subsequently, the Club changed its name to the Ladies' Putting Club in 1948.

The Club conducted its affairs from tents on competition days for the first 30 years of its existence, until 1898 when permission was given to erect a shelter. Nowadays, a small pavilion clubhouse is there for the convenience of members, and at which all members of the public – boys, girls, men and women – can pay a small green fee to play the course when it is open between April and October.

The weekly-changing route over the Himalayas is very popular with locals and visitors alike. The Club is a sociable one, and has regular putting matches against the town's other ladies' clubs, The St Rule and St Regulus, not to mention its yearly challenge against the past Captains of the R&A.

Perhaps we should allow one of the greatest golf course architects of all time, Dr Alister MacKenzie, who always thought that golf should be about fun, to have the last word:

The most interesting putting course I have seen is the Ladies' Putting Course at St Andrews. Even first class golfers consider it a privilege to be invited there and are to be found putting with the greatest enthusiasm from early morning till late at night. There the undulations are of the boldest possible type – large sweeping hollows rising abruptly four to five feet or more to small plateaus. A modern architect who dared to reproduce the boldness of these St Andrews undulations could hardly hope to escape hostile criticism.

The Himalayas – 'the undulations are of the boldest possible type.'

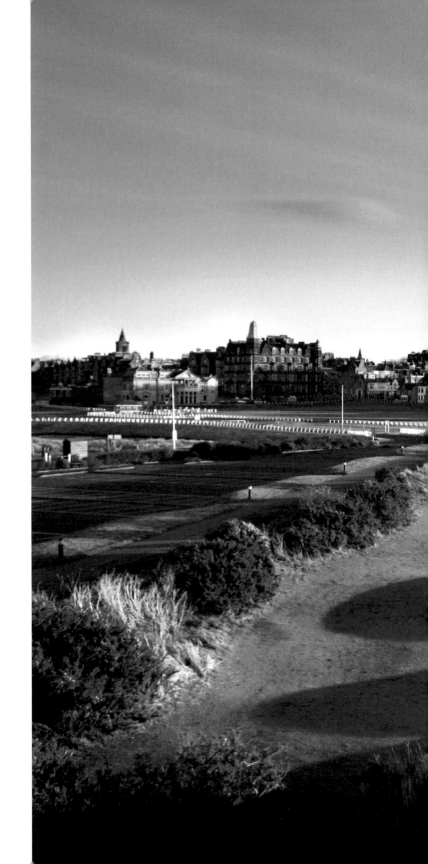

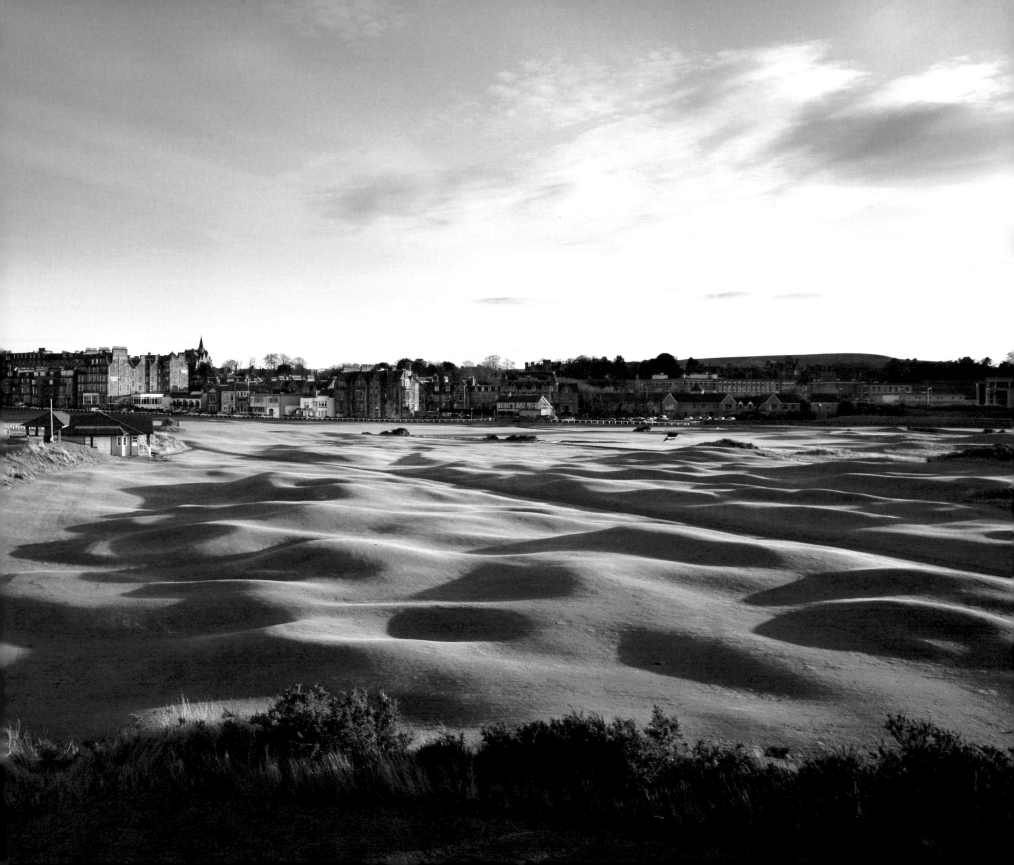

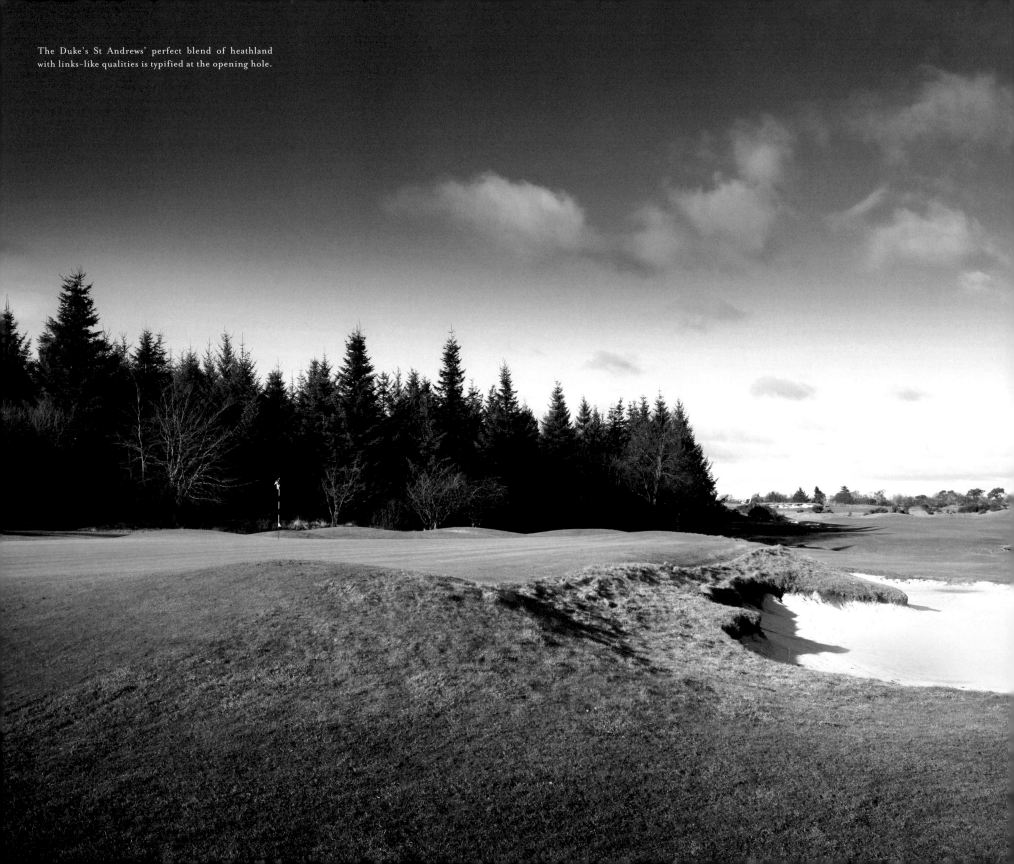

The Duke's St Andrews' perfect blend of heathland
with links-like qualities is typified at the opening hole.

THE DUKE'S ST ANDREWS

While visiting The Duke's St Andrews, one of the best places to be when you are not enjoying a post-round drink in the sumptuous clubhouse bar is standing on the high tee of the 13th 'Braw View' hole. Swivelling north at this par four, you catch glimpses of other fairways fanning out through patches of heather, punishing gorse and the indigenous woodland of Craigtoun Park. Adding to all this is a panoramic backdrop of St Andrews Bay, the ancient burgh, and beyond it the Angus coastline – a truly majestic site that endures in the memory long after the day's golfing is done.

Despite The Duke's position on a hillside about two miles inland, its existence is owed to the superbly situated Old Course Hotel beside the 17th 'Road' hole of the Old Course. The luxury hotel and spa, now owned by the Kohler family (who also run the Whistling Straits and Blackwolf Run golf venues), was built in 1968 to cater for an increasing number of golfers making their pilgrimage to the game's spiritual home. As a result of the government's privatisation policies of the 1980s, the hotel was sold by its owners British Transport to European Ferries before being passed on in 1988 to an international consortium called The Old Course Ltd, set up by the R&A, Robert Fleming & Co., trusts for the Rockefeller and Oppenheimer families, and the Japanese Seiyo Corporation.

In 1992, Kosaido Company Ltd joined the consortium, becoming a major shareholder and effectively running the hotel. It was Kosaido's enthusiasm and previous expertise in owning and managing golf courses that made the original Duke's Course possible. As a consortium, The Old Course Ltd recognised the importance of providing its hotel guests with guaranteed championship-standard golf. Given that all of the courses on the St Andrews Links are public and that tee times on the Old Course are subject to a lottery ballot, the only way for the consortium to fulfil this assurance was to build a course of its own.

Those arriving at The Duke's for the first time will quickly discern, given its setting in 330 acres of countryside, that the course is far from being a typical St Andrews layout – most of the holes appear to fall naturally across tree-lined ridges or through secluded glens. Yet it was carefully planned

and designed to complement those nearby classic coastal links hewn by wind and tide. The Duke's is a hybrid. Quintessentially heathland in character, it is an inland golf course with some classic links elements — the fairways pitch and roll, bunkers are rough-edged and jagged, fringes of gorse sway in the wind.

Fittingly, Peter Thomson was the man chosen to design the course, which opened in 1995. As Australia's greatest ever golfer, winner of five Open Championships — one of those at St Andrews in 1955 — and a member of the R&A, Thomson's architectural philosophy mirrors his own style of play that made him so successful on the seaside courses of the British Isles. At The Duke's, low running shots hit under the wind that harness the contours of the land are rewarded just as much as, if not more than, high targeted shots through the air. This was Thomson's first venture in Britain. His idea of offering a contrast to the nearby links courses while simultaneously bringing their challenges to an inland setting was carried out with pride. Importance was placed on making sure the course could be enjoyed by normal club golfers as well as catering for the challenge expected during international championships.

The golf course was built in the grounds of the Mount Melville estate, which had been home to several eminent members of the Melville and Younger families since the late seventeenth century, some of whom were also elected Captain of the R&A. In July 1995 the duty fell on another past Captain of that most venerable club, HRH The Duke of York, to play an inaugural round over the new Duke's Course with British Lions and former Scotland rugby captain Gavin Hastings.

The most recent development for The Duke's has been as remarkable as any of the previous ones in its history. Its owners felt that while Peter Thomson's course was very fine indeed, improvements in fairway drainage and some tweaks to the course were needed to fully capture a traditional heathland style reminiscent of the great courses that were built to the south-west of London in the early twentieth century. As a result, the gem that is The Duke's has been recut and newly polished. The craftsman was the American Tim Liddy, a protégé for almost two decades of the renowned golf course architect Pete Dye and a skilled designer of courses in his own right.

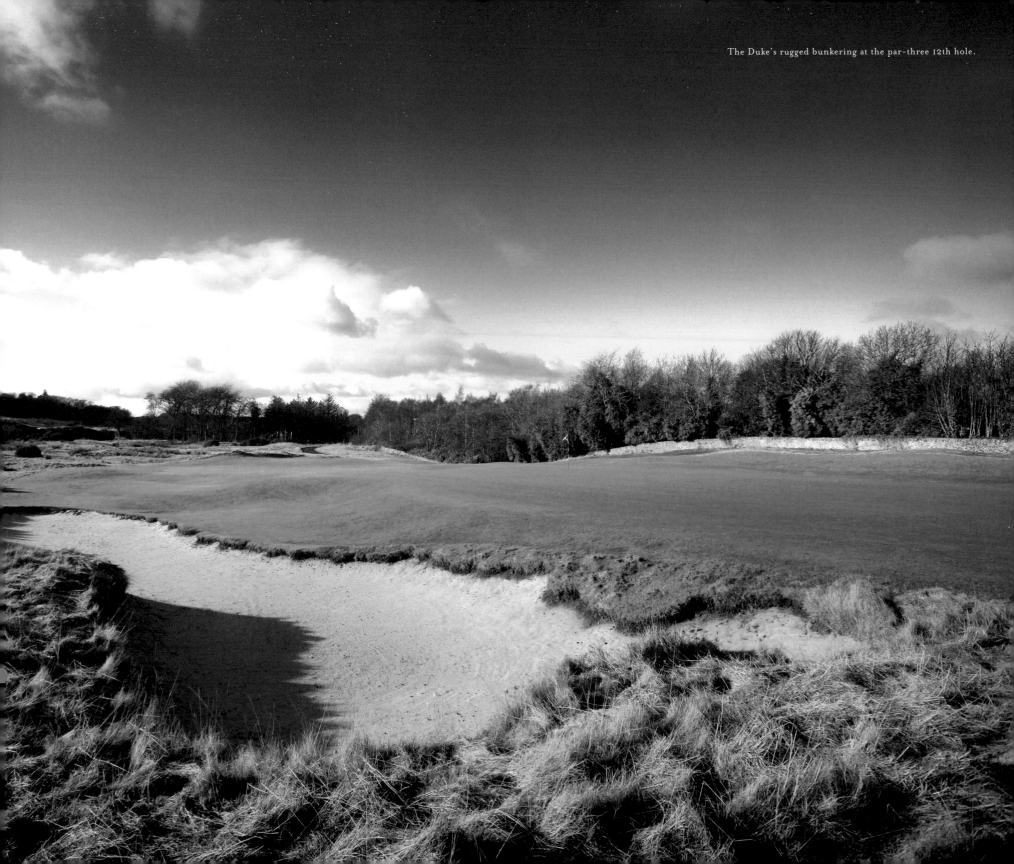

The Duke's rugged bunkering at the par-three 12th hole.

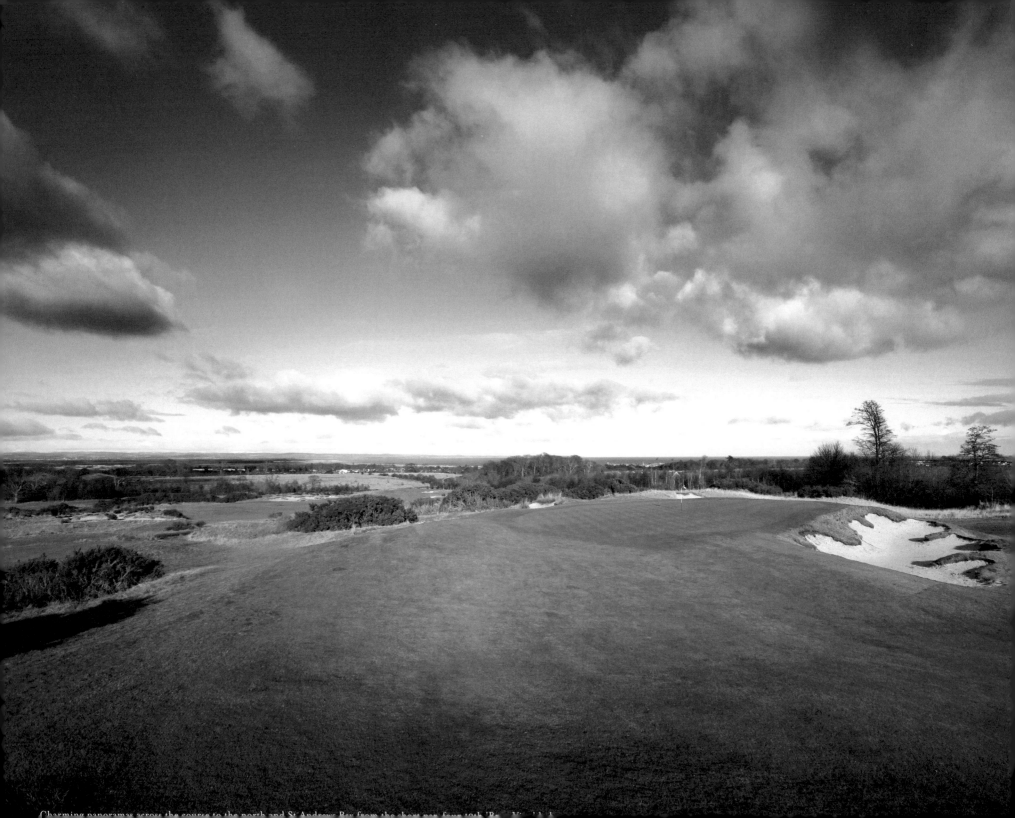

Charming panoramas across the course to the north and St Andrews Bay from the short par four 10th 'Res... Vi... A...

When Liddy began work in 2006, he stood on the course overlooking the beautiful Fife coastline and turned his head towards the town's links, using nature's example of course architecture as inspiration for the renovation. He made numerous significant bunker alterations, added three new closing holes and relocated the greens on holes 13, 14 and 15. Liddy's philosophy is one of allowing the course to 'grow out of the land' rather than imposing upon it. 'Centuries-old links golf has much to teach us ... this has become clear to me in recent years while working in Scotland on a renovation [The Duke's],' wrote Liddy in *Golfweek* magazine. 'An increased exposure to the "real" game has enabled me to see the relevance of links golf on a wider front.'

Thomson's course was already considered a modern-day classic by top golfers, having hosted the Scotland vs. France International Match (1997), the Glenmuir PGA Club Professional Championship (2000) and the Scottish Amateur Championship (2003). The result of Liddy's links-inspired revisions, of working with nature and not against it, is that The Duke's now possesses one of the finest heathland courses in the British Isles, with flexibility and challenge to appeal to golfers at every level.

From back tees the course measures a heavyweight 7,512 yards, but it starts with a relatively gentle, straightaway par five called 'Highland' that is open and dotted with gorse and heather, lending an almost moorland quality to it. The next couple of holes move into the trees before emerging out onto more exposed heathland again – an interweaving trend that continues for the rest of the round. There are a number of solid par fours on the front nine, many with wide undulating fairways such as the 4th 'Roundel' and 7th 'Denbrae', both favouring low links-style run-up approaches to their contoured greens.

The course's four par threes are well spaced throughout the round and all of them demand courageous shots in their own way. The uphill 8th 'Fair Dunt' and 12th 'Double Dyke' holes average over 235 yards in length from back tees and often require one more club than appears necessary. The 16th 'Melville' regularly plays with a prevailing crosswind to a green perched on a long, thin ridge with bunkers either side and a large swale in front. But perhaps the most pleasing and picturesque of the one-shot holes is also the

Golden eagle trophy in The Duke's clubhouse (detail).

then again at the monster 640-yard 11th 'Winthank' just before the two-tiered green, making getting home in two shots almost impossible for even the longest of hitters.

Coupled either side of the par-three 16th are four stern par fours each measuring over 430 yards from championship tees, keeping the quality and pace of the round high to the very end. Particularly pleasing is the 17th 'Strath', curving to the right around an expansive open strip of sand to a narrow green. An accurate drive is favourable here, given the large sentinel oaks either side of the fairway at the hole's halfway point, blocking wayward approaches. A gruelling uphill par four called 'Ice House' brings the round to a close, doglegging left around a few standalone trees. The hole is named after an old domed chamber that is still visible behind the 18th green, used to preserve ice and act as a cold store for perishable goods prior to the invention of refrigerators. It serviced Mount Melville House, a glorious Victorian mansion next to the clubhouse now known as the Duke's Residence. The building is being restored to its former glory for luxury accommodation thanks to the Old Course Hotel's Kohler family.

There is much to admire about The Duke's St Andrews. Despite being located just a few miles from some of the most colossal links golf in the world, its consistently solid layout across tumbling ridges and through gorse means it can hold its own as one of the premier inland courses in Britain. Visitors to St Andrews may not think of straying far from the traditional golf available along the coast, but The Duke's outstanding natural beauty and series of excellent holes make heading for the hills well worth the detour.

shortest, the 171-yard 3rd 'Denhead'. Enclosed by an amphitheatre of trees, the hole has sandy scrubland running from the tee almost all the way to the green, lending a rugged and naturalistic look reminiscent of the legendary 10th at Pine Valley.

At the turn, spectacular views open up over St Andrews town and the sea beyond, and a burn suddenly comes into play twice in quick succession: bisecting the fairway halfway down the 448-yard 10th 'Burn Brig' that doglegs sharply left;

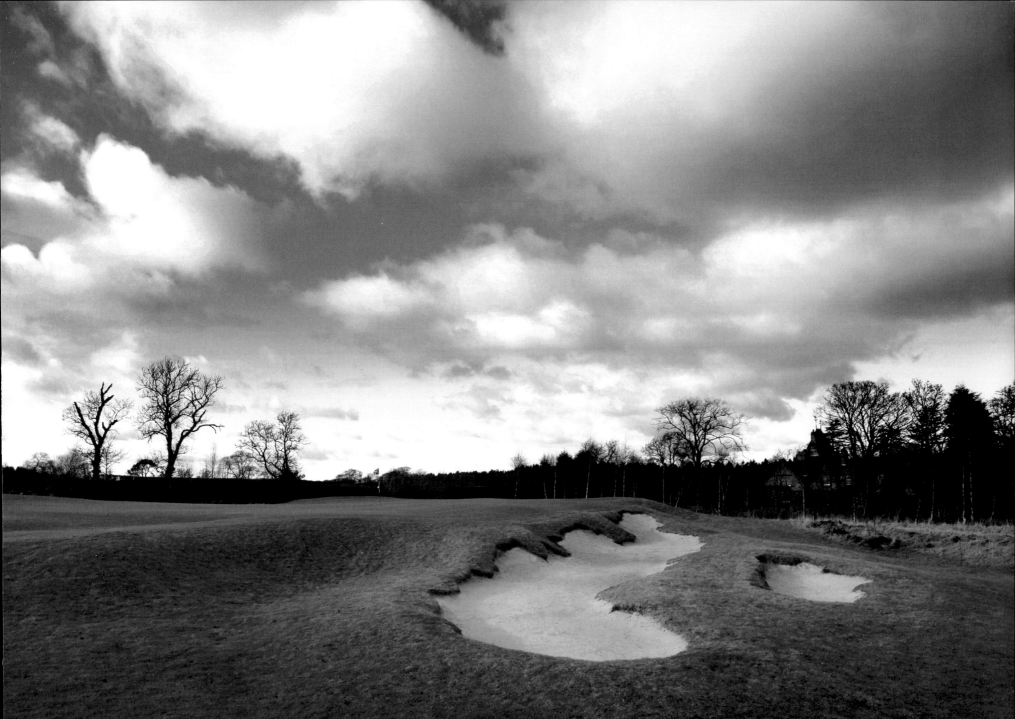

The Jigger Inn, next to the Old Course Hotel and the 17th 'Road' hole.

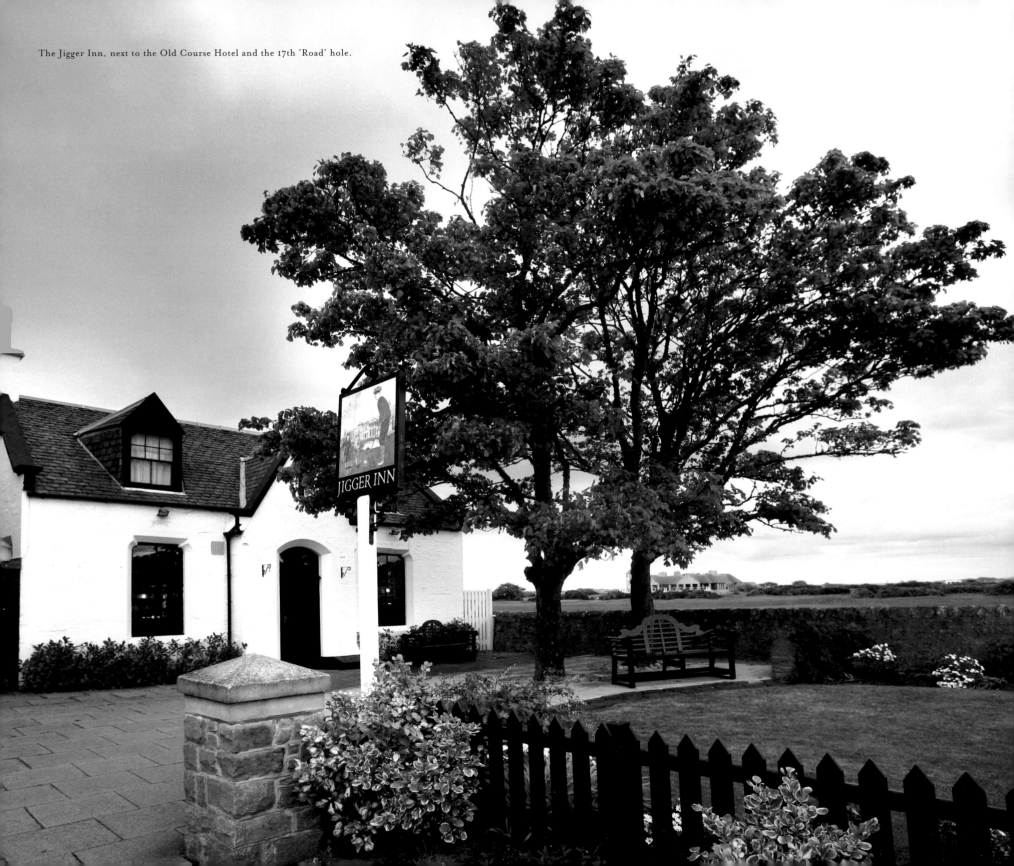

GOLF SHRINES:

THE JIGGER INN

Despite Scottish weather being ever unpredictable – one minute lashing rain and gale-force winds, the next dazzling sunshine and millpond calm – tired golfing spirits are certain to revive when walking through the front door of the Jigger Inn. Visitors find themselves quickly drawn in by the displays of sporting memorabilia, crackling fires and a superb selection of beers and whiskies. Antoinette, the Jigger's wonderful Irish landlady (who spoke only Gaelic and Latin until she moved across the Irish Sea as a young girl) ensures patrons' glasses are brimming and lends a friendly atmosphere that is so typical of the pubs of her birthplace.

Attached snugly to the Old Course Hotel that flanks the 17th 'Road' hole, the Jigger's small, whitewashed building dates back to the 1850s when it was a stationmaster's lodge. It was turned into a tavern after the railway closed in 1969 and the Jigger Inn soon became a favourite haunt for local caddies and golfers to meet and discuss the goings-on of the town and Links while sipping a pint of ale or a dram of something stronger. Incidentally, the name 'jigger' is a doubly appropriate term for the public house, as it means both an old narrow-faced iron golf club and a traditional barkeep's implement used for dispensing measures of drink.

Antoinette, landlady of the Jigger Inn.

In golf, 'the 19th hole' is a familiar phrase indicating somewhere to enjoy a drink after a game, usually the clubhouse bar or nearby pub. St Andrews has no shortage of these watering holes, but time after time – especially during Open week or other major tournaments when the whole town is abuzz – it is often the Jigger to which star players and their managers return after a day's work. 'It's a place where people, whoever they are, can relax and just be themselves,' explains Antoinette. 'Now, will it be a Scotch or an Irish whisky?'

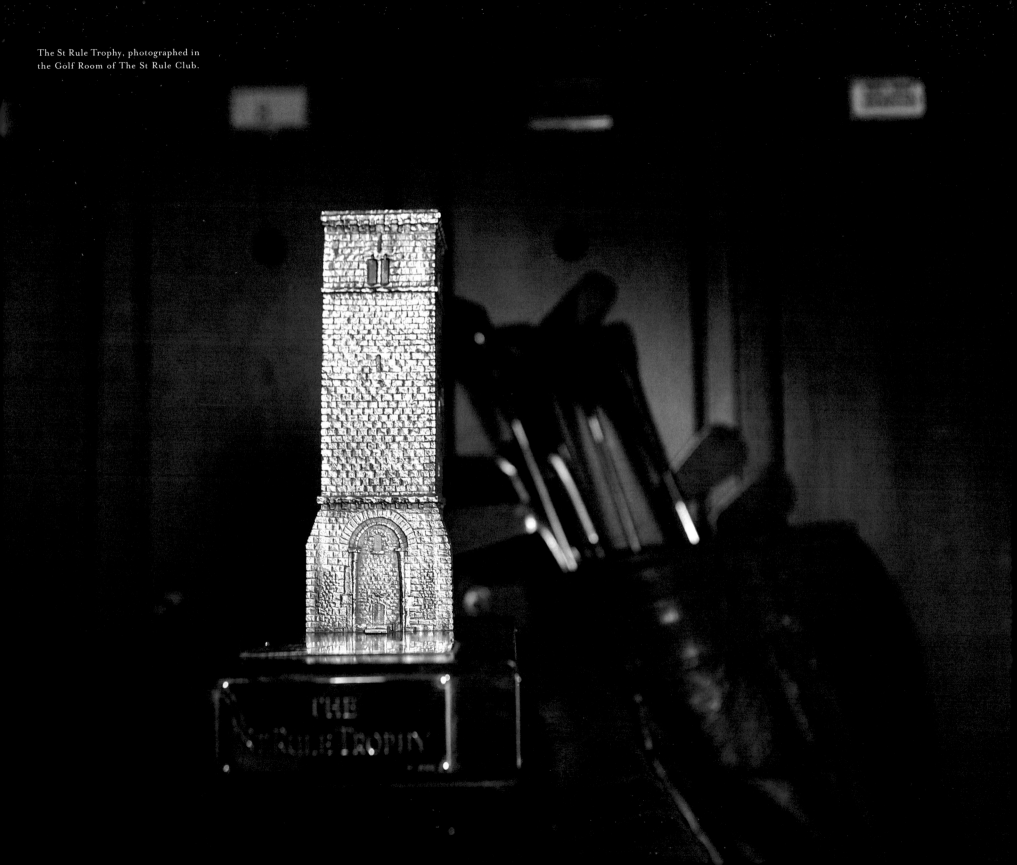

The St Rule Trophy, photographed in
the Golf Room of The St Rule Club.

THE ST RULE CLUB

In *For the Good of Golf and St Andrews*, the knowledgeable and absorbing book recounting the history of The St Rule Club, Marcia Ellen Julius explains the institution's unusual dual function. 'It's a social club which provides fine dining and amenities, offers its members bridge competitions, travel opportunities, book exchanges, cultural excursions, and a series of fascinating winter talks. Just like London ...' she wrote. 'But wait! Its members also play for golf medals on a monthly and yearly basis, hold a number of club competitions throughout the season ... Oh, it must be a golf club. So which is it? The answer is: it depends whom you ask!'

The reason for this changeable perception about St Andrews' elegant ladies' club stems from its rich, varied and occasionally turbulent history. The St Rule Club was founded in 1896 as a private social club for ladies belonging to the upper echelons of Fife, and indeed British, society — families of wealth, rank and title whose men held influence both at home and across Queen Victoria's glorious British Empire. Indeed, besides the five ladies who made up the Club's provisional committee, it contained four senior gentlemen of the R&A. Among them was Captain George Boothby, who

served as Honorary Secretary in St Rule's fledgling years before a permanent female Secretary was installed in 1898.

Starting life as 'The Ladies' Club, St Andrews', it wasn't long before a more distinctive name was called for by the 188-strong membership. St Rule was an obvious choice, given the presence of the St Rule Tower rising among the town's Cathedral ruins. (As we've seen, this remnant of an ancient chapel takes its name from the fourth-century Greek saint who, legend has it, fled to Scotland and deposited the bones of Saint Andrew in St Andrews.) And so the Club now had a suitable name and a keen social membership. But this was St Andrews, and where there is St Andrews there is golf.

The key figure in St Rule's early golfing days was Agnes Grainger, one of the Club's founding members who towards the end of 1898 proposed 'that a Golf Club be formed in connection with the Club'. Grainger quickly mustered up management and handicap committees, as well as a sizeable membership (entrance fee: 2s 6d; annual subscription: 10s). She put in place a largely independent working constitution of rules, competitions and bylaws that was adopted without challenge. There were now two clubs united under one roof: The St Rule Golf Club and the purely social St Rule Club.

The St Rule clubhouse.

There was, however, a problem with golfers' wish for autonomy — the constitutional prerequisite that members of the golf club had to be admitted to the social club first. This tie meant that it was extremely difficult to admit promising young golfers who were not eligible for social membership because of their age and the restrictively high entrance fees. Despite growing tensions between the two factions, Agnes Grainger pressed on with building the golf club. She organised weekly matches on the Old Course and in 1901 presented the Captain's Challenge Medal when she assumed the mantle of playing Captain. A breakthrough in relations came the following year, when The St Rule general committee finally allowed certain ladies to be admitted to the golf club without first being made social members. The golfers' cause was further strengthened at that time by joining the Ladies' Golf Union and instituting a Scottish Ladies' Championship.

By 1904, Agnes Grainger had been made President of the golf club and her ever-growing influence gave her enough momentum to found the Scottish Ladies' Golfing Association. She and many other members from the golf club of St Rule worked tirelessly for the next half-century to make Scotland an international force in ladies' golf. In 1952 the social and golfing factions were amalgamated into The St Rule Club that exists today — a cohesive social club with a strong golfing section.

Two years after its formation in 1896, The St Rule Club had managed to secure the use of its present clubhouse at number 12, The Links. This elegant four-storey Victorian townhouse has possibly the best views of any club in St Andrews, looking over the Old Course's 18th green, the R&A

clubhouse and straight down the windswept beach of West Sands. Walking around its rooms, you can sense plenty of golfing pedigree. A light and elegantly appointed first-floor drawing room holds a trophy cabinet displaying just some of the Club's beautiful trophies, including the distinctive St Rule Trophy, a silver version of the Cathedral's historic St Rule Tower in miniature. It is played for each spring over the Old and New courses in open strokeplay competition and has been attended by some of the world's top international women amateurs since its maiden year in 1984.

On the ground floor is the Golf Room, which used to be Old Tom Morris' golf shop. In 1906, two years after Morris had retired as Keeper of the Greens and been made Honorary Professional to the R&A, he downsized his business and put the premises up for sale. The Club was quick to make the purchase to cater for its expanding golfing contingent and turned the space into a generously proportioned dressing room with lockers. Around the walls now hang honours boards showing past Captains and winners of the Golf Scratch Medal competition, going right back to the inauguration of the golfing section of the Club. Between them hangs the Keith Mackenzie Centenary Trophy, a hickory-shafted wood that was presented in the golf club's centenary year – 1998 – by President Barbara Mackenzie, in memory of her husband, a past Secretary of the R&A.

In addition to its championship golf and club competitions, St Rule competes widely with St Andrews' other clubs across the Links. There are biannual mixed foursomes events, a spirited rivalry with the St Regulus Ladies' Golf Club for the Herkless Trophy and with The New Golf Club for the Bob Jessiman Trophy, and also a very popular putting section within the Club that plays weekly from spring to autumn.

The St Rule Club has had strong ties with championship golf ever since Agnes Grainger established the Scottish Ladies' Golf Championship in 1903 and co-founded the Scottish Ladies' Golf Association the following year. As well as winning major amateur events, in the early years St Rule members were helping to mobilise and administer the game. One of the first ladies to endow the Club with the stuff of legend was Elise Kyle, who at eighteen won the 1909 Scottish Ladies' Championship and did it again the following year. Her sisters Ida and Audrey were also fine players, the former winning the Victory Cup Competition while the latter represented Scotland internationally from 1923 to 1925.

Since the Second World War, many names have become synonymous with St Rule and high sporting achievement, but none more so than Marigold Speir and Lady Angela Bonallack. Speir joined the Club as a nineteen-year-old in 1952, having moved to St Andrews from the south of England. 'St Andrews was a place where you could talk golf with everyone,' she remembers. Within two years she made her first appearance in the Scottish Championship, and won the event at Troon in 1957. The Scottish golf writer Frank Moran wrote a press report of the victory, which is quoted in the Club history:

Miss Marigold Speir, 24-year-old member of the St Rule Club, St Andrews, has broken through what, in no uncomplimentary sense, I may dub the 'iron curtain' of established reputations to win the Scottish Ladies' Championship. In the 36-hole final she defeated Mrs A.M. Holm, five times winner of the title and twice winner of the Ladies' Open Championship.

In the decades that followed, Marigold went on to represent Scotland internationally on three occasions before later serving as a team selector and a senior official of the Scottish Ladies' Golf Association and also the Ladies' Golf Union, which moved into the top two floors of the St Rule clubhouse in 1976 before later relocating a short walk up the road to The Scores. For St Rule, she was twice elected Captain and has also served as its President.

Lady Angela Bonallack came to St Rule in 1983, having moved to St Andrews to join her husband Sir Michael Bonallack, one of the game's all-time great amateurs, when he assumed the role of Secretary to the R&A. She was a hugely accomplished player herself, twice winning the English Ladies' Championship as well as several illustrious European titles, playing on the Curtis Cup team six consecutive times, and for years taking part in the Home Internationals. 'During these years I had four children,' said Lady Angela. 'Of course, I was married to a very good golfer and our lives have always been surrounded by golf, but the family came first. Before we came to St Andrews we lived in an old rectory tucked away in Essex, along with horses, dogs, cats, ducks, and chickens ... it was a very active life: I could never do things by halves!'

While the Club's luminaries look back on their achievements, other new and extremely talented players are carrying on the winning tradition. Julie Hall joined The St Rule Club in 1996 when she was appointed Secretary of the Ladies' Golf Union. She was part of the Curtis Cup team five times, a regular member of the Vagliano, Espirito Santo and Commonwealth teams, and held the unparalleled record of once being the British, English, Australian and Spanish champion simultaneously. Catriona Matthew, an honorary member of St Rule and past winner of the St Rule Trophy, won the 2009 Women's British Open at Royal Lytham & St Annes, the first Scot in the history of the championship to do so.

St Rule's membership has stayed at a steady level of around 300 for a number of years. There is no junior golf section, but many younger ladies earn their spurs through golfing interests and general deportment at the nearby St Regulus Ladies' Golf Club before being put forward for St Rule membership later on.

A slow walk around St Rule's clubhouse provides a good history lesson, with its trophies and golfing memorabilia, and evokes an aura of well-connected exclusivity. Yet the modern Club carries its lineage lightly and is remarkably unpretentious and friendly. It is a very social club, with a busy kitchen serving good food and home-baked cakes and biscuits at the regular Golfers' Coffee Mornings. A Christmas Fayre is held each year to raise money for various charitable causes. During the St Rule Trophy many members volunteer to ensure the competition runs smoothly, arranging scoreboards, officiating card marking and keeping players fed and watered from the clubhouse kitchen.

The St Rule Club is a living monument to the ladies who, well over a century ago, banded together and rose beyond the social boundaries of their time with steadfast determination. The camaraderie is still clearly evident today on a visit to the refined clubhouse, where there is much coming-and-going and frequent ripples of laughter. 'Whether you serve on the Management Committee, or you bring honour to the club as a champion golfer, or you're an ordinary member who faithfully pays your annual subscription,' ends Marcia Ellen Julius in her history of the Club, 'you are part of the future of St Rule just as you are part of the past.'

THE ST RULE TROPHY

Year	Winner	Country	Year	Winner	Country
1984	P. Hammel	U.S.A.	1999	L. Nicholson	Scotland
1985	K. Imrie	Scotland	2000	V. Laing	Scotland
1986	T. Hammond	England	2001	A. Coffey	Ireland
1987	J. Morley	England	2002	H. Stirling	Scotland
1988	C. Middleton	Scotland	2003	K. Borjeskog	Sweden
1989	C. Middleton	Scotland	2004	L. Stahle	Sweden
1990	A. Sorenstam	Sweden	2005	N. Edwards	England
1991	A. Rose	Scotland	2006	K. Caithness	Scotland
1992	M. Wright	Scotland	2007	M. Reid	England
1993	C. Lambert	Scotland	2008	K. Walker	Scotland
1994	C. Matthew	Scotland	2009	K. Walker	Scotland
1995	M. Hjorth	Sweden			
1996	A. Laing	Scotland			
1997	K. Rostron	England			
1998	N. Clau	Spain			

Clockwise, from top left: Mrs Penny Newman-Carter, Vice-Chairman, and Mrs Almer Robertson, past Captain of St Rule, in the first-floor drawing room; honours boards hanging in the Golf Room at St Rule; Marigold Speir, one of St Rule's most distinguished golfers, holding The St Rule Trophy; The St Rule Trophy winners' board.

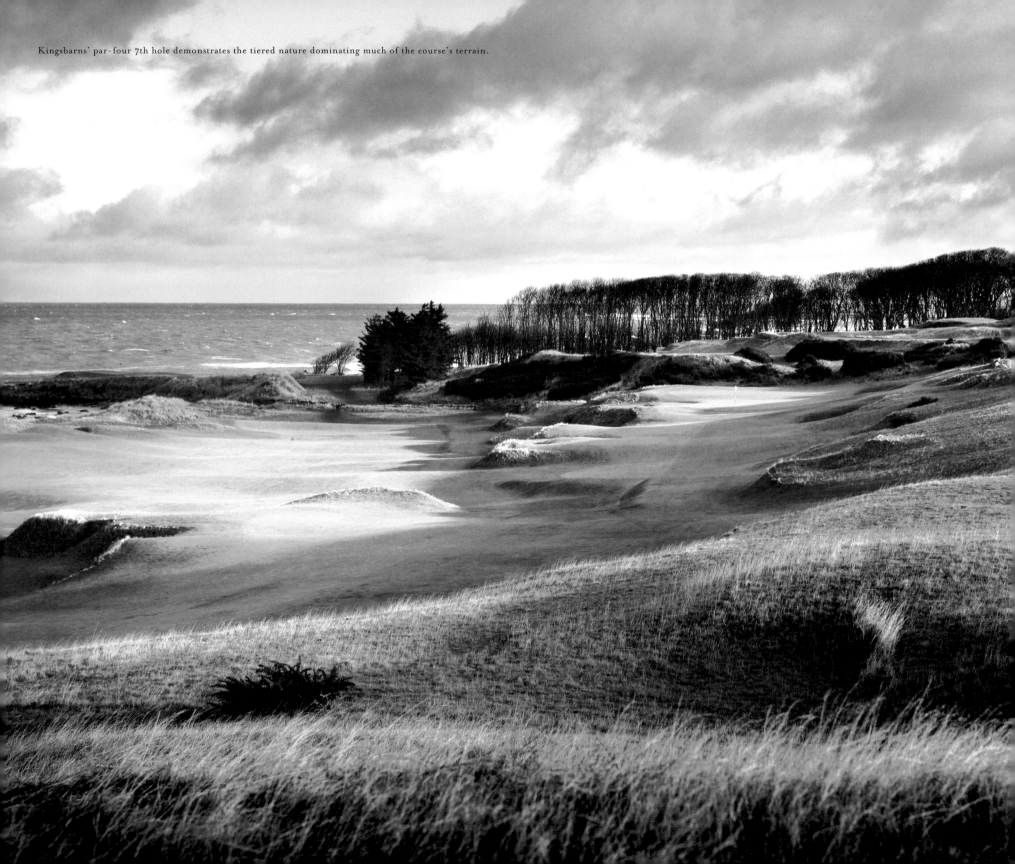

Kingsbarns' par-four 7th hole demonstrates the tiered nature dominating much of the course's terrain.

KINGSBARNS GOLF LINKS

The village of Kingsbarns lies six miles south-east of St Andrews on the coastal road that runs along the eastern shore — or East Neuk — of Fife towards the fishing town of Crail. ('Neuk' is the Scots word for nook or corner.) Turning off the road through low, discreet gates, visitors to Kingsbarns Golf Links drive a short distance up a narrow track before suddenly emerging at the clubhouse — a neat gabled building made of local stone with a simple Doric portico entrance. From here, atop the highpoint of the property, a panorama of the golf course unfolds, sweeping along a mile and a half of craggy beach with the North Sea as its backdrop.

When Kingsbarns opened to the public in 2000 it was an instant international success, making it straight into many pundits' top twenty golf courses of the British Isles. Steve Carr, a seasoned writer reviewing the course for *Golf World* magazine in 2002, was captivated: 'It looked natural and as God-only-made as any golf course on earth … if push came to shove I could happily play this beauty for the rest of my days. It's a welcome addition to our links heritage.'

Kingsbarns is both old and new. While the present course is still relatively young, golf has been played on the site as far back as the 1790s when local merchants and lairds drafted articles to form the Kingsbarns Golfing Society on land leased from the Cambo Estate. Much like their Royal and Ancient peers along the coast in St Andrews, these gentlemen of the Society would meet, wine and dine in high gambling spirits, arranging wagers and matches to be played while wearing their distinctive blue coats, a de facto uniform of the time.

For over half a century the Society flourished as a small, highly sociable group. Then in 1850 came the first setback when the links was given over to the Cambo Estate's tenant farmer for tillage. Golf then was still of an age when it was merely seen as a whimsical Scottish pastime. There was more money to be made from the land by farming it. With the lack of a suitable home the Society stopped functioning until 1922, when Lady Erskine of Cambo realised that golf's growing popularity as a sport among locals and tourists made it worth reviving the land for play. The Society was reformed as Kingsbarns Golf Club and a new nine-hole course was subsequently built by Willie Auchterlonie, the legendary St Andrews-born Open champion and Honorary Professional of the R&A.

A later blow came with the Second World War, its turmoil spilling over onto the course as yet again the land was cleared for agriculture, this time by the Ministry of Defence as part of the war effort. Golf at Kingsbarns was thwarted once more, the Club disbanded, and a remarkable stretch of coastline lay under crops and livestock for most of the twentieth century.

In the 1990s, the American course designer Kyle Phillips laid eyes on the dormant golfing property overlooking the sea and immediately understood its potential. 'Being familiar with some of the new courses in the St Andrews area, I had confidence that something greater could be achieved,' said Phillips. 'At that point in my career as a golf course designer, I was up for the challenge.' Phillips realised that with vision, hard work and patience he could turn what was essentially featureless farmland into a winning combination of rolling dunes, crumpled fairways and unparalleled sea views. His foresight and passion was shared by Californian real-estate developers Mark Parsinen and Art Dunkley, who financed much of the project and who have gone on to support other notable successes like Castle Stuart near Inverness.

Kingsbarns was a great opportunity for Phillips to make his name as an architect, the moment having come shortly after he left Robert Trent Jones Jr.'s practice to strike out on his own. Parsinen was consulted on every aspect of the design and his input garnered at every stage. A huge amount of earthmoving was undertaken in order to create the large sand dunes that run in a series of ridges parallel to the shoreline, and which now

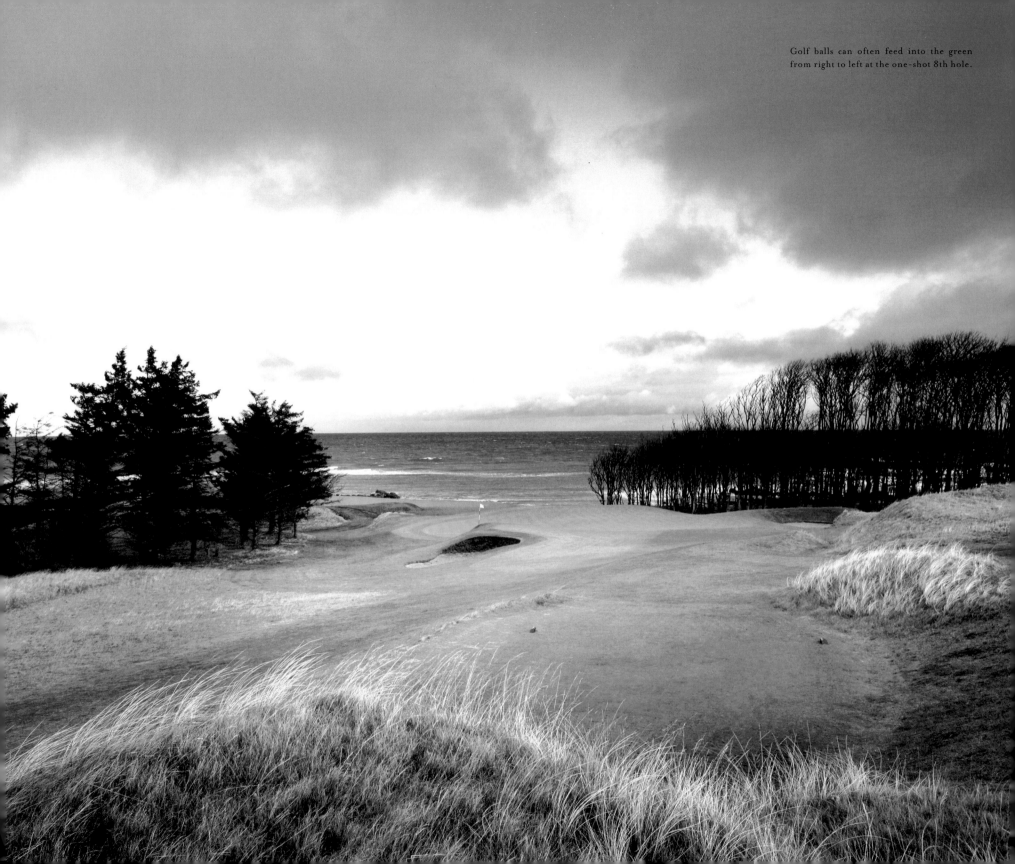

Golf balls can often feed into the green from right to left at the one-shot 8th hole.

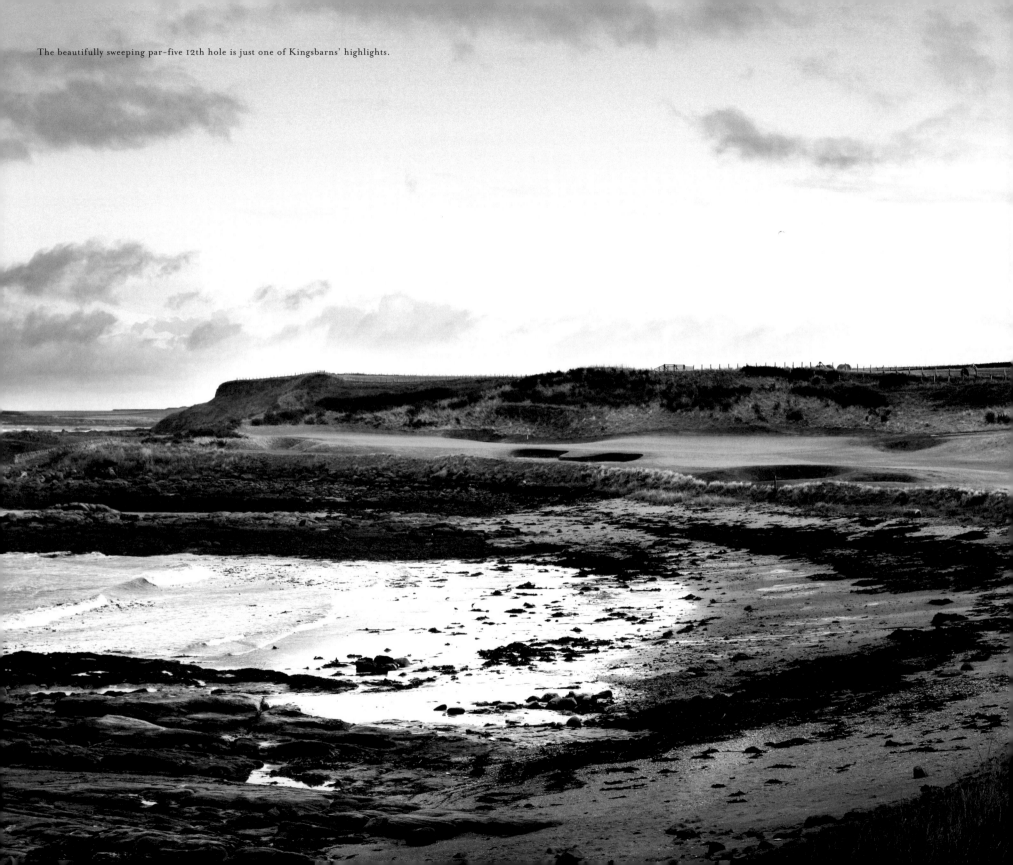

The beautifully sweeping par-five 12th hole is just one of Kingsbarns' highlights.

spectacularly frame many of the fairways and greens. Phillips stabilised unruly hillocks with native marram and fescue grasses, growing them rugged and wispy to make it look as if the site had been sculpted by wind and sea over aeons. The next stage in the creation process was to carve beautifully warped fairways into the dunes like tiered steps rising from the sea, ensuring that water views could be clearly appreciated from every hole. The result is one of the most authentic-looking modern golf links ever made.

When playing the course there is not only the spectacular scenery to reflect on, but also eighteen golf holes where strategy is at the heart of the design. 'Almost on every hole a braver line rewards an easier approach, while safer drives can leave more awkward shots over swells and dips,' continued Steve Carr in his appraisal of the course shortly after it opened. 'For every flag position, there is an optimum place to attack it from, and the greens are huge, leaving plenty of room for pin positions and endless head-scratching.' Indeed, the putting surfaces swell with tough, well-thought-out contours that make three putts a distinct possibility during a round, should there be any lapse in concentration.

The opening hole starts high by the clubhouse, running 400 yards from back tees, curving right and downhill to the sea. The way is strewn with deeply revetted bunkers, introducing golfers to the links' gnarled, windswept characteristics. This is followed by four extremely attractive holes that run out alongside the sea and back in a narrow loop. At the par-four 6th a real sense of the plateau nature introduced by Phillips to the land is noticeable as the round enters what was the location of the original course played over by Kingsbarns Society in the eighteenth century. The hole is not a long one at 337 yards, but the green is angled so that it favours approaches from the right-hand side of the fairway. For those brave enough to attempt it, a good drive must carry over two fairway bunkers. Any bailing out short and left leaves a tricky blind shot to the green.

After a long and testing par-four 7th hole comes some respite at the pretty par-three 8th. Of all the course's short holes – the others being at 2, 13 and 15 – this is probably the least dramatic. However, the back nine more than makes up for it with a number of standout holes. The monster 600-yard 12th hugs the adjoining beach, its fairway arching around to the left and demanding three carefully considered shots if the green is to be

reached in regulation. Then comes the shortest hole on the course, the charming 13th with a tiny shelf green cut into the side of a rocky mound that is devilishly hard to hold. Another great but very different par three is met at the 15th, which plays across the corner of a small sea inlet to a green set atop a jutting promontory. Often played into the prevailing wind, this hole measures every inch of its 185 yards from back tees.

As the round draws to a close the final three holes provide a very strong finish. The par-five 16th almost plays like a mirror image of the 12th, curving around the bay on its way home with the sea to the right. Behind and to the right-hand side of the green a deep burn (unearthed during the course construction process) gathers overhit approach shots. Both the penultimate and final holes are solid par fours, each measuring around 440 yards from back tees. The 17th plays to a raised putting surface that often palms away anything badly struck into a deep greenside bunker. A similar story awaits at the last hole, although after a blind tee shot it is water and not sand that factors in the approach. The 18th green sits perched on a ledge that is skirted all around its front by a sheer drop into a waiting burn. Such an unequivocal feature at the finish can stir all sorts of emotions in the golfer, calling for decisive action, whether aggressive or defensive, when there is a card in hand or a match is being concluded.

'When I first presented the Kingsbarns site to the eventual developers, I was able to convey to them my vision of transforming the fields at Kingsbarns into a course that would look and feel like a natural seaside links,' explains Kyle Phillips about his creation. Just a year after opening, Kingsbarns was chosen by the European Tour to complete the trinity of courses that co-host the annual Alfred Dunhill Links Championship, alongside two ancient and colossal links: the Old Course and Carnoustie. In 2008 the course further hosted two major amateur matches between Great Britain and Ireland and Continental Europe: the men's St Andrews Trophy and the boys' Jacques Léglise Trophy. Having such a string of prestigious tournaments to its name after only one decade of existence reflects the great esteem in which Kingsbarns is held and the success of what Phillips has managed to achieve – a modern layout that can stand comfortably alongside the greatest linkslands in the world.

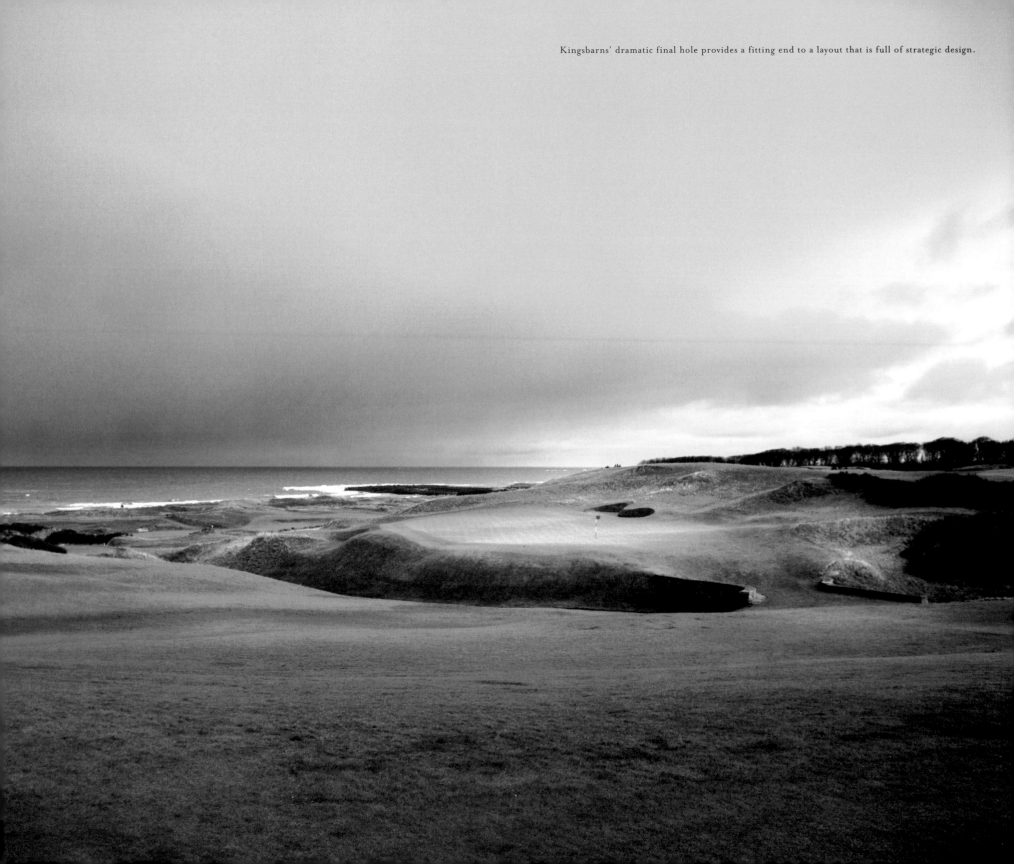

Kingsbarns' dramatic final hole provides a fitting end to a layout that is full of strategic design.

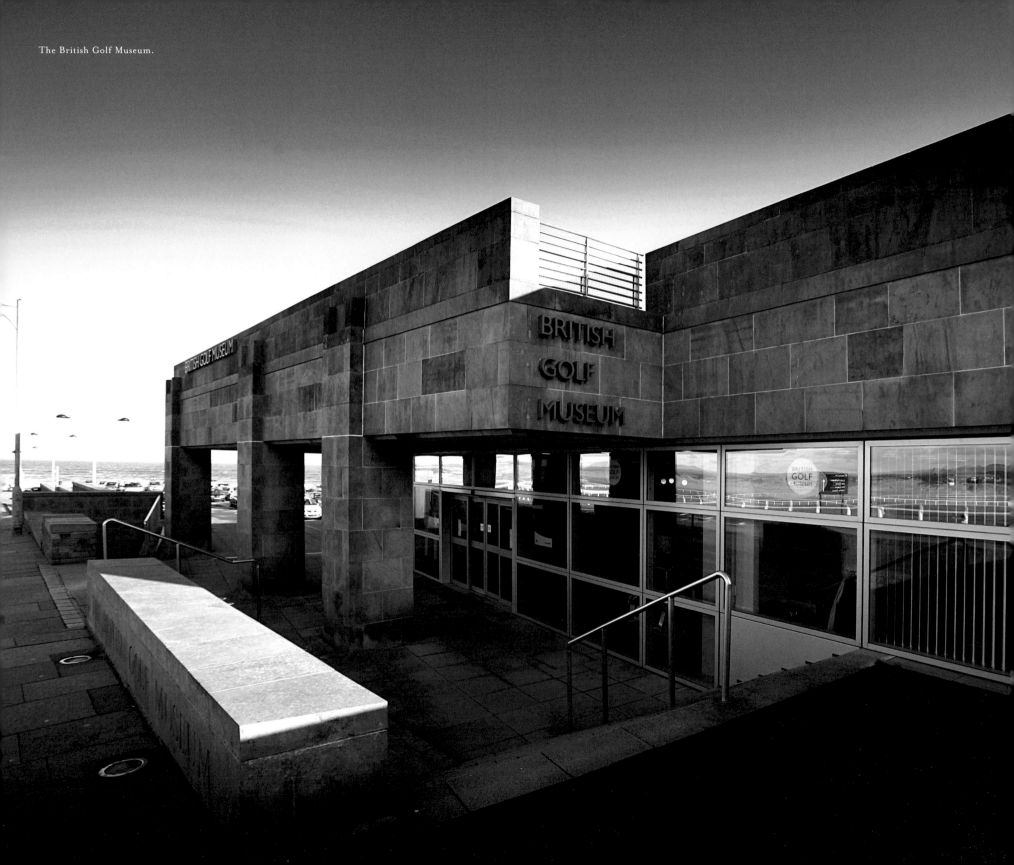

The British Golf Museum.

THE BRITISH GOLF MUSEUM

In 1864 the R&A empowered a committee 'to collect such articles relative to the game as they may think necessary and to make such arrangements to render them accessible to members as may be consistent with their due preservation.' Within twenty years a collection of artefacts – described as a 'cabinet of curiosities' – was on display in the clubhouse. As the years passed the size and scope of the collection increased, to the point where by the 1960s the R&A was running out of room to house its heritage. Something needed to be done.

Midway through the 1980s, the R&A decided that a charitable trust should be established to build and run a British Golf Museum. Opening in 1990, the unobtrusive low-lying building nestles behind the R&A clubhouse on Bruce Embankment. Its location – at the very heart of the Home of Golf – is as fitting as that of its neighbour.

The inside of the museum is a fine monument to the history of the game that it safeguards. A spacious entrance hall and gift shop contains bronze hand castings that capture the club grips of several modern-day Open champions such as Arnold Palmer, Gary Player and Jack Nicklaus. To the right, behind a reception desk, stand helpful museum staff to direct or inform visitors and dispense exhibition tickets. In pride of place, and keeping an eye on the general comings and goings, is a large statue of Old Tom Morris.

The adjacent network of well-proportioned rooms moves linearly through the story of golf, from its very earliest forms to the present day. Informative wall placards complement display cabinets containing some of golf's most precious jewels, either belonging to the R&A or on loan from other golf club collections around the world, including early wooden clubs and clubheads stamped by their makers; 'featherie' golf balls like those made by the first golf professional Allan Robertson; various items of golf clothing and regalia; and glistening championship medals and silver cups. The names engraved into these amateur and professional trophies – both men's and ladies' – include nearly every great golfer throughout the ages, an unparalleled representation of golfing legends that stirs up wonder and admiration.

Then there is the Edwardian art gallery, containing splendid portraits and landscape works produced towards the end of

the nineteenth century, when the national interest of golf exploded and clubhouses and courses became a recreational nexus for various levels of society. For certain spells the gallery hangs possibly the most famous golf painting in the world – *The Golfers* by Charles Lees, R.S.A. – on loan from its permanent home at the Scottish National Portrait Gallery. The huge painting, completed in 1847, portrays a match in progress, played over St Andrews Links during the R&A Annual Meeting. It contains a crowd of more than 50 figures, many of them notable golfers, huddled around a hole, wondering if a putt will drop and whether they will win or lose their bets. The masterpiece captures the true spirit and atmosphere of the early Scottish game.

The future of golf never stands still, and nor does its past. The British Golf Museum is continually updating its collection, unveiling fascinating and timely installations including displays exploring the history of golf in the Olympics and the role that the R&A plays in governing and main-taining equipment standards at a time when the industry's technological advances seem to know no bounds. In 2010 the museum celebrated its twentieth anniversary, happily coinciding with the 150th anniversary of The Open Championship. Stepping outside from the captivating labyrinth of golfing history and back into the bracing sea air that rattles across the ancient Links leaves one in no doubt that the heritage of the game is in safe hands.

The Golfers: A Grand Match played over the Links of St Andrews on the day of the Annual Meeting of the Royal and Ancient Golf Club 1841 by Charles Lees R.S.A., completed in 1847. There are over 50 figures in the immense work. The match paired Sir David Baird of Newbyth and Sir Ralph Anstruther of Balcaskie against Major Sir Hugh Lyon Playfair of St Andrews (seen putting) and John Campbell, Esq. of Glensaddel.

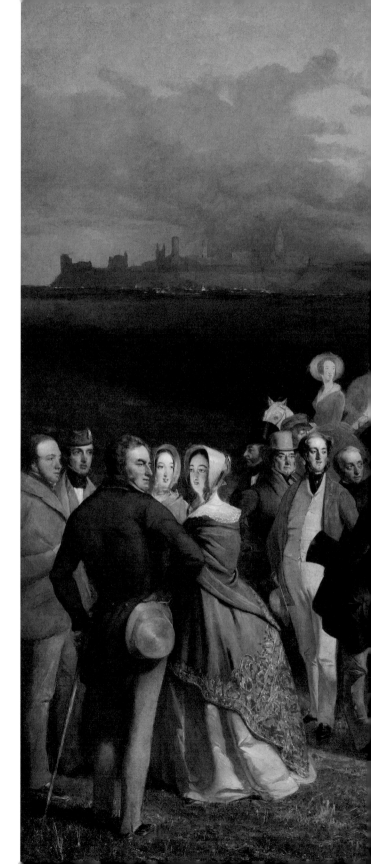

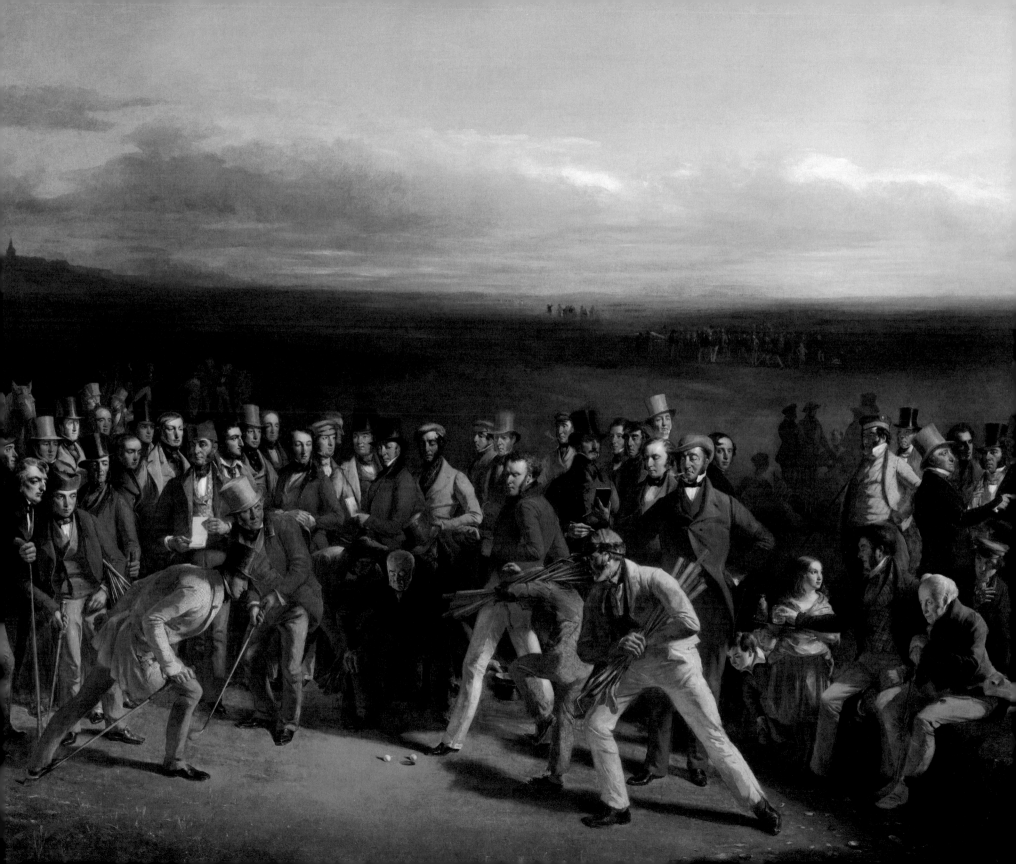

The distinctive trophy for The New Golf Club's Old Tom Morris Memorial Tournament.

THE NEW GOLF CLUB OF ST ANDREWS

It may sound macabre, but one of the most notorious happenings in the history of The New Golf Club of St Andrews was the tragic death of its first honorary member. The passing of any dear friend at a golf club is a sad event among his or her peers. When that person happens to be Old Tom Morris, Keeper of the Greens on St Andrews Links and 'the Nestor of Golf', whose bearded, wizened image came to epitomise early Scottish golf for many people, it makes international headlines.

Old Tom had been presented with honorary membership of The New Club at its constitutional meeting held in March 1902. Shortly afterwards, a fine townhouse on Gibson Place looking over the Swilcan Burn and the 1st and 18th holes of the Old Course was purchased for use as the Club's headquarters. Old Tom would regularly visit to have an afternoon drink with his old friends and discuss the news from the town and the Links over a few wee drams. On a bright Sunday, 24 May 1908, he walked to the clubhouse after Communion at the Holy Trinity Church. Settling into his usual leather window seat in the members' lounge, Tom let the spring sunshine warm his 87-year-old bones. After a while he rose from his group and made his way down a dark corridor to the lavatory,

the door of which is next to the cellar door. On hearing a cry, Tom's friends rushed over to find that he had fallen down the cellar stairs, cracking the base of his skull and bringing the life of one of golf's most noble characters to an end.

The time leading up to The New Golf Club's founding was a turbulent stage in St Andrews' golfing history. At the end of the nineteenth century, golf had exploded in popularity across the globe and the game's hub was the Kingdom of Fife. Aside from the gentlemen golfers of the R&A who had a superb clubhouse, the town's other players belonged to several individual clubs, none of which had premises of their own. Instead they relied on meeting halls or drinking parlours. Competitions were played on fixed days in the calendar and the annual dinner or prize-giving ceremony was usually the only time during the year when most members congregated.

The matchmaker who brought many of these clubs together came, surprisingly, from out of town. Herbert Montague Singer was a Victorian renaissance man. He arrived in St Andrews a butler and ended up owning and running a very prosperous boarding-house empire. A popular, energetic figure with huge mutton-chop whiskers, he came to be affec-

tionately nicknamed 'Monkey Brand' (after a patent shoe polish of the time whose tin lid bore the trademark image of a whiskered monkey). Despite being a poor golfer he was a man of action, founding the town's cycling and cricket clubs, running the Fife Golf Association and the Telegraph Cup (a precursor of the Scottish Amateur Championship) and playing a key part in the foundation of the Scottish Golf Union.

Singer's contribution to The New Golf Club and St Andrews golf cannot be overstated. He orchestrated The New's founding by bringing together over 100 members from several homeless clubs to the council chambers in February 1902 to agree on a course of action, and he also found premises on Gibson Place that would become the clubhouse.

The record does not state who first suggested the Club's name. Many of the golfers meeting that February already belonged to the roaming Thistle Golf Club and wanted to retain that moniker. Others proposed, ironically in retrospect given his later death there, that it should be called The Tom Morris Golf Club, which the Grand Old Man modestly insisted against. Whatever the precise events on that day, it was eventually rationalised that as the R&A was sometimes referred to as the Old Club, then a new golf club should be called The New Club. The official opening was set to coincide with the coronation of King Edward VII. Fittingly, and one suspects with good humour, it was decided that the first Captain of the Club should be one Edward King, teacher.

The needs of the town's amalgamated and growing golfing fraternity spurred progress. The garden belonging to the clubhouse had been built on to make the large members' lounge with bay windows overlooking the Old Course and

wooden lockers lining the walls, where Old Tom so enjoyed sitting. The clubhouse continued to expand over the years through the purchase of neighbouring properties, and it now boasts a sprawling complex with prime Links-side frontage including a billiard room, a first-floor reading room with views across St Andrews Bay, and a large dining room.

The New Golf Club has had its fair share of great players and characters. Many of its golfing glories are enshrined on its championship and team boards, and its collection of silver trophies and medals is equal to that of many older clubs. Two early amateur stars were Fred Mackenzie and Willie Greig. Mackenzie won the Telegraph Cup three times, played twice for Scotland and won the R&A Gold Medal (Strokeplay Championship of the Links) eight times. In the inter-war years, Capes and Murray collected a trophy at the 1922 Scottish Foursomes Championship; another pair, Boumphry and King, followed suit at Gleneagles in 1924 and retained the title at Troon the following year. But perhaps the most kudos should go to Ken Greig, who won the 1930 Scottish Amateur Championship at Carnoustie.

The list of honorary members at The New Golf Club is a small but extremely distinguished roll of Open champions. Only four were elected in the first hundred years of the Club's existence and never more than one at any time. After Tom Morris (1902) came Sandy Herd (1938), Bobby Jones (1959) and Arnold Palmer (1973). Palmer has always been particularly proud of his association with the Club and makes a point of visiting whenever he is in St Andrews.

'We have over 1,600 male members who play over the St Andrews Links and there is always stiff competition with the

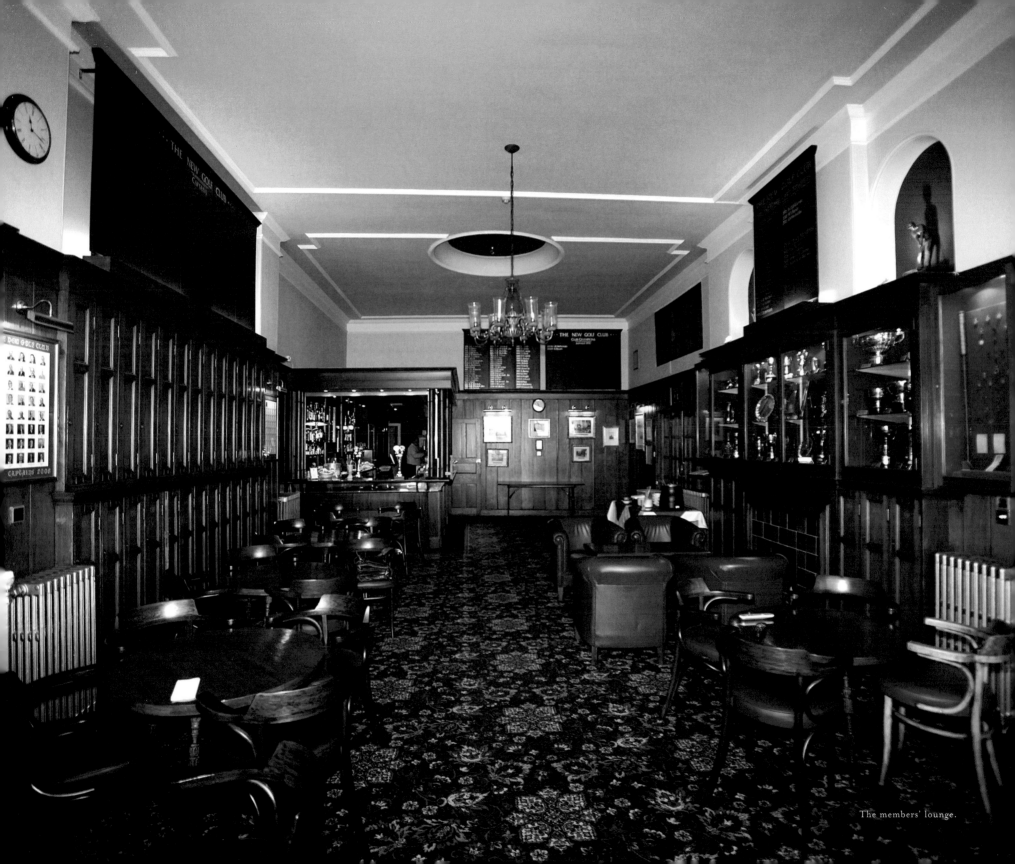

The members' lounge.

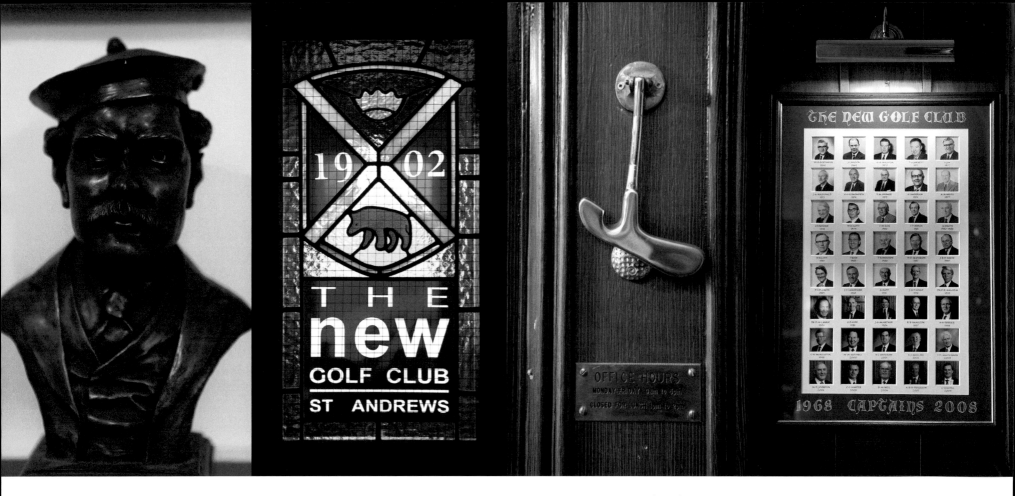

Clubhouse interior details, from left to right: bust of Willie Park, Jr.; stained glass detail of the Club crest; Secretary's office door (detail); past Captains of The New Golf Club, 1968–2008.

other clubs in town, as well as further afield,' says J.J. Simpson, a retired Glasgow police officer who moved to St Andrews and is now Junior Convenor at the Club. 'The social side of things is also very lively. One of our past Captains, Jim McArthur, organised a superb Burns Night Supper last year to celebrate the 250th anniversary of the great poet. The mixed lounge was absolutely packed and the evening entertainment went on well into the night.'

How can one sum up The New Golf Club? From its inception it was a dynamic institution, mirroring the characteristics of its founder Herbert Montague Singer. Any visitor walking around the clubhouse or talking to its members today will still see that same vitality in its social and golfing calendar. Its playful Latin motto *Semper Nova* or 'Always New' seems to encapsulate things perfectly.

Opposite page: J.J. Simpson, Junior Convenor of The New Golf Club.

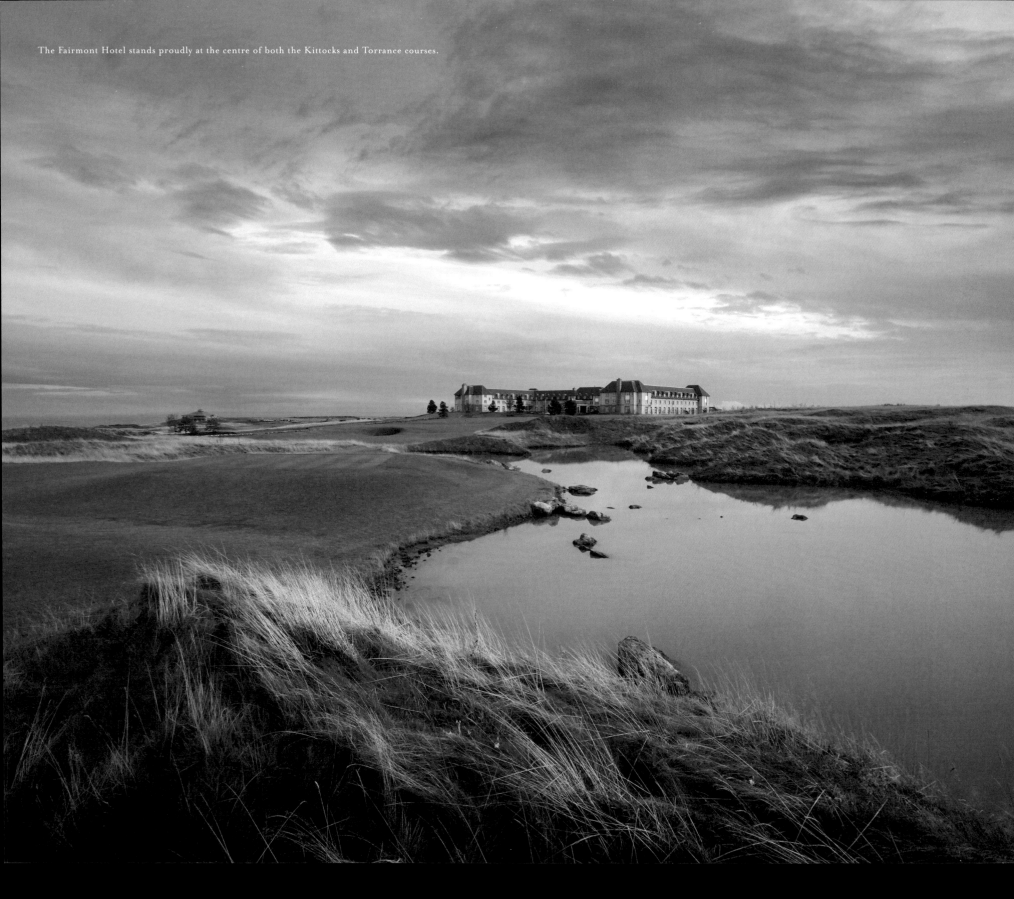

The Fairmont Hotel stands proudly at the centre of both the Kittocks and Torrance courses.

FAIRMONT ST ANDREWS: THE KITTOCKS AND TORRANCE COURSES

The Fairmont Hotel lies a few miles to the east of St Andrews on a spectacular cliff-top summit, encircled by two championship-quality golf courses with stunning panoramas of the River Tay estuary, the North Sea and the medieval skyline of St Andrews. Both courses – the Kittocks and the Torrance – are considered among the finest in Scotland, and when they opened around the turn of the new millennium they firmly established the Fairmont as a must-play destination for serious golfers.

Originally called the Devlin Course, the Kittocks was designed by the legendary Gene Sarazen and was refurbished and renamed in 2008. Like Kingsbarns, it has a slightly American feel while still honouring the traditions of links golf, with two double greens, numerous deep pot bunkers and a desolate windswept aspect. Rather than a traditional out-and-back routing, the Kittocks loops towards the sea, tantalising players by turning inland and then returning to the water. This arrangement enables the course to fully take advantage of the natural properties of the landscape and provide a rich, varied golfing challenge thanks to the incorporation of Kittock's Den (a deep ravine that cuts through the course) and the stunning shoreline.

The first four holes start innocently enough, providing wide, firm fairways that move through an ocean of fescue grass and around water features. When the par-five 5th is reached, however, the full splendour of Kittocks is visible as its fairway rolls over the land with the fabulous backdrop of St Andrews Bay. The hole itself is a classic, stretching across the edge of Kittock's Den to a slightly obscured green that seems almost to float on the sea. Closer inspection reveals the putting surface to be an island of green beautifully surrounded by bunkers. Immediately following is the par-three 6th, deceptive in its brevity. With club selection often tough to judge, many lofted approaches are buffeted by the wind and end up in one of the three greenside bunkers.

Other thrills include the course's signature hole, the long par-four 15th which doglegs towards a hanging cliff-edge green. It plays downhill to a target that is built on top of an old Iron Age fort and protected by numerous surrounding greenside bunkers. It is a fantastic golf hole and also the start of a wonderful climax to the round. The 17th and 18th were formerly a part of the Torrance Course before they were innovatively altered to become the finishing holes of the Kittocks in 2008. The 17th bounds along cliffs that plummet 100 feet down to the sea on the right, while to the left is a picturesque blend of mounds, gorse and sand. The par-four 18th is similarly pleasing, and a notable finishing hole, as its dogleg fairway is flanked on both sides by water hazards.

The Torrance Course was designed by golfing greats Sam Torrance and Gene Sarazen. When he first saw the property, Sarazen was so taken by the potential of the site that he likened it to Pebble Beach in California. The layout that the two men created has harnessed the essence and feel of links golf in a cliff-top location, with wide rolling fairways, strategic approach angles and large contoured green sites that present golfers with a variety of interesting short-game challenges. Gary Stephenson was asked to redesign the course in 2008, and he continued the excellent work by remodelling eight of the holes, building up new tee box areas and incorporating revetted bunkers throughout. The natural contours of the land and dramatic coastal setting make the course very special – in the words of Sam Torrance, it is 'without doubt a must-play for those making their golf pilgrimage to St Andrews, the Home of Golf'.

As well as being beautiful, the Torrance is also challenging, and is used for regional Open Championship qualifying events. It opens with a lovely, sweeping dogleg left, where players must avoid a stream that runs across the middle of the fairway before it passes up by the front left-hand side of the green. As with the rest of the course, the opening green is often hard and true, and is renowned for being quick. Water hazards appear at

The perched 17th green on the Fairmont Hotel's Kittocks Course.

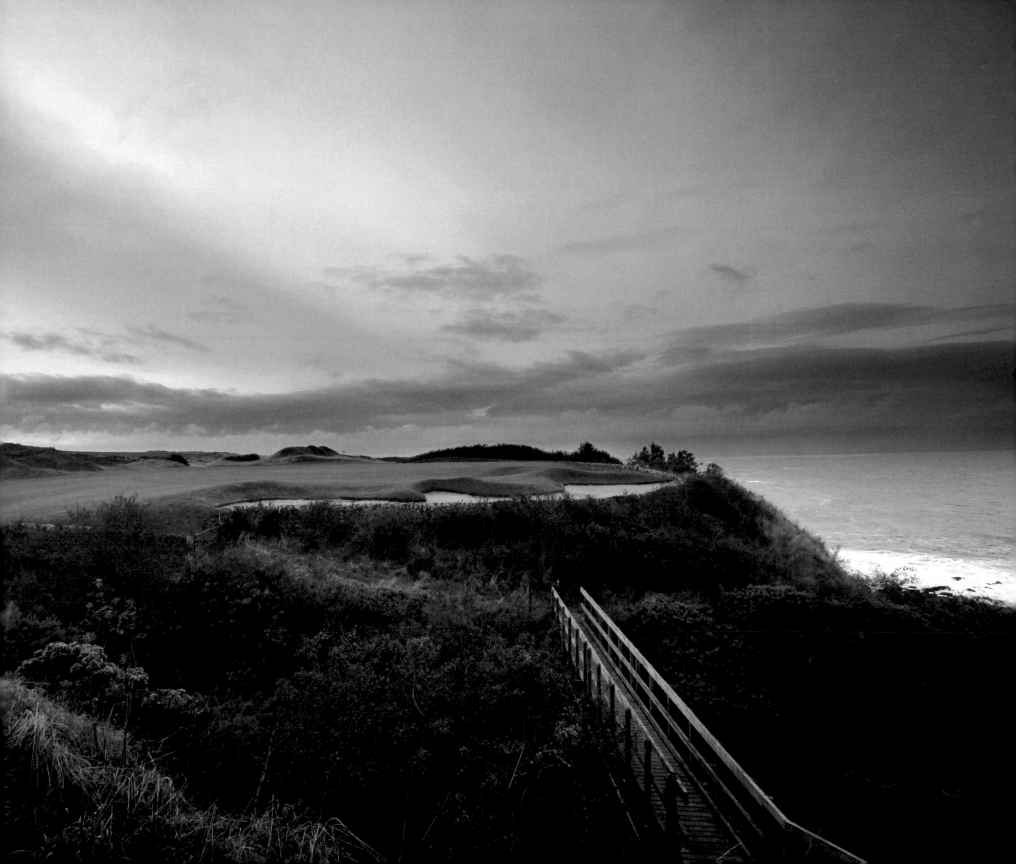

intervals on other parts of the front nine, most notably at the 587-yard par-five 3rd, where water encroaches onto the right side of the fairway to catch a pushed tee shot and a dangerous burn lurks before the green to swallow any under-hit approaches.

Undoubtedly the highlight of the Torrance Course is its compelling closing stretch, as every yard from the 16th hole to the clubhouse is a pleasure to play. The 16th tiptoes to the edge of the sea in such a way that it appears that any over-hit approach might tumble down the cliffs and into the water. From the par-three 17th there are majestic views of the course and the large green has ingenious contouring, making three putts a distinct possibility even after a good tee shot. The final hole is a gloriously long and undulating par five that plays every inch of its 561 yards. The hole tempts better players to go for the green in two, but with tough bunkers placed in very hittable areas it is also quick to penalise inaccuracy.

Thanks to its enviable location, the Fairmont Hotel is blessed with two very exciting courses, each with a strong and distinctive identity that caters to numerous golfing preferences. It was always going to be a tough job to build two layouts that did not languish in the shadow of St Andrews' established linksland. However, Sarazen and Torrance, and more recently Stephenson, have done a fantastic job, ensuring that all 36 holes have come to be regarded as among the best on the Fife coast, an achievement that is to be both admired and respected.

Shades of North Berwick's famous stonewalled 13th hole are evident on the Torrance Course.

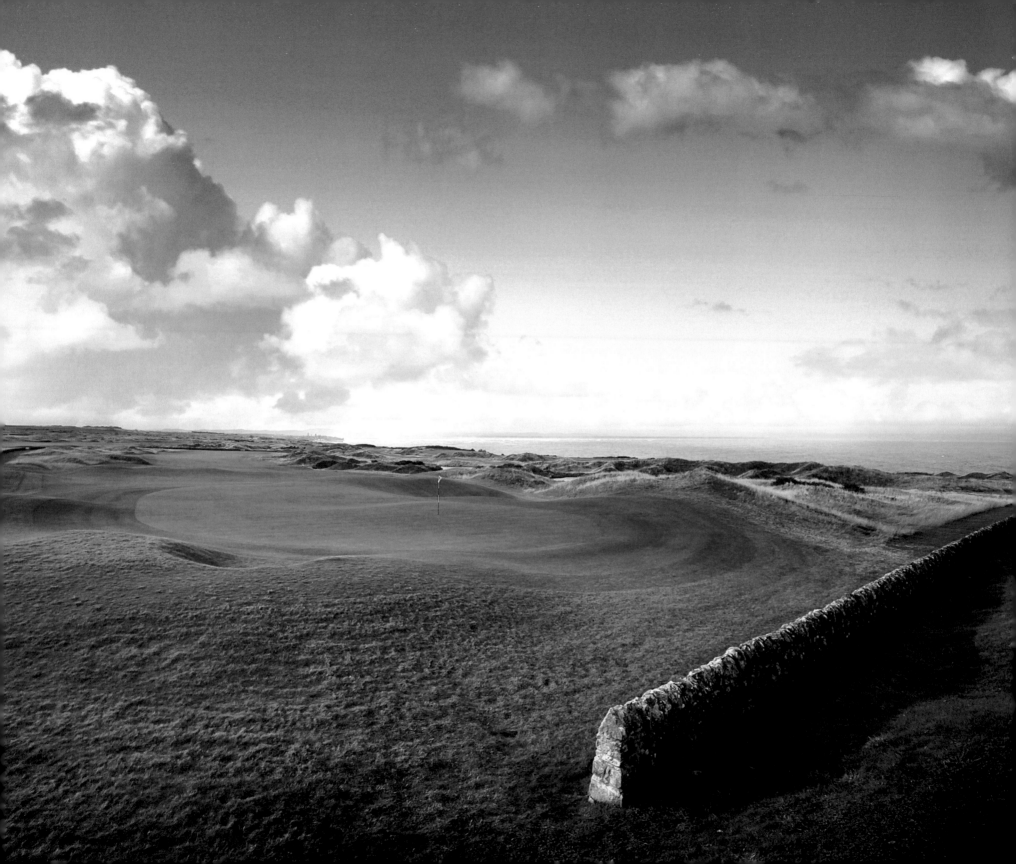

ST. REGULUS LADIES
GOLF CLUB

THE ST REGULUS LADIES' GOLF CLUB

St Regulus Ladies' Golf Club and The St Rule Club are the two most prominent ladies' clubs in St Andrews, and both of their names come from the same source. As mentioned, Saint Regulus or Saint Rule was a Greek monk of the fourth century who, according to Scottish legend, fled to St Andrews with the bones of Saint Andrew and deposited them there. Despite this similarity there is also a simple but important distinction between the clubs. 'St Rule is a club for ladies with a golfing section,' says Sylvia Dunn, a resident of St Andrews since 1962 and incumbent Captain of St Regulus. 'We are a golf club.'

The enthusiastic golfing institution of St Regulus was founded in 1913 by 25 former pupils (known as FPs) of Madras College, St Andrews, calling it the Madras Ladies' Golf Club. Together with some of their other friends they held initial meetings in the school, but had to find a new headquarters in 1916 when the building was requisitioned by the military for the First World War. The Club slipped into hibernation during the conflict and when it awoke in 1919 it was reconstituted and renamed St Regulus Ladies' Golf Club.

The rector of the school was less pleased with the regrouping, however, and announced his wish to cease any association with the Club, as it contained far more 'friends' than it did Madras FPs. Before a new clubhouse could be found, committee meetings were often held standing by the 18th green of the Old Course. After much searching and migrating from rented room to rented room throughout the 1920s, 1930s and 1940s, the Club finally purchased the present clubhouse in 1949, thanks to carefully managed funds and interest-free loans from members and friends. By 1955 St Regulus had paid back all loans and owned the freehold of the building, providing some financial security.

Unlike its slightly older sister The St Rule Club, which is based in an elegant four-storey Victorian townhouse overlooking the Old Course, the St Regulus clubhouse is a more modest affair. The discreet grey stone house is located one road back from the Links, almost directly behind

THE RAMSAY SALVER
ST. REGULUS L.G.C.
* 1982 *

Silver trophy detail, from The Ramsay Salver.

The St Andrews Golf Club and The St Rule Club. After purchase, the property was sub-divided and the two upper floors sold off, with the Club retaining the ground floor and cellar. Recently refurbished, the ground floor holds a smart lounge and kitchen, while the rooms below contain lockers, changing rooms, a cloakroom and the Secretary's office. For the convenience of golfers heading out onto the Links, at the back of the clubhouse a narrow wynd cuts through the surrounding buildings and out onto the Old Course.

There are around 300 members in all, ten of whom have been awarded honorary life membership either because of their many years of service to the Club or for golfing prowess – Krystle Caithness, a member of the 2008 Curtis Cup team, is the newest and youngest life member. The active core of the Club is centred on the local community and has a very full competition calendar throughout the year. Matches against the other St Andrews clubs are played over the town's courses and there are various home and away events against clubs from across Fife.

The thing that strikes visitors most about St Regulus is that it is a very harmonious, welcoming club without cliques and with a wide range of ages. There is a small but talented junior section, while older ladies can become Putting Members – an internal constituent of St Regulus that holds weekly summer putting competitions over the Himalayas against the Ladies' Putting Club and The St Rule Club. During the harsh Scottish winters, members can keep their eye in and the chill

Sylvia Dunn, Captain of St Regulus Ladies' Golf Club (2009–10).

out with a fortnightly indoor putting competition and coffee morning held at the clubhouse.

Ladies join St Regulus to play golf and be with friends and, indeed, treat the Club as an extension of their own homes. This relaxed atmosphere of golfing fellowship and friendliness is almost palpable to visitors. Long may it continue.

AUCHTERLONIES OF ST ANDREWS

On the corner of North Street and Golf Place, just a short pitch-shot away from the Old Course's 18th green, stands Auchterlonies of St Andrews, an establishment that has been a maker and purveyor of fine golf clubs since 1895. On the surface it looks like a large and very finely stocked modern golf shop: row upon row of the latest high-performance drivers and irons; shelves stacked with comfortable clothing and shoes; a variety of Old Course merchandise from ball markers to umbrellas. But at the back of the store a door leads to a small, fully operational workshop complete with vice and work-bench. Lining the walls from floor to ceiling are individual hickory-shafted golf clubs, both antique and newly crafted.

'The clubs in this room go to collectors or hickory-playing enthusiasts from all over the world,' says Ian Smith, a genial young Scot who has recently risen from his apprenticeship to take over the running of the workshop after long-standing club-maker Brian Nicholson retired. 'Japan and America have a large representation, but there are also a growing number of British golfers who like to try out the original implements of our game. The trick is to swing slower!'

Auchterlonie is a notable family name in St Andrews golf. Laurie Auchterlonie, born in 1868, had great success in America, competing in eleven US Opens with several top ten finishes, including a win in 1902 at Garden City Golf Club, New York. He died in St Andrews aged 80. Laurie's younger brother, Willie, was born in 1872 and was himself no small talent on the golf course, winning The Open Championship at Prestwick in 1893 aged just 21. He only ever played with seven clubs, carried in the same bag that he used in the 1890s up until his death in 1962. But it was the making of clubs, not the swinging of them, for which Willie is best remembered. Starting his working life as an apprentice club-maker, Willie's reputation grew to that of a master craftsman.

Together with his other brothers David and Tom, Willie founded D&W Auchterlonies in an era when the club-making industry was booming in St Andrews. Hugh Philp was producing clubs in his workshop on what is now Links Road prior to 1836, while his nephew Robert Forgan carried on the tradition after Philp's death in 1856. Two years later, Forgan moved into new premises next door and in 1866 Old Tom

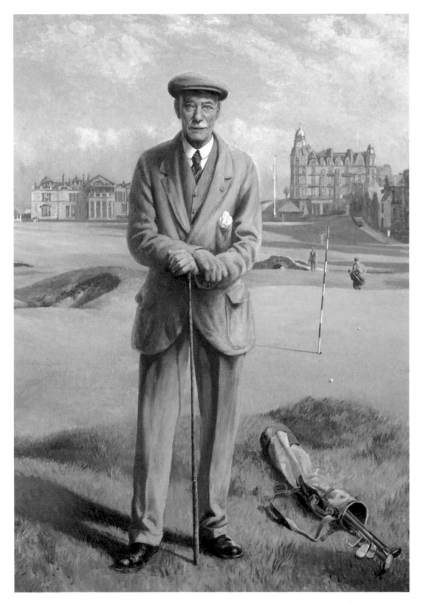

Willie Auchterlonie, 1893 Open champion, Honorary Professional to the R&A, 1935–63, master club-maker.

Morris bought the Philp site. By the end of the 1890s, Auchterlonies had joined the elite ranks of these renowned club-makers in supplying equipment to many of Britain's top golfers, thanks to the quality and precision of their workmanship. Willie Auchterlonie passed his club-making gift on to his son Laurie (named after his US Open-winning uncle), and both generations continually served the R&A as Honorary Professionals for more than 50 years.

Up until the late 1920s, when steel-shafted clubs were legalised, club-makers would buy iron club heads from cleekmakers and fit them to wooden shafts, with hickory being the regular material of choice. Wooden-headed clubs such as drivers, brassies and spoons would be personally hand-carved and shaped. Lead weights were also inserted before being filed flush with the slender clubface to achieve the right balance. There was a genuine art, some might say an alchemy, to producing quality clubs in this way.

For golfers playing the game today, it is obvious that club development has come a long way since the late 1800s. Individuality quickly gave way to the production line and the range of materials now used by club manufacturers can create lighter, increasingly performance-enhancing equipment. Stainless steel, titanium, graphite, tungsten and carbon fibre all spelled the end for most traditional club-makers years ago. Only a handful of such artisans still survive around the globe, but it is comforting to know that cocooned in a small St Andrews workshop, people like Ian Smith are keeping both the heritage of the game and the noble name of Auchterlonies alive by crafting their own clubs for discerning consumers.

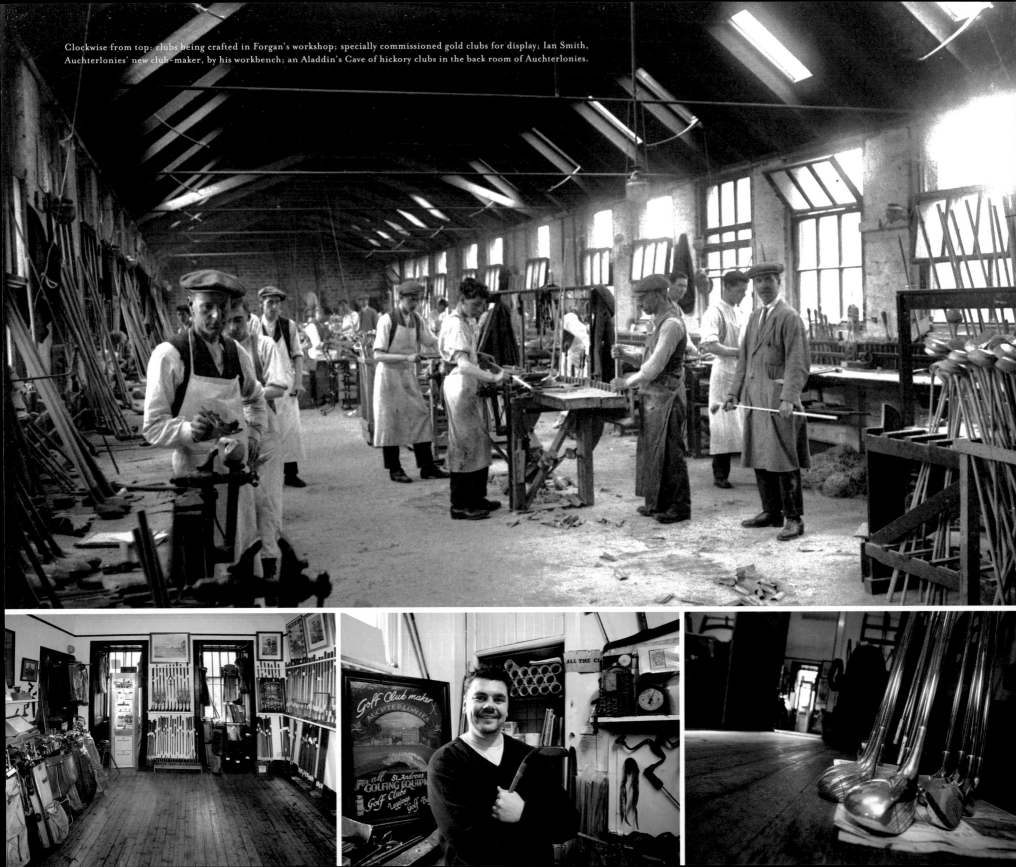

Clockwise from top: clubs being crafted in Forgan's workshop; specially commissioned gold clubs for display; Ian Smith, Auchterlonies' new club-maker, by his workbench; an Aladdin's Cave of hickory clubs in the back room of Auchterlonies.

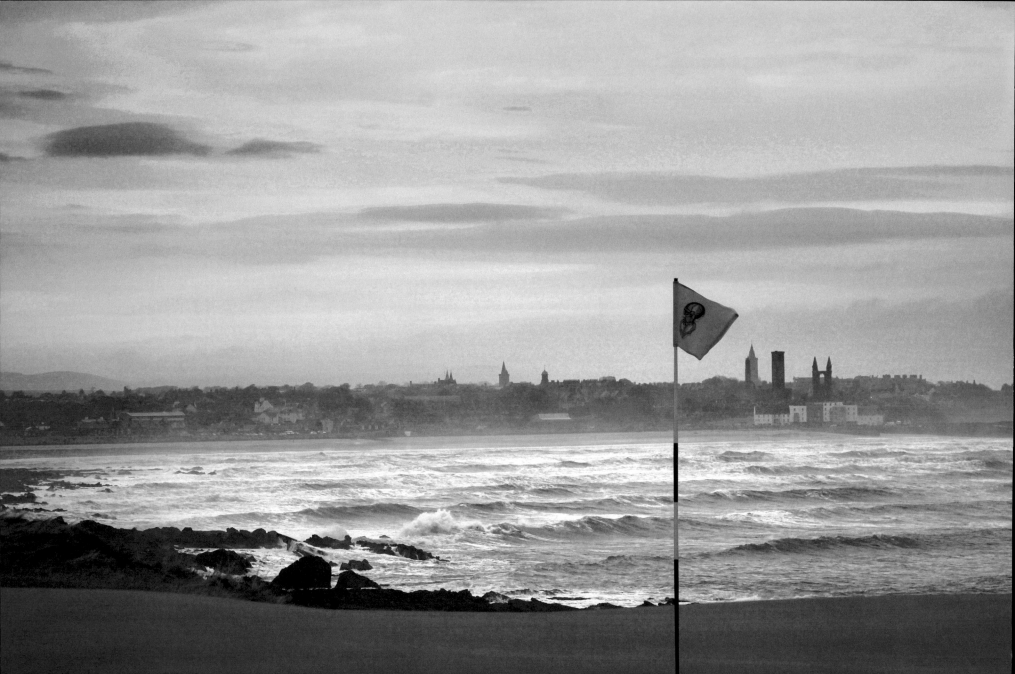

THE CASTLE COURSE

As the newest of the courses under the stewardship of the St Andrews Links Trust, the Castle Course remains in its infancy when compared to the vaunted histories of its siblings. Perched three miles to the eastern side of St Andrews in a dramatic cliff-top setting, the Castle's breathtaking views across the bay towards the town's ancient skyline and the Grampian Mountains beyond make it a different golfing experience to other courses nearby.

The Castle layout is just as much a visual masterpiece as the setting itself, with each nine-hole loop building to a dramatic crescendo at the edge of the sea. The design has enhanced the golfing spectrum of St Andrews by blending elements of craggy coastline and linksland together — an aesthetic more akin to Kingsbarns or Pebble Beach than the Old Course. Symptomatic of this uncommon feel are the layout's wild bunkers, made to look like 'a gash on the face of a boxer', creating a different atmosphere to the usual stacked-sod traps that appear on other seaside links. Furthermore, the Castle is known for its unique visual trickery: many tee shots play through intimidating labyrinths of hummocky marram grass; cunning gullies and banks introduce fascinating recovery shot options; and boldly contoured greens present a beguiling challenge.

During the late 1990s, the Links Trust recognised that golfing demand was soon going to outstrip capacity on the existing courses beside the town. Many plans were suggested to rectify the issue, including joint ventures with other golf courses or even buying an existing local course, but it was decided that a wholly new layout should be built, as it could be constructed to the high and exacting standards of the Trust and would fall under their sole control. After much searching, it came to light that a property might be available to the east of the town — a 220-acre potato farm resting on a headland about three miles away. Legends suggest that in the eighth century the land formed part of a hunting ground for Pictish kings and was called Muckross (from *muic* meaning 'boar' and *ross*, a 'promontory'). Kinkell Ness, the stunning escarpment at the northern edge of the property, was also the site of Kinkell Castle in the Middle Ages, and was the home of the prominent Moneypenny family who were deeded the land in 1211.

A visit to the site revealed an area of sloping farmland on spectacular coastal cliffs, yet the property did have some significant problems despite this impressive feature. Although gently sloped, the terrain was uniformly flat, treeless and featureless, with poorly draining clay soil that was certain to prove difficult to build a golf course on. In spite of the difficulties, the property was purchased and the long process of gaining planning permission began in 2002. The original planning application from the Trust was finally submitted in 2003, and 27 alterations were needed before permission was finally granted a year later.

With the land secured it was then a matter of finding the right golf course architect for the job. After much deliberation over a wide range of proposals, the commission was given to David McLay Kidd and his company DMK Design. Kidd was young, Scottish and highly acclaimed for his work in bringing traditional links to the American mainland at Bandon Dunes, Oregon, as well as creating a modern classic in the buckle of England's heathland belt – Queenwood, Surrey. After receiving the commission, Kidd wrote in a letter to the Links Trust:

The views from the site are exceptional. I have learnt that golf is a pastime enjoyed as much by the eyes as the body, especially for golfers of lesser ability. The site will provide them with a great deal of pleasure, of that I have no doubt. Once on the site it is apparent that generations of farming have removed every subtlety from the terrain. Imaginative golf design must restore these subtleties.

A design tenet for the Castle Course was to make it an enjoyable experience for all. Five separate teeing grounds were placed on each hole so that every level of golfer could play without feeling that the course demanded shots beyond their capability. It was also envisaged that although it was to be a cliff-top course, the Castle would retain a links-like feel and offer sea views from every hole. Kidd brought many tons of earth to turn the flat, bland farmland into a plunging and twisting dune-swept landscape. Incorporating movement into the terrain, he enclosed many of the holes in banks of marram grass to give each one a separate identity.

After a worldwide competition that attracted over 4,000 entries from as far away as Thailand and Australia, it was decided that the course was to be called the Castle Course.

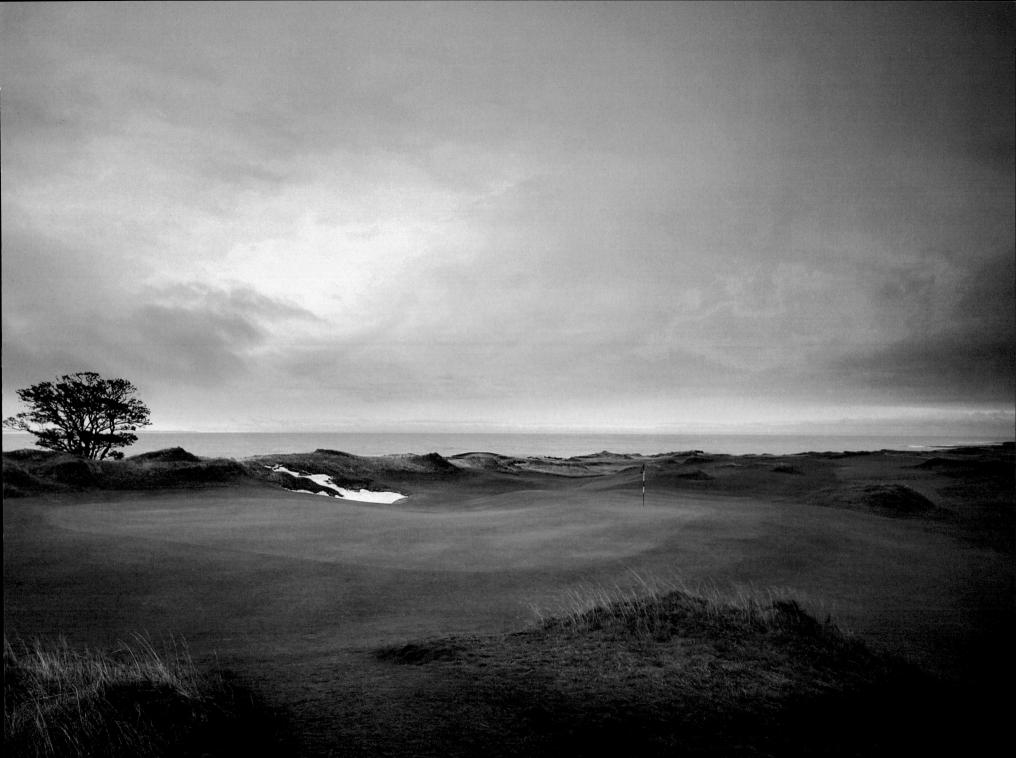

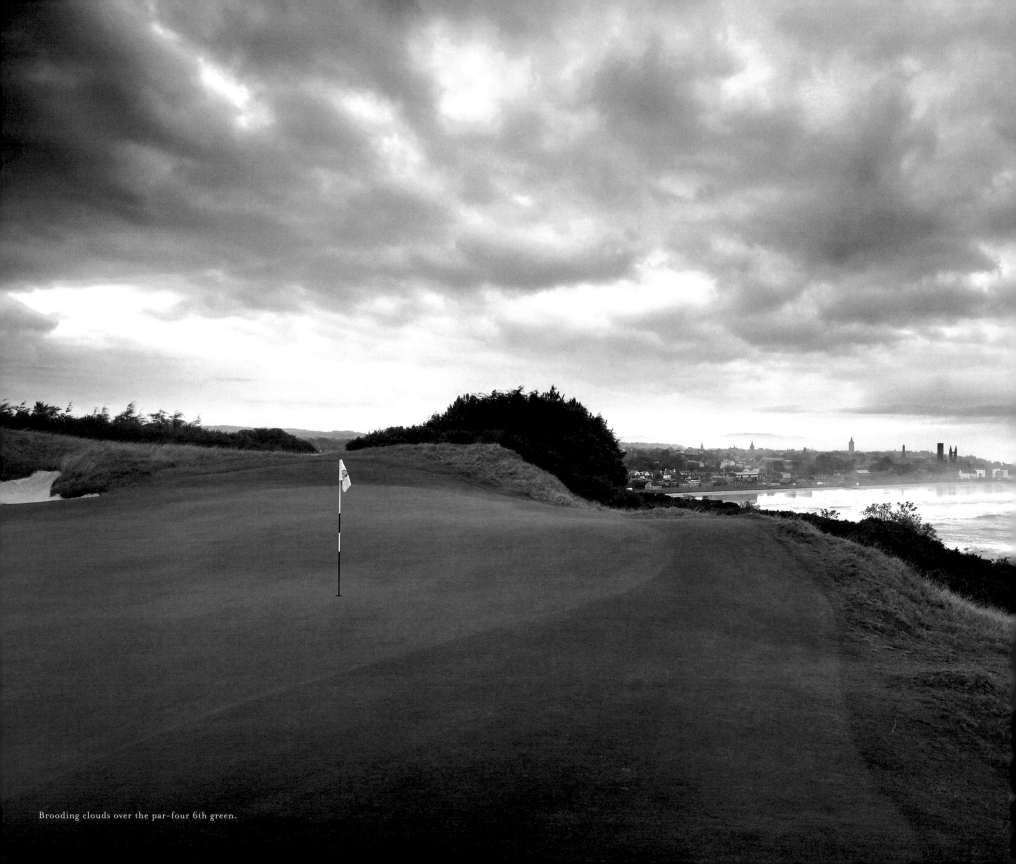

Brooding clouds over the par-four 6th green.

The winning entry was submitted by Edwin Burnett of Florida, USA, who suggested that the name would reflect the fact that Kinkell Castle once stood on the promontory. His prize was the privilege of hitting the tee shot that opened the course in the presence of HRH the Duke of York on 2 July 2008, as well as being able to associate his name for ever with the Home of Golf.

The opening two par-four holes are comparatively gentle when compared to the rest of the round, yet they provide an early definition of the principles upon which the course was crafted, with fairway valleys and windswept hazards all in sightline from the tee. The 1st curves right to a green that sits invitingly in a punchbowl, ready to feed approaches towards the pin. The 2nd, much like the great holes of Ballybunion and Lahinch, uses illusory intimidation on the drive. There appears to be very little room to play into, even though the landing area is actually reasonably forgiving. Placing a shot to the most advantageous portion of fairway, as Kidd himself says, 'requires a giant leap of faith, stepping off into nothing, and believing you are not going to fall'.

Back-to-back par fives midway through the front nine require solid ball striking and, above all, a steady putter. The long 4th particularly showcases the billowing contours available on the Castle's superior green complexes. Similar to the par-four 14th green for its slopes, uncompromising gradients and hidden borrows, the 4th's heart-shaped putting surface moves from a front-right high point down to the back left and over a dominating central fold.

The course builds to its first major crescendo by touching the coastline at the 421-yard 6th hole. The green offers a sterling view of St Andrews, with the Castle and Cathedral ruins in full view across the water, as well as the rest of the 'auld grey toon'. From the outset of the project, Kidd designed the 6th green to be a scenic moment to savour:

We knew that the culmination of delivering golfers down to the water for the first time, coupled with surprising them with how close they are to the town, was going to be a fantastically dramatic effect ... The big thrill comes as golfers walk through a swale at the end of the fairway and emerge up on to the green. There it is, the old town. It is truly breathtaking, seeing the beach at East Sands for the first time and looking right at the cathedral. It is so close that it appears you could tee up a driver and start lacing balls at the spires.

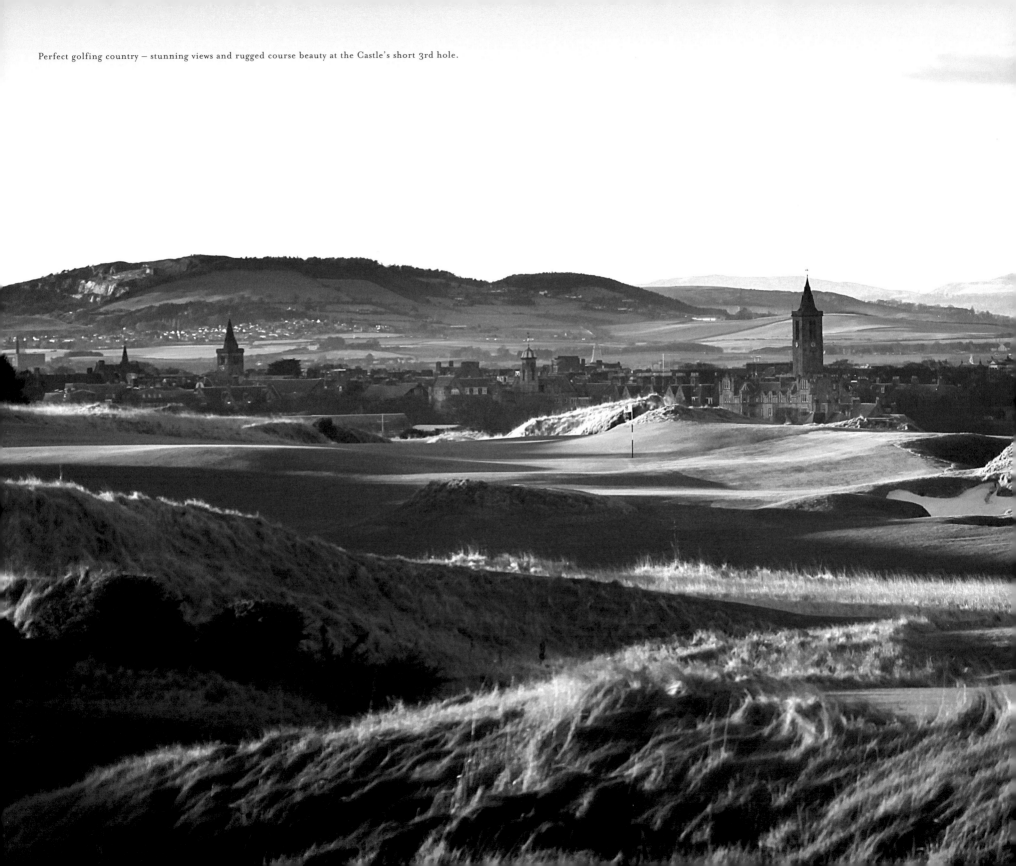

Perfect golfing country – stunning views and rugged course beauty at the Castle's short 3rd hole.

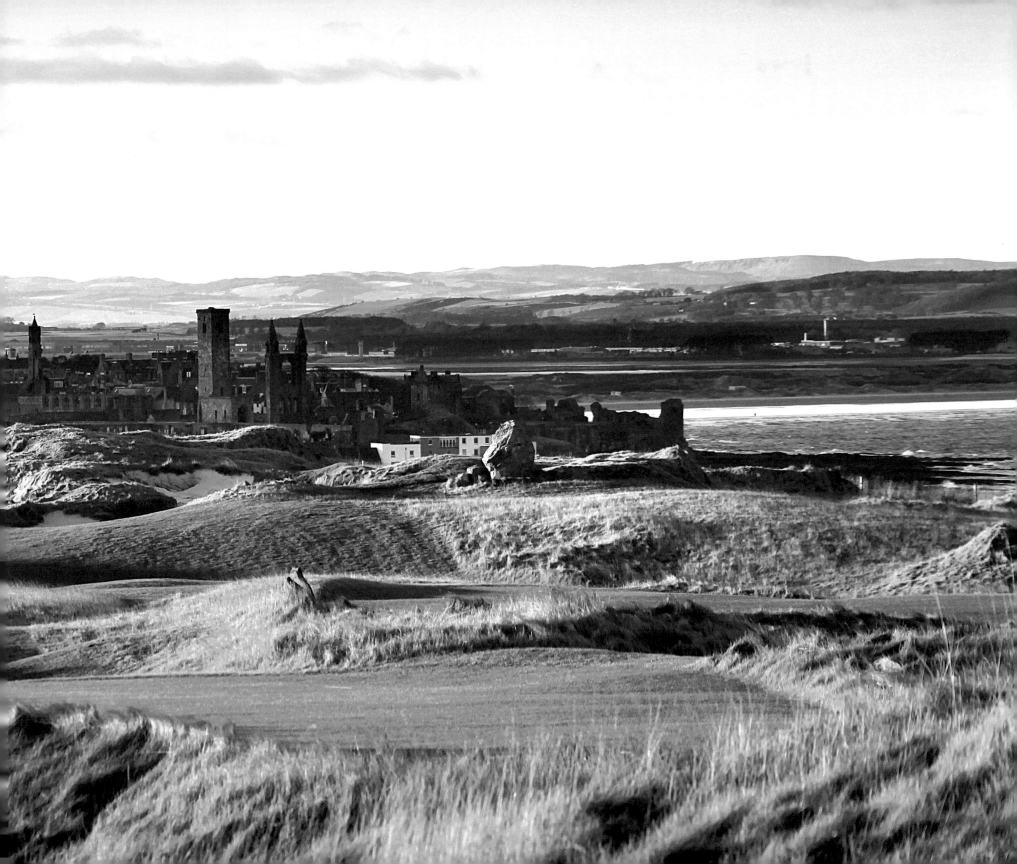

The back nine is dominated by a closing stretch that forms some of the most picturesque and outstanding holes in St Andrews, or anywhere for that matter. The enormous 585-yard 15th is a lovely par five with a split fairway inspired by an Alister MacKenzie sketch of the Elysian Fields on the Old Course. The tight landing area on the left-hand side of the dividing hummocks makes the green reachable in two, but there is also an easier three-shot route to the right, which is more appealing to high handicappers. The tiny plateau green puts a premium on accuracy.

When the tee of the par-three 17th is finally reached it is easy to see why it is known as the course's signature hole. Playing over 180 yards across a yawning chasm to a green set on an opposite ledge in the rugged coastline, the 17th is simply unique in its elemental beauty and has the aura of a truly world-class golf hole. With the natural landscape so perfectly conducive to a one-shotter, as Kidd says, 'this hole just had to be'.

The par-five 18th is a great finishing hole, doglegging sharp right to a traditional double green shared with the 9th. For design brilliance, it successfully carries on from where the show-stopping 17th leaves off. As a concluding point to the Castle Course, it was a hole that Kidd was determined to perfect:

The double green shared by holes nine and eighteen is the sweetest spot on the entire site. We had the chance to do something pretty special there on Kinkell Point, and we believe we made the most of our opportunity.

Fittingly, the home green is supposedly where Kinkell Castle is said to have stood, reflecting the immense care taken by Kidd in making sure that this modern golf course pays homage to the area's historical connections, as well as a wider golfing heritage. The Castle Course is full of charismatic golf holes and does not attempt to parody the greatness of the Old Course in any way. Instead it adds a new dimension to St Andrews Links because of its charming, atmospheric challenge that fits perfectly with its surroundings and feels like a timeless layout.

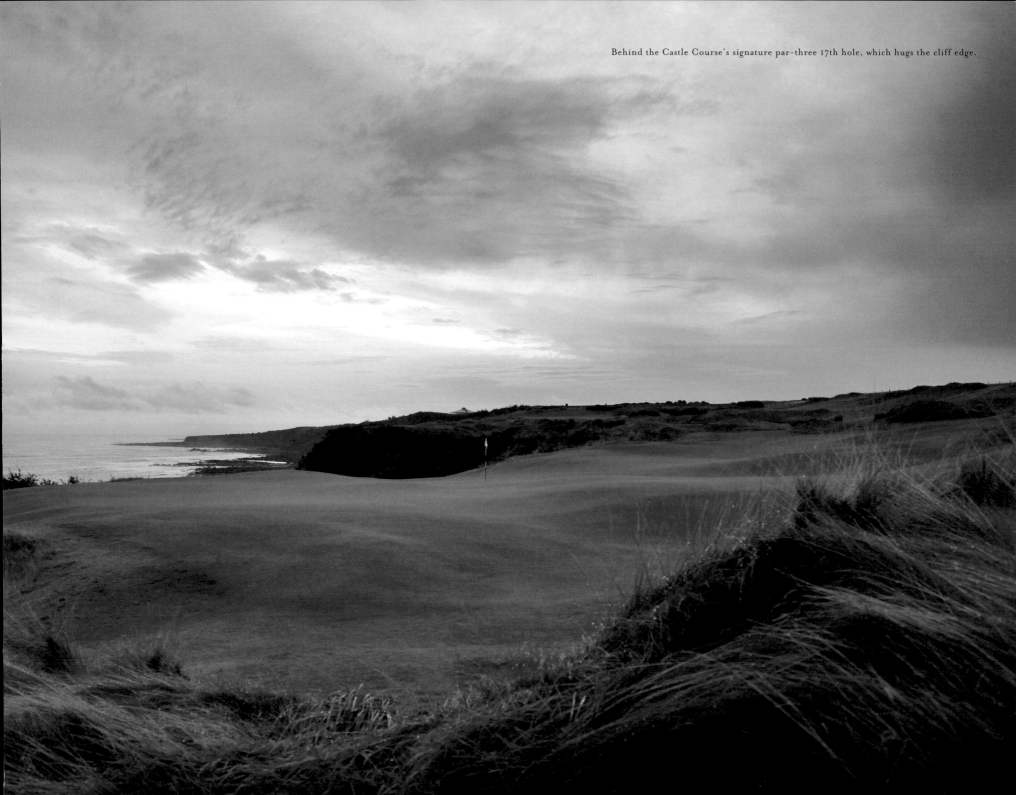

Behind the Castle Course's signature par-three 17th hole, which hugs the cliff edge.

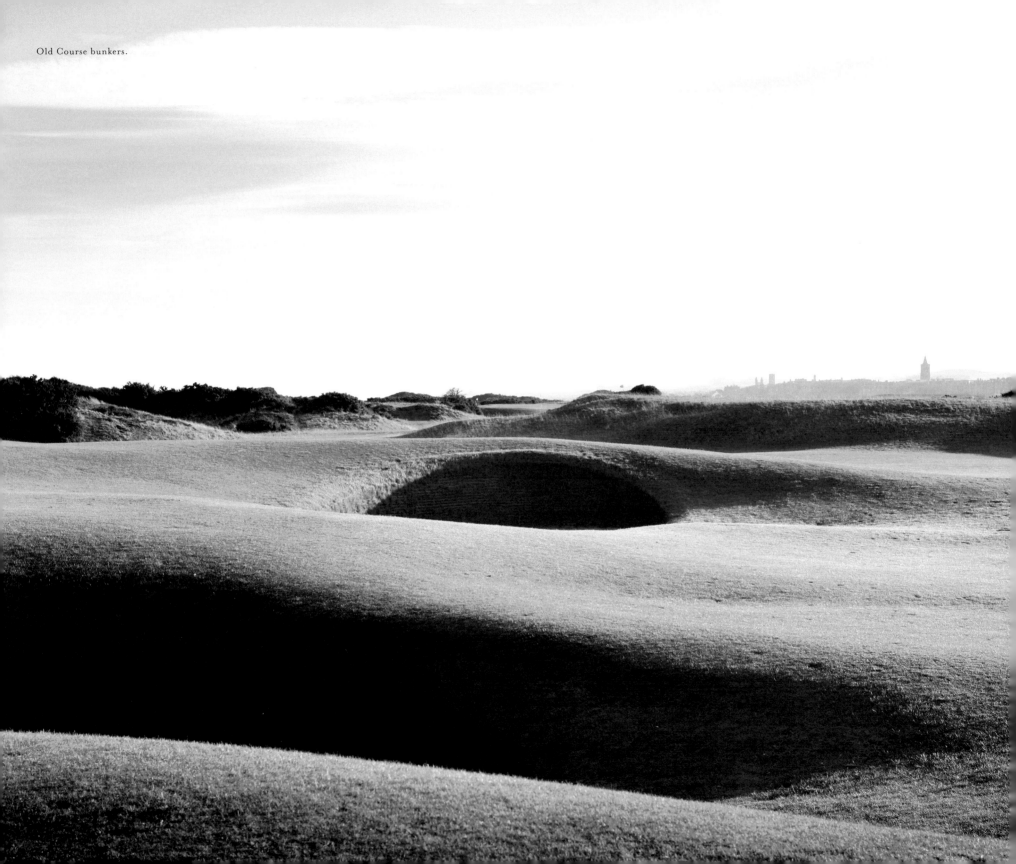

Old Course bunkers.

THE XIXTH HOLE GOLF CLUB

The Golf Hotel, St Andrews, 1973. It is a raw winter evening with gusts of rain thrashing the Links. A night to be indoors, and no better place than at the 19th Hole bar overlooking the final green of the Old Course, in one of the Home of Golf's most unpretentious and comfortable hotels. Sitting in a smoky corner is the venerable golf commentator Henry Longhurst, sharing a drink and a joke with Arnold Palmer's Scottish caddie, Tip Anderson. Everyone else in the bar knows who these two are, but they go unbothered. St Andrews is used to seeing famous faces.

Around the room can be heard much bantering and many bursts of laughter; a sea of glowing faces; almost tangible camaraderie; and an air of excitement. Tonight, the entire membership – nineteen gentlemen – of the newly formed XIXth Hole Golf Club is in situ. They greet each other with back-slapping familiarity, for they are part of a fellowship that is both universal and specific; they are drawn together by golf and by their physical connection with the game's ancient capital, where most of them live. Their purpose is to fix matches of competitive yet social golf.

Fast-forward to the present and the Golf Hotel is no longer there (it was converted into flats in 1976). Nor, sadly, are Tip Anderson or Henry Longhurst, an honorary member and long-time friend of the Club. The XIXth Hole has no clubhouse and no golf

XIXth Hole Golf Club crested tie (detail).

course to call its own, yet the spirit in which St Andrews' youngest golf club was founded remains unwavering. The clubhouses of The St Andrews Golf Club and The New Golf Club, where its prize-giving ceremonies, charity events, the Annual Meeting and Club Dinner are held, are the nearest thing these golfers have to a headquarters.

The Club was founded in 1973 with the full support of the Golf Hotel's owner, Ian Brewster, its first Captain, and a select few patrons of his 19th Hole bar who due to work and other recreational activities were unable to take part in the normal competitions of the golf clubs to which they already

belonged. The number of members was restricted to nineteen as a level at which social and golf interaction could remain strong. After membership of the Scottish Golf Union and Fife Golf Association was attained, medal rounds and competitions were played on a Sunday, and this tradition continues today for the majority of Club events.

The key of the XIXth Hole's success seems to be the energetic organisation and promotion of its crammed fixtures calendar – nineteen members, nineteen competitions and even a nineteen-hole tournament. Most prominent on the list is the annual St Andrews Inter-Club Stableford Team event, introduced by the Club in 1976, that brings together all of the main local clubs – both men and women – for a six-a-side points event that is often played over the Eden Course. Other highlights include a match against The Thistle Golf Club for The DL Joy Trophy; spring and autumn meetings on the Old Course; the Invitational Texas Scramble; and the Club Championship played to handicap. The year usually ends with a short golfing tour in October, which regularly visits some of the top championship courses in the British Isles.

In terms of who today's members are, the Club remains intensely local, although there are sometimes rare associate members not fortunate enough to live in the St Andrews area. In 1992 it was decided that gentlemen who had been members for nineteen consecutive years should be offered life membership, allowing new blood into the Club while maintaining the founding principle of at least nineteen active members. There are today 27 members in total, aged from the early fifties to the mid-seventies, mostly also belonging to The St Andrews Golf Club or The New Golf Club. The XIXth Hole is a quintessentially Scottish institution. Membership is by invitation and the candidate must have sufficient support from within the Club to be admitted. He must also show a real interest in golf and be a good, sociable companion – someone you would like to have a game with. Although small, the membership is nonetheless highly inclusive when it comes to interacting with many other golf clubs through enjoyable matches. The fraternity, sincere friendship and integrity promoted at the Club since its foundation in a St Andrews bar all those years ago has always reflected in microcosm the qualities of Scotland's great gift to the world – golf.

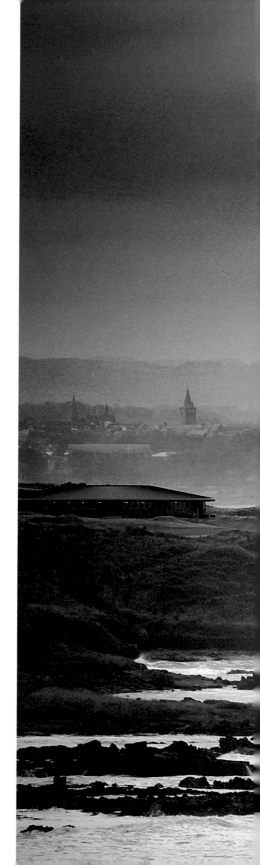

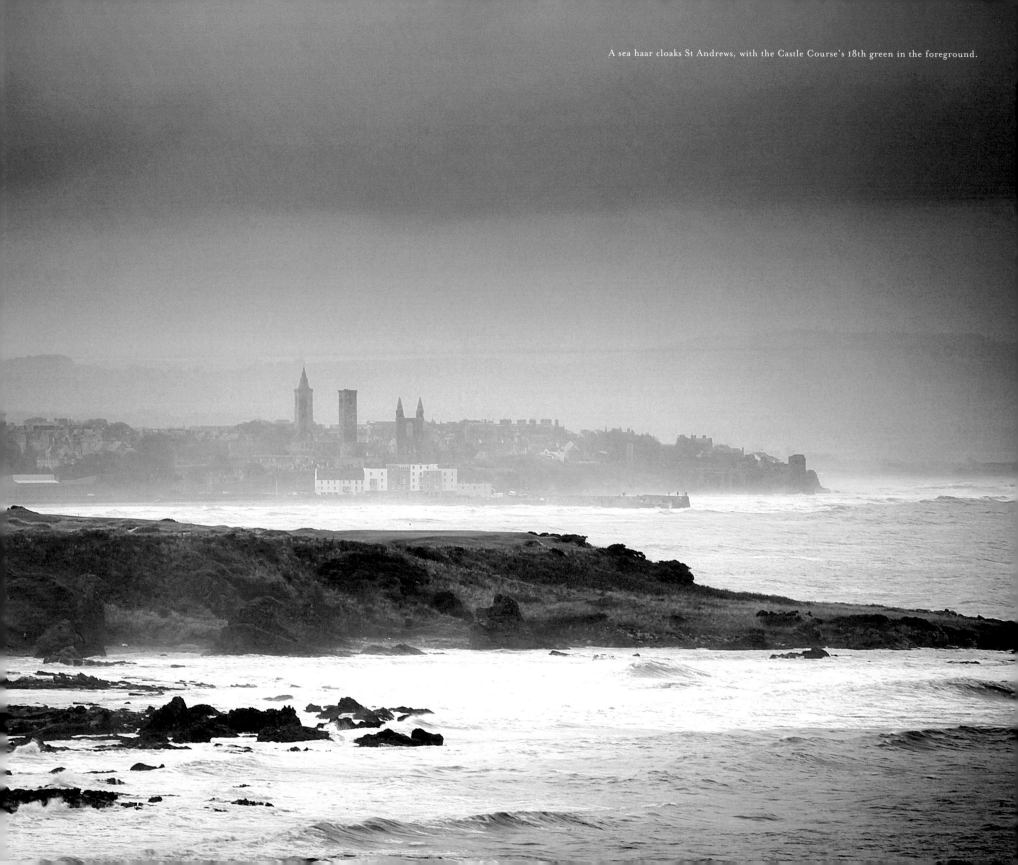

A sea haar cloaks St Andrews, with the Castle Course's 18th green in the foreground.

AUTHORS' ACKNOWLEDGEMENTS

St Andrews: The Home of Golf came about through the lens of photographer Kevin Murray. For several years Kevin has been visiting St Andrews, capturing the unique qualities of its ancient linksland, the wonderful nature of its citizens, and the haunting beauty of its timeworn buildings. We are extremely grateful to him for providing such vivid images to accompany our words, and for making the creation of this book a very enjoyable collaborative process.

There are many people who were kind enough to give their time and insight into St Andrews. The members and secretaries of each club who allowed us access to their clubhouses and agreed to be interviewed and photographed were all of invaluable assistance. We would also like to draw particular attention to the following individuals who lent their support and were extremely helpful in making this book possible:

Jim McArthur; Hannah Fleming and Angela Howe of the British Golf Museum; Noel Stephens; David Joy at the XIXth Hole Golf Club; Ian Smith of Auchterlonies; Ayden Roberts-Jones, Professional of The Duke's St Andrews, for his hospitality; Neil Doctor of The St Rule Club; Sylvia Dunn at St Regulus Ladies' Golf Club; Tom Gallacher of The St Andrews Golf Club; J.J. Simpson at The New Golf Club; Stephen Fontes for his enjoyable company on the Links.

We've been very fortunate to have the considerable design skills of Oliver Pugh at Simmons Pugh to produce a beautiful book. Duncan Heath and Sarah Higgins, editors at Icon Books, helped enormously with the editorial work.

Last but by no means least, sincere thanks and admiration to Seve Ballesteros, a truly courageous champion of golf and one of the game's greatest, for contributing the foreword.

SOURCES AND IMAGE CREDITS

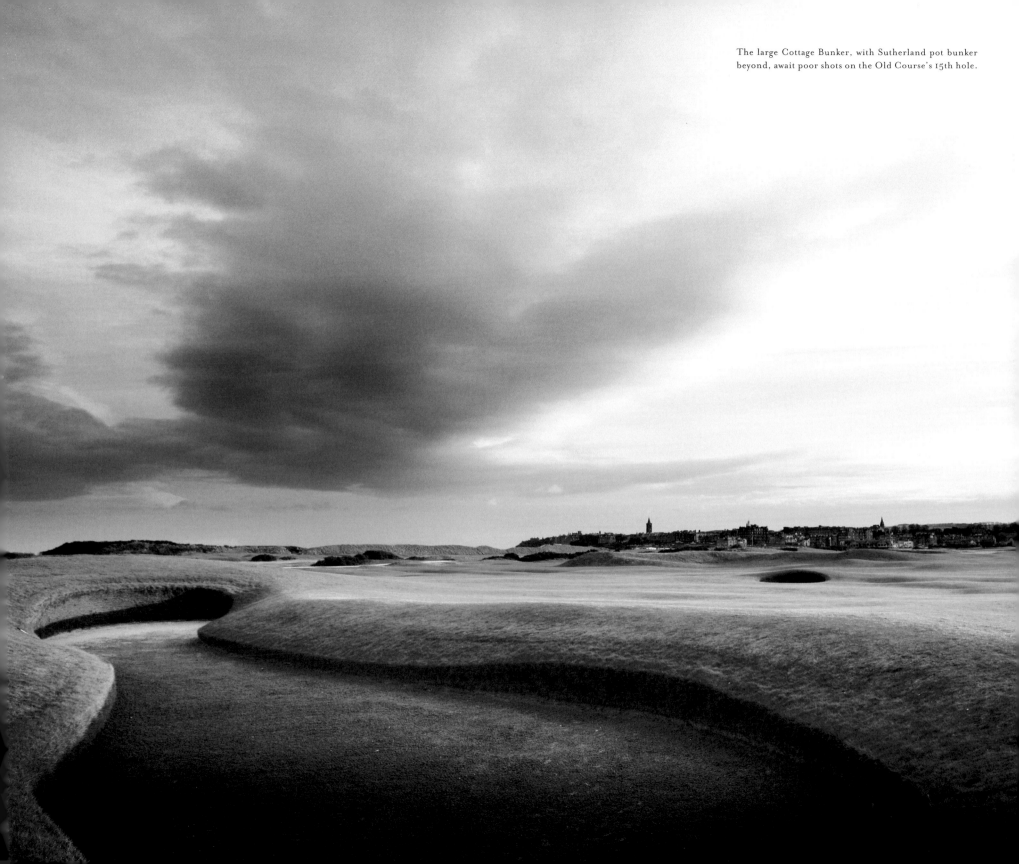

The large Cottage Bunker, with Sutherland pot bunker beyond, await poor shots on the Old Course's 15th hole.

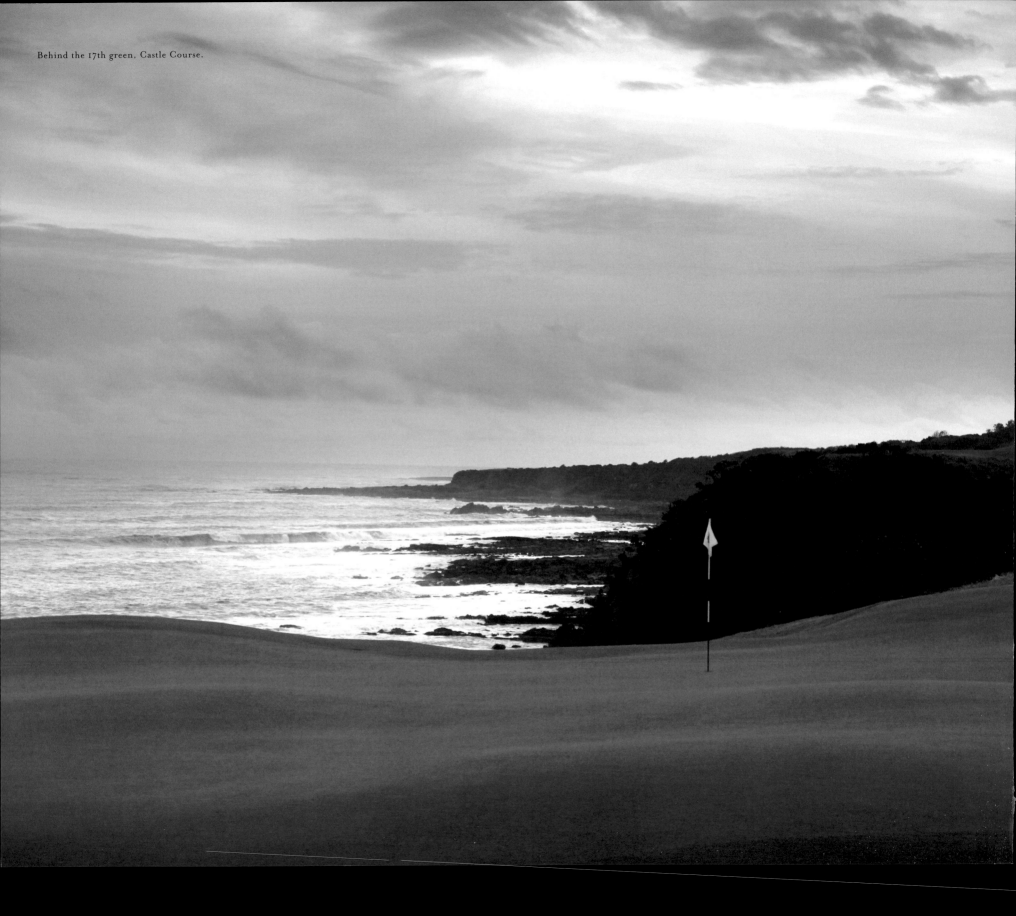

Behind the 17th green, Castle Course.

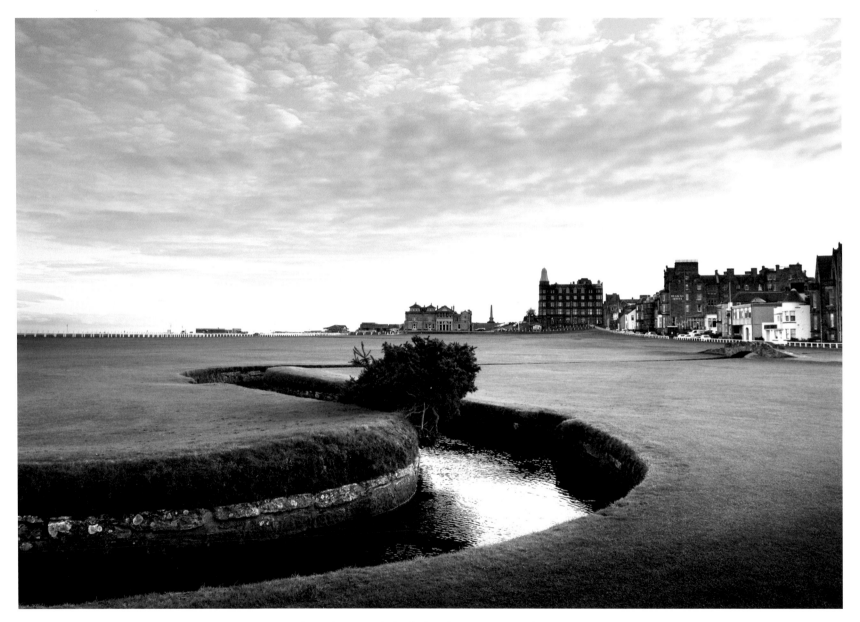

Gorse clinging to the bank of the Swilcan Burn, Old Course.

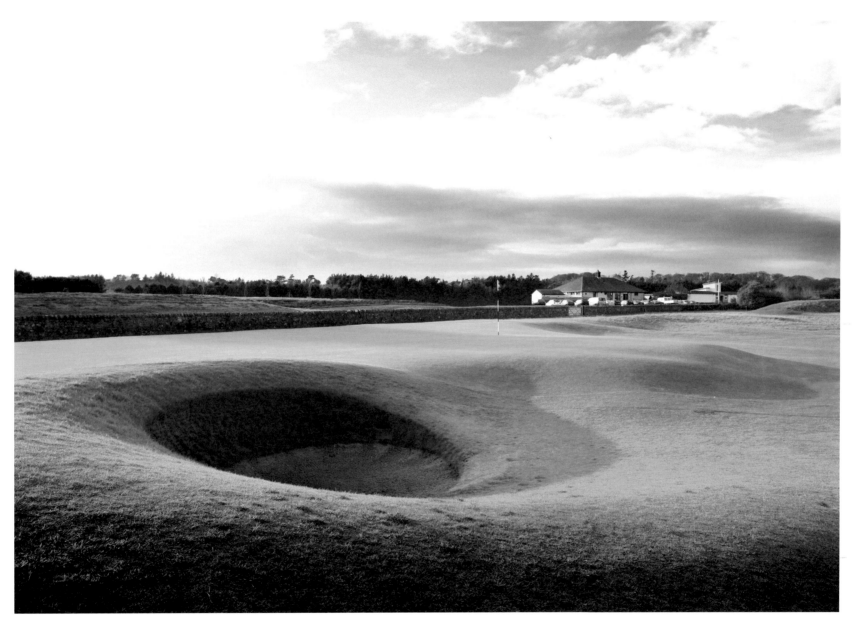

A forgiving front pin position on the 17th 'Road' hole green, Old Course.

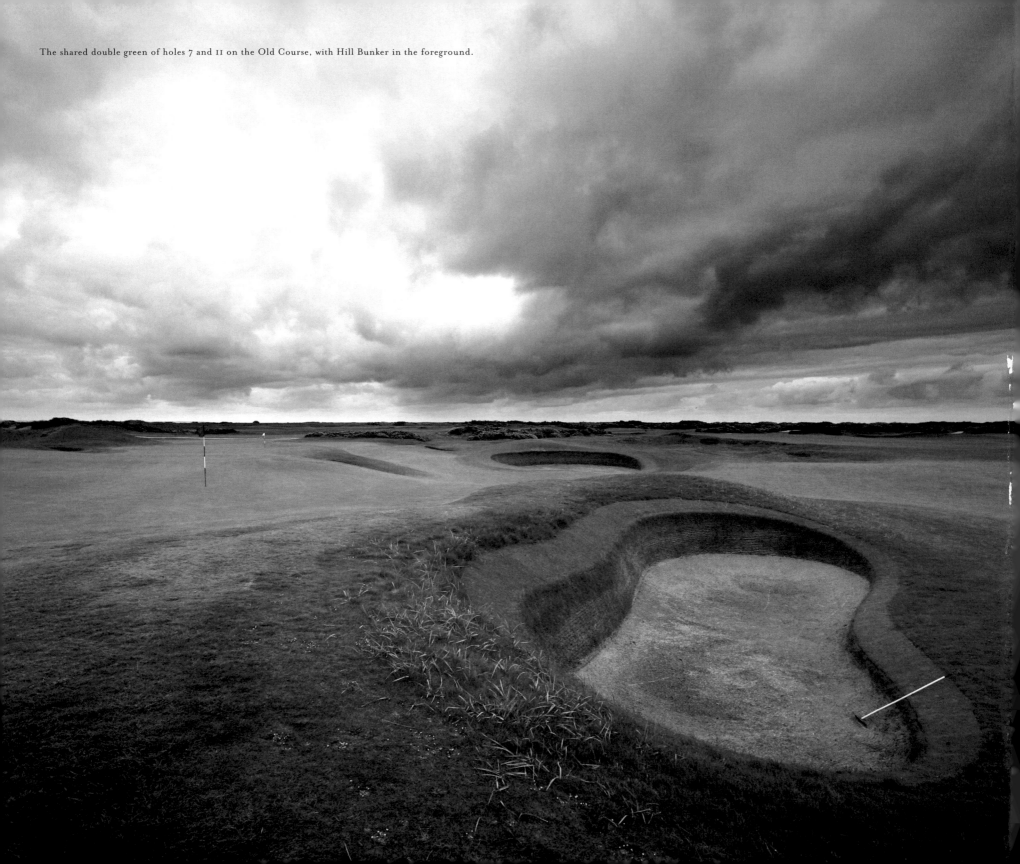

The shared double green of holes 7 and 11 on the Old Course, with Hill Bunker in the foreground.